BEST OF WATERCOLOR

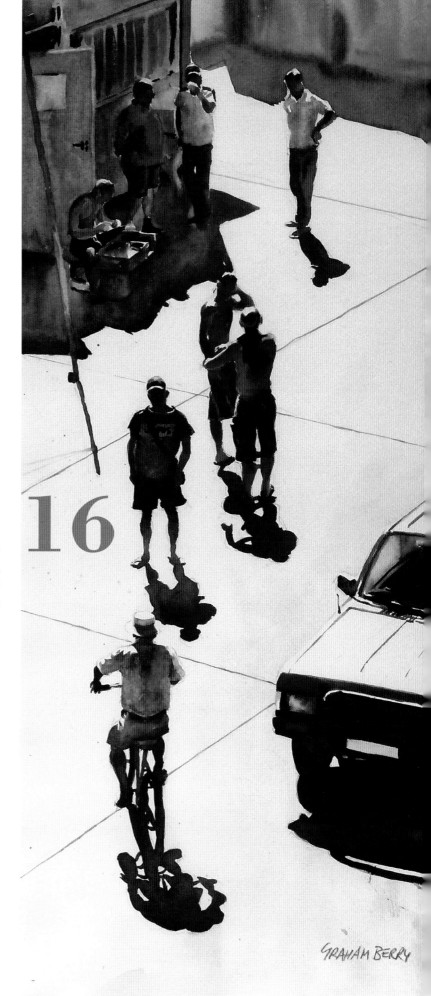

SPLASH 16

Exploring
Texture

edited by Rachel Rubin Wolf

NORTH LIGHT BOOKS
CINCINNATI, OHIO
artistsnetwork.com

CONTENTS

Land and
Waterscapes

6

Close-Ups

22

Animal
Kingdom

38

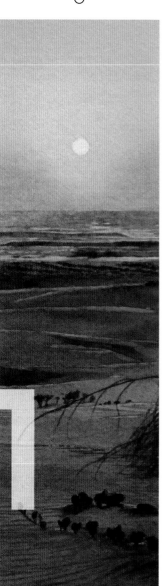

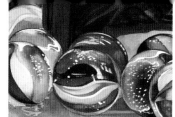

INTRODUCTION

Over the years we have found that texture is of particular interest to many watercolor painters. Perhaps it is because watercolor is so adaptable to so many different applications. Endless variations can be produced with the help of common or unlikely tools—or by merely directing water or air through the paint—or by tilting your paper. Brushes are optional. In fact, Janet Nunn says, "Creating art with texture forces you to rethink how to paint." Yael Maimon advises, "When it comes to texture, just go for it—wash, scrub, glaze, scratch and lift!"

Nature produces an unending array of textures that artists can copy or merely be inspired by. "Texture is the fabric of nature. The crinkles, divots and folds in the natural world are what make it astonishing," observes Jill M. Cardell. How to get that intriguing texture on paper? Most in this volume agree: any way you can! Sandy Delehanty notes, "The most interesting textures come from pure experimentation." On the other hand, some artists work slowly and deliberately with only pure and simple watercolor techniques. Cindy Brabec-King informs us, "It is nothing for me to have at least one hundred hours in a painting …."

Texture, unlike tonal value, is not usually the foundation of a painting. Texture acts not as the steel girders of a building, but as architectural ornamentation with its vast decorative styles and motifs that give beauty and interest to a structure. "Texture to a painting is like salt to food—each enhances one's flavor of the subject," comments Cheryle Chapline.

Some of its other facets include bringing one's painting to life. "Texture gives your painting a sense of believability," says James Toogood. And "Textures reveal what time does to an object … telling the story of its life," Deborah L. Chabrian insightfully adds.

Irena Roman shared this short poem by William Carlos Williams that in few words sums up the importance of contrasting color and texture:

so much depends
upon
a red wheel
barrow
glazed with rain
water
beside the white
chickens

I hope you enjoy this new and beautiful volume of *Splash*. Let me know what you think!

Rachel

—Rachel Rubin Wolf

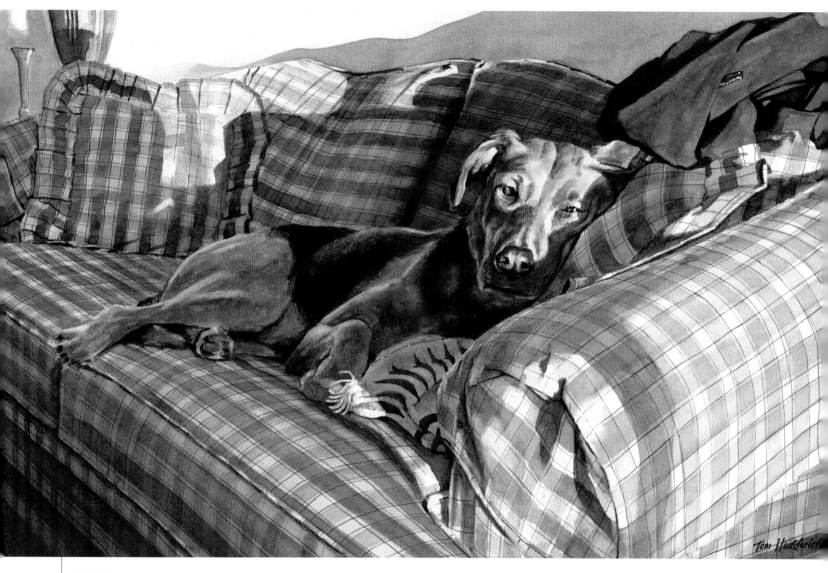

ABBY | TOM HEDDERICH
Transparent watercolor on 300-lb. (640gsm) cold-pressed Arches
11" × 18" (28cm × 46cm)

I began with a wonderful photograph of Abby caught in the act of sleeping on the living room love seat. The brilliant morning sun cast dramatic shadows and reflected golden light. I manipulated the image in Photoshop to enhance the composition and included my brown coat, which was ready for our long morning walk. In order to bring out the intense yellow that filled the room, I washed an underpainting of New Gamboge on most areas that were not to be left white. What attracted me to the scene was the contrasting textures of Abby's soft fur, the crisp feel of the couch fabric, my soft brown coat, and the hard, shiny lamp and vase in the background.

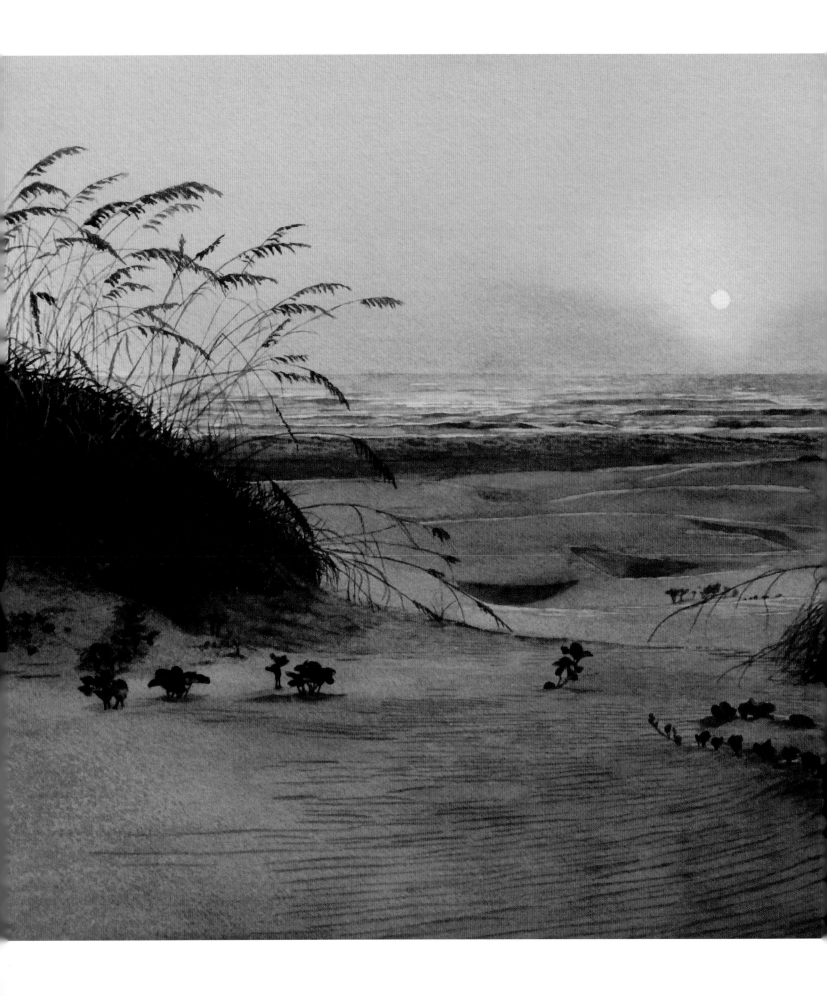

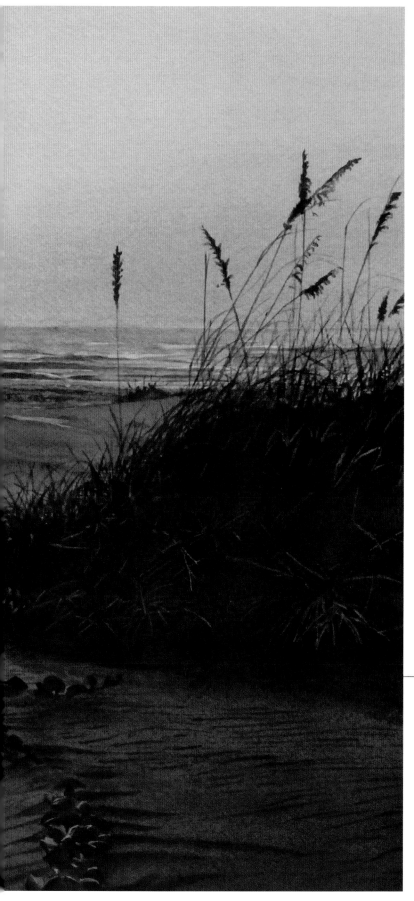

1

LAND AND WATERSCAPES

PRELUDE TO A BEAUTIFUL DAY | KEIKO YASUOKA
Transparent watercolor on 300-lb. (640gsm) cold-pressed Arches
18" × 26½" (46cm × 67cm)

Padre Island is the second largest island by area in the contiguous United
States. Yet it is one of the most isolated places I have ever visited. I felt
quite fortunate to be at this unusual location at sunrise. The yellow and
red colors gave me feelings of warmth, energy and a sense of peace. I
applied layer upon layer of washes to obtain this specific color and value.
I used a stippling brush to produce the texture of the sand. As I painted,
the sea oats swaying in the wind made me smile. I strove to convey the
same harmonious effects to my viewers.

Visit artistsnetwork.com/splash16 to download free bonus wallpapers from the *Splash* series.

7

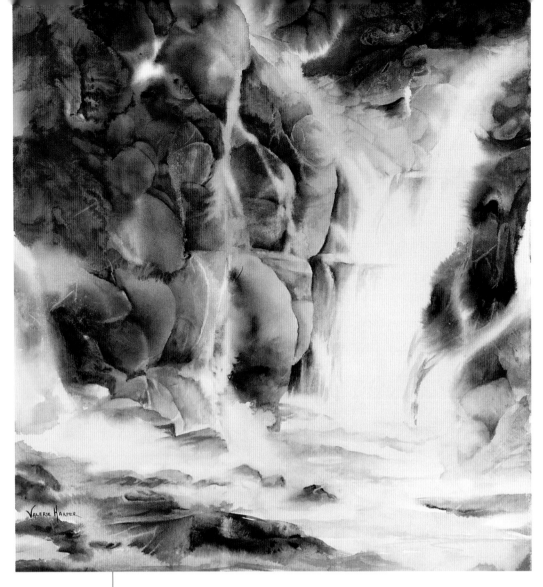

Creating texture simply using water, flat-surfaced paper and pigment … exhilarating!

99

—Valerie Harper

MAJESTIC FALLS | VALERIE HARPER
Watercolor on 300-lb. (640gsm) hot-pressed Arches
26" × 24" (66cm × 61cm)

I began this painting with a very loose sketch guiding the flow of water and roughly placing the rocks. I then let the paint weave their appearance. My wet, flat 1-inch (25mm) brush loaded with pigments created texture on the saturated hot-pressed paper. I first painted boldly, letting the colors swirl and blend together, working into my precious white spaces with very soft edges. I did not use any masking. When the paper was completely dry, I painted the negative spaces around and between the rocks. A few loose strokes guide the direction of my tumbling water.

BARN WITH TRACTOR | LAURIN MCCRACKEN
Transparent watercolor on 300-lb. (640gsm) soft-pressed Fabriano Artistico
17" × 14" (43cm × 36cm)

I had taken a lot of photographs of barns in the Mississippi Delta, but this was the first one that told me it could be a watercolor. The sun raking across the delicate texture of the grass contrasting with the solid tractor in the shadow of the barn is what compelled me to paint this landscape. The textures of the leaves in the trees, the roof and siding of the barn, and the grasses in the foreground gave me a vocabulary of techniques by which I could tell the story.

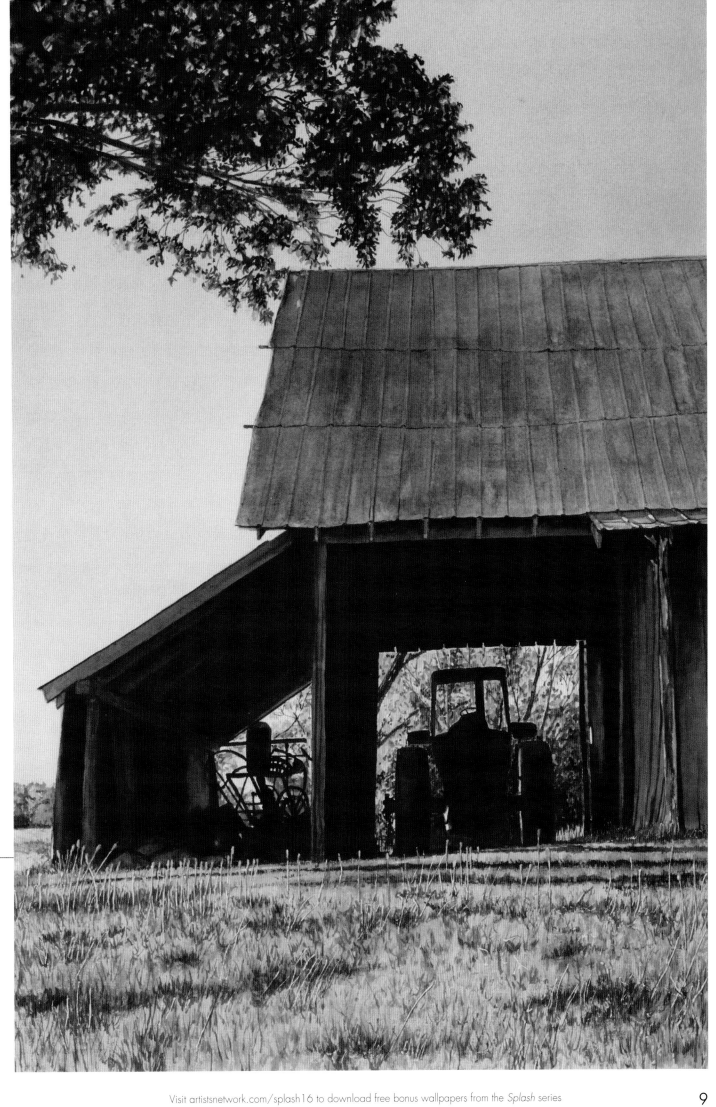

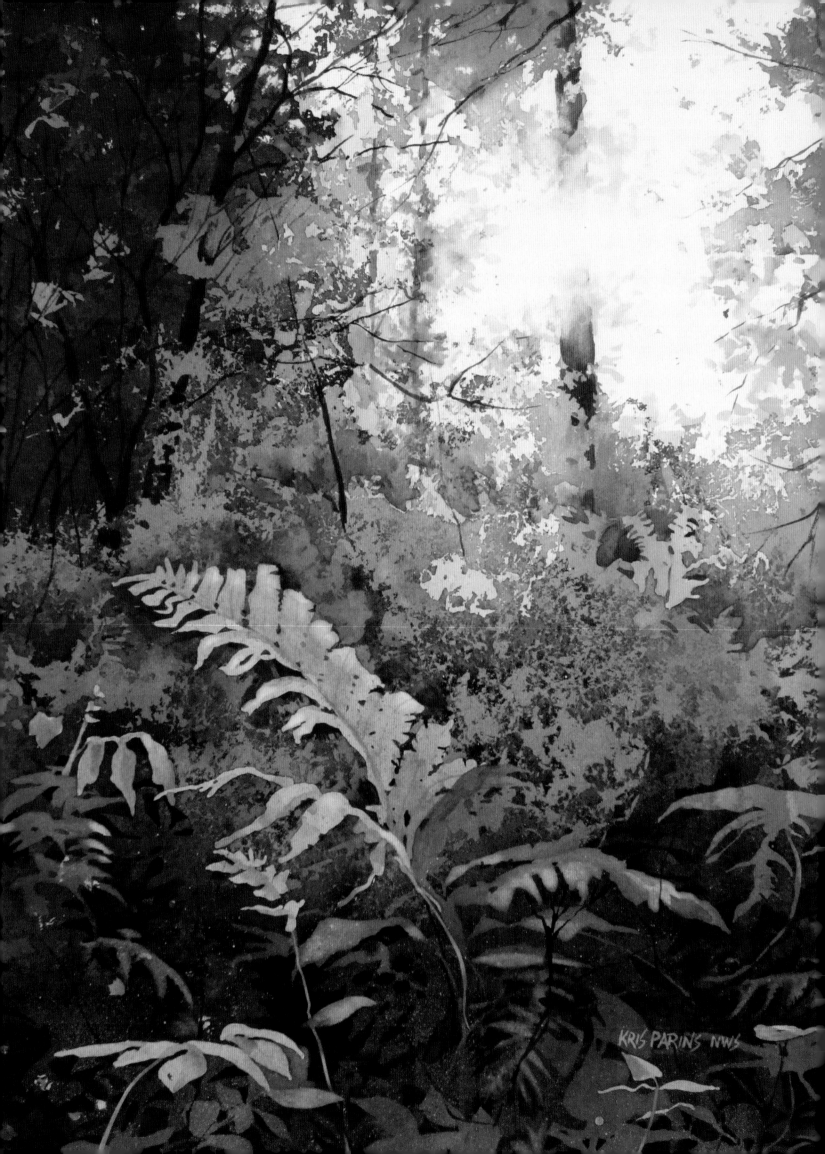

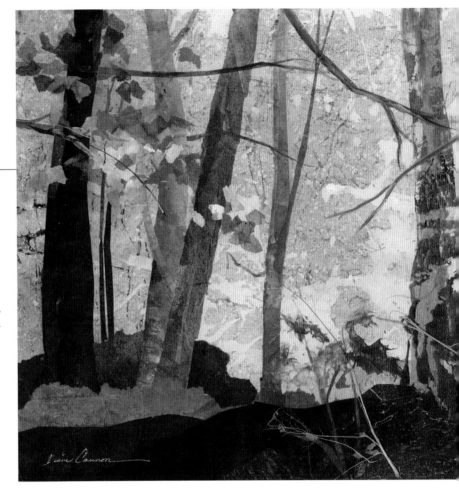

FALL FROLIC | DIANE F. CANNON
Collage on mat board
11" × 11" (28cm × 28cm)

To unwind, I paint and manipulate paper. I love color and texture and find excitement in this intuitive process. Spattering, sponging and crinkling a variety of papers that I have painted in various values inspires me and provides a background for collage. Trunks, branches and foliage are favorite shapes of mine, all made by tearing and cutting from papers that I have painted.

66

I like to use texture to suggest atmospheric perspective by using hard edges in the foreground and less distinct shapes in the background.

99

—Kris Parins

SALUTE TO THE SUN | KRIS PARINS
Transparent watercolor on 140-lb. (300gsm) cold-pressed Arches
29½" × 21½" (75cm × 55cm)

For a few days around the summer solstice, the sun hangs low over the lake opposite my studio windows. It shoots a brief flash of brilliance through the trees as it reaches its most southerly sunset of the year. Every June, I marvel at the lighting effects on the surrounding forest as I attempt to communicate my sense of awe at this annual phenomenon. I built up this scene layer by layer, stamping and spattering with both masking fluid and paint, creating the random textures of nature that this painting required. As the painting got closer to completion, I brushed in the darkest negative shapes, lifted some of the highlights and softened edges with scrubber brushes.

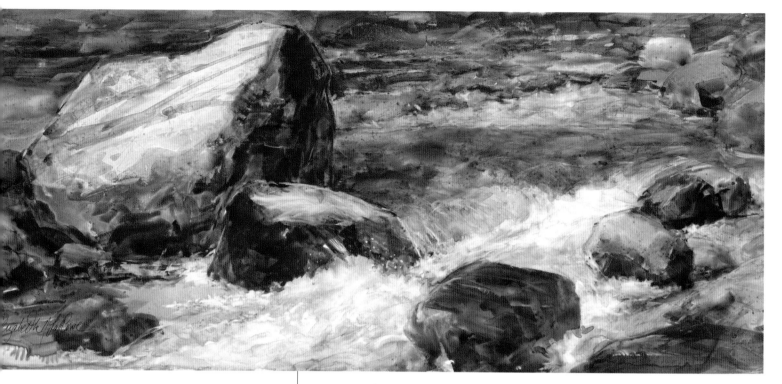

ROCK CREEK | ELIZABETH NICKERSON LAROWE
Watercolor on 140-lb. (300gsm) Yupo
10" × 22¼" (25cm × 57cm)

On Yupo paper, paint floats and glows, naturally creating color mixing
and texturing. *Rock Creek* was created using on-site value studies and
personal photographs. Waiting for the rocks to dry before applying
the stream around them required patience. For the white water I used
brushes, clean water, a spray bottle and occasional tissues to lift color
back to the white paper. After all paint dried, shadows were glazed
using rich, dark values with single, non-overlapping brushstrokes.

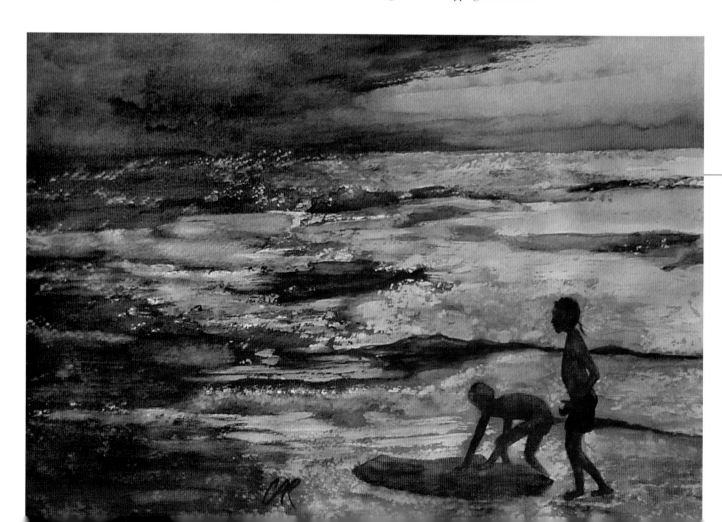

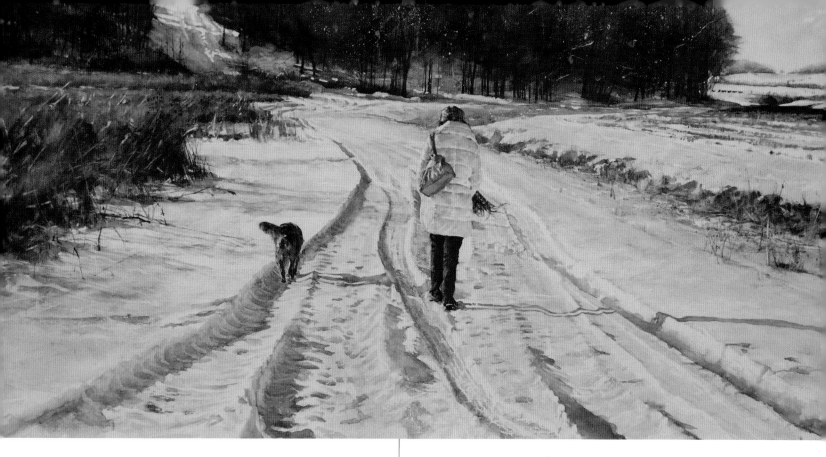

LAST MILE ... ALMOST HOME | CHRISTINE MISENCIK BUNN
Transparent watercolor on 140-lb. (300gsm) cold-pressed Arches
15" × 29" (38cm × 74cm)

This shows a cancer survivor, my daughter, bravely navigating her pathway toward healing. I was inspired to create the cold, snowy journey of struggle, fear, desperation and finally a positive outlook as the end of the trek drew near. The texture of snow was most important. The changing light, the shadows, the footsteps, the tire tracks and even the pathway were imperative. My predominant color was Ultramarine Blue. To produce the many textures, I employed washes, glazes, wet-into-wet and an old toothbrush to soften some of the edges. With my own sense of helplessness, I was trying to understand my daughter's hopeful "last mile."

MY TURN | CHRIS ROGERS
Transparent watercolor on 140-lb. (300gsm) cold-pressed Strathmore
18" × 24" (46cm × 61cm)

While vacationing in the Caribbean, I caught some interesting shots of boys playing on the beach. Unfortunately, midday sun turned the boys to silhouettes and bleached the sky and sea. At home I decided to turn that flat background into a sunrise. Masking fluid preserved the brilliant dots of light as I flooded areas with yellow, red and blue, allowing them to mingle in places.

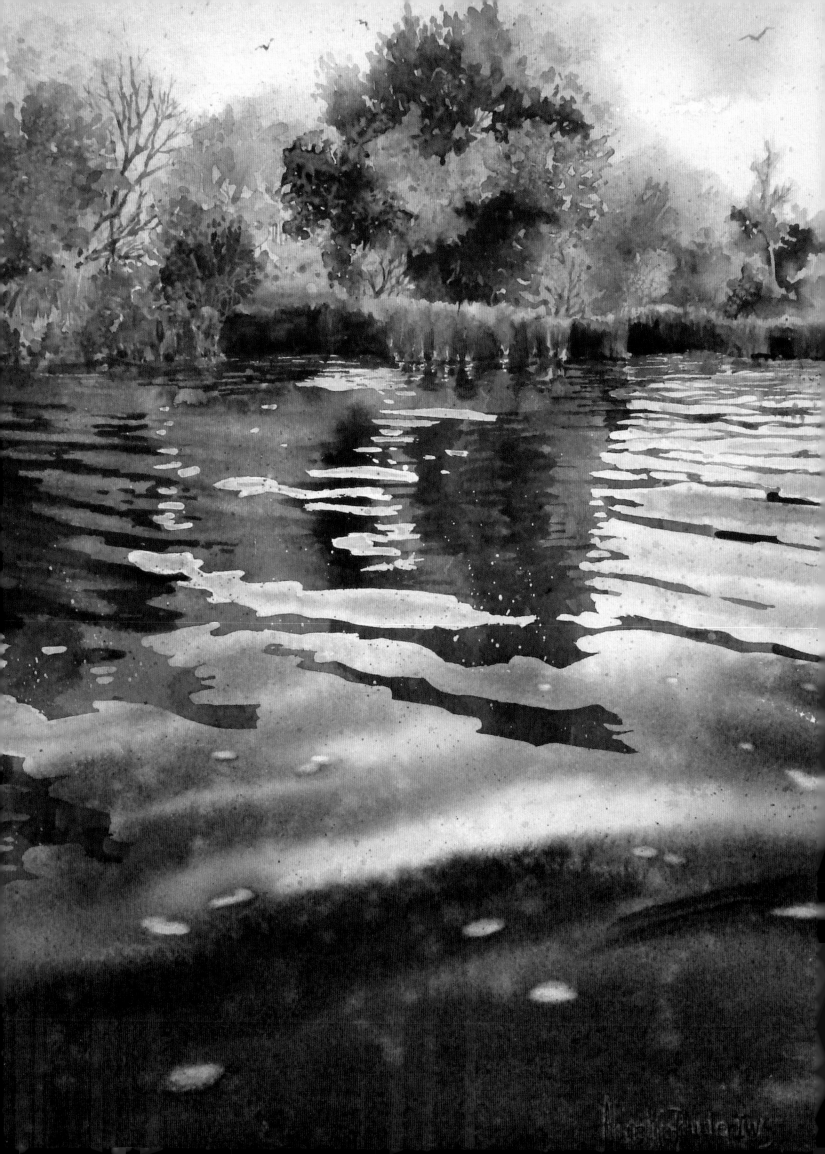

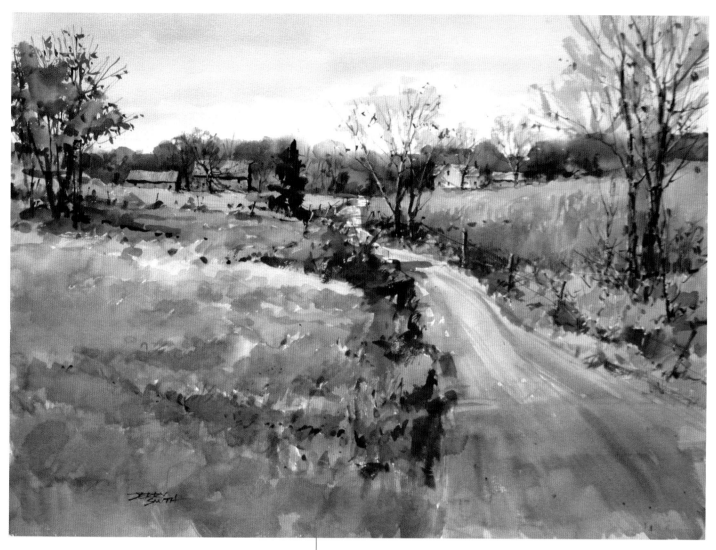

HEARTLAND CONNECTION | JERRY SMITH
Transparent watercolor on 140-lb. (300gsm) cold-pressed Kilimanjaro
21" × 29" (53cm × 74cm)

Heartland Connection represents a shift from the way I have used and represented texture in my watercolors. I have typically relied heavily on the surface texture of the paper itself and drybrushing to depict and interpret landscape texture. I made a conscious effort in this painting to rely more on washes and value changes to execute the large foreground. For the sake of unity I tried to carry this approach throughout the rest of the painting including the sky, background trees and buildings. The painting was done with photographic reference via watercolor sketch/study.

FROM MY KAYAK – TRUMBALL LAKE | ANITA K. PLUCKER
Watercolor on 140-lb. (300gsm) cold-pressed Arches
17½" × 13" (44cm × 33cm)

Nature tops my list as inspiration for watercolor paintings. I especially love being on the water in my kayak. With camera in hand, my photographs freeze the water movement, helping me to see the patterns, shapes and textures. I began by laying the blue lines of the waves into a very wet wash, paying close attention to the perspective of the waves. At different drying stages, I took a damp, thirsty brush and swiped away paint to create the almost-white areas and, at the same time, added more rich blue toward the bottom. While the paint was still damp, I spattered clean water and color into the blue, creating subtle texture and depth to the water.

66

Keep the most prominent texture in
close proximity to the center of interest.

99

—Kris Parins

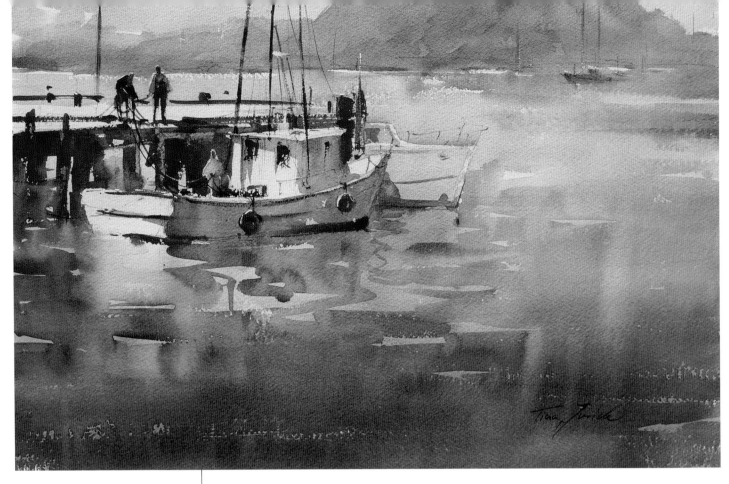

MORO BAY, CA | KRISTINA JURICK
Transparent watercolor on 140-lb. (300gsm) Arches torchon
36" × 54" (91cm × 137cm)

Moro Rock is a very boring shape, so I only suggested it in the upper
part of the painting. The water was first painted with a light layer,
followed by another darker layer, leaving light reflections as nega-
tive shapes. Dark reflections were painted wet-into-wet. Drybrush
here and there suggests glistening on the water. The painting was
done almost vertically on an easel, so some paint runs are visible.

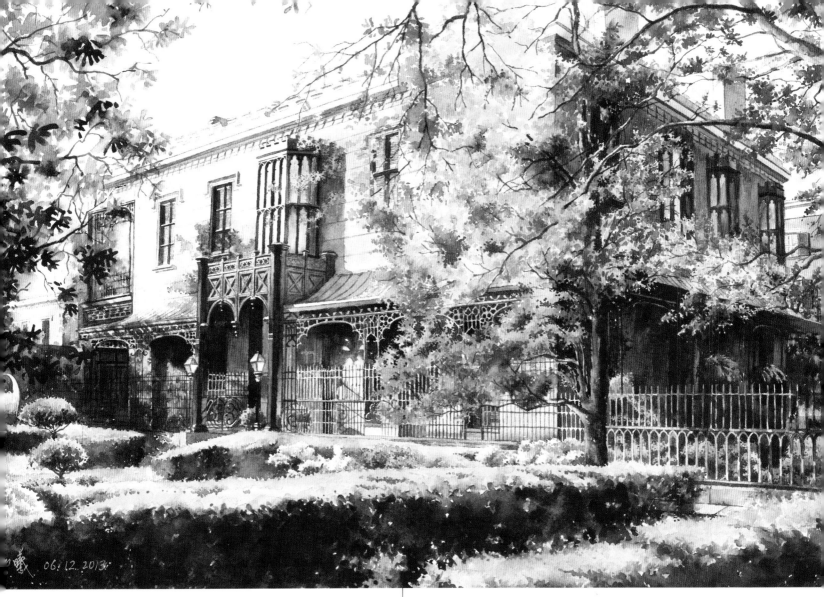

GREEN-MELDRIM HOUSE IN SAVANNAH | XI GUO
Transparent watercolor on 300-lb. (640gsm) rough Arches
13" × 19" (33xcm × 48cm)

I usually take reference photos first and then use tracing paper to copy the image onto watercolor paper. Watercolor is my favorite medium because I am fascinated by the texture, the uncertainty and the "happy accident." You need foresight and instinct to decide on technique, how much water and how much longer you need to wait to add the next stroke. I was born and raised in Shanghai, China. I studied Chinese painting when I was little, so I've been very influenced by Zen philosophy. For me the process of painting is like a practice of meditation.

TILL IT BE 'MORROW | Nicole Renee Ryan
Watercolor on 74-lb. (155gsm) Yupo
13" × 26" (33cm × 66cm)

This painting developed from a photo I took at age 14 at a beach in Rhode Island. I wanted to capture the depth of the clouds and the sense of anticipation they contained. I took great liberties in color and texture to reflect my memory of that place, using foam rollers and towels, adding and removing paint in equal measure. It is named after a line from *Romeo and Juliet*: "Parting is such sweet sorrow, That I shall say good night till it be morrow."

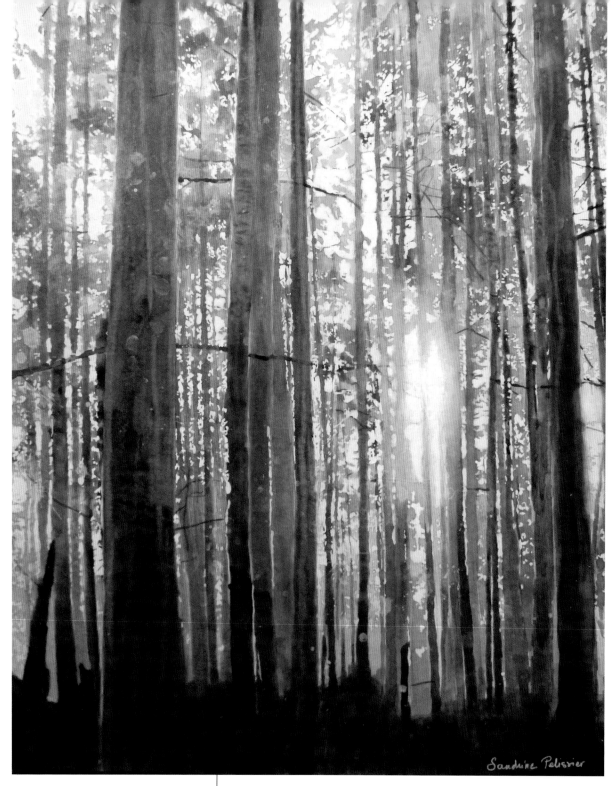

PRINCESS PARK | SANDRINE PELISSIER
Watercolor and gouache on paper mounted on board
30" × 24" (76cm × 61cm)

> "
> Texture is
> more visible
> at the edges of
> a subject and
> at the edges of
> value changes
> in that subject.
> "
>
> —Sandrine Pelissier

I am inspired by the beautiful rainforest we live in here in British Columbia and wanted to render the effect of the light showing through the complex texture of the foliage. I wanted the foliage to be detailed, but the white of the paper was essential to show the edges and the light shining through. I painted a lot of intricate shapes with masking fluid so I could paint freely in a wet-into-wet manner. For more texture I added drips and splatters of mixed watercolor and gouache once the painting was dry.

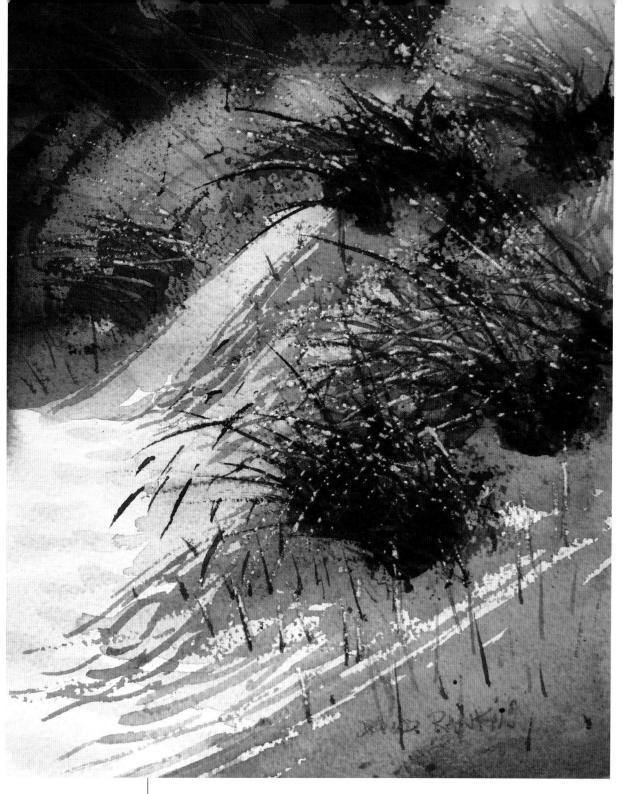

BEACH GRASS ABSTRACTIONS | DAVID RANKIN
Transparent watercolor on 140-lb. (300gsm) rough Arches
14" × 9" (36cm × 23cm)

This subject caught my eye while sketching out on the beach dunes at Mentor Headlands State Park east of Cleveland, Ohio. Rough watercolor paper allows me to create the widest variety of textures. A variety of watercolor textures was required to figure out how to replicate the soft feeling of the mounds of beach grass and couple that soft quality with the delicate and complicated details of the grasses in the afternoon light. The various sharp edges as seen in the cast shadows actually helped increase the feeling of softness. I did not use opaque color for the grasses. Instead, the thin individual strands of grass were scratched out of the dry surface with a craft knife tip and then delicately filled in with transparent color.

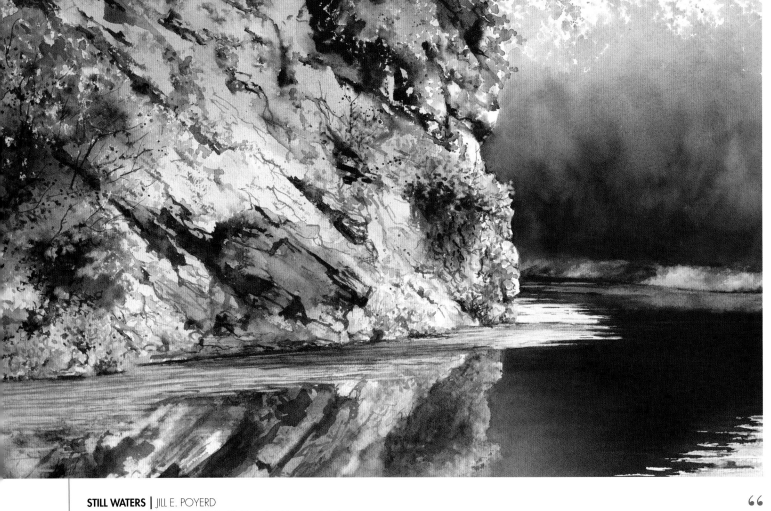

STILL WATERS | JILL E. POYERD
Transparent watercolor on 300-lb. (640gsm) cold-pressed Arches
15" × 22" (38cm × 56cm)

One of the joys of painting in watercolor is the ability to combine loose washes with fine detail. Using these two techniques in layer after layer—keeping some edges hard, losing others—I was able to capture the wonderful craggy texture of the rocks and contrast it with the smooth flow of the water. Many of the directional lines in my dark rock values were drawn using a palette knife and then selectively smoothed out with small washes or spritzes of water. When contrasted by the smooth, dark wash of the water's bend, the two implied textures successfully enhanced one another.

66

A spray bottle is a nice tool to keep handy. Use it for texture in moist paint or to loosen things up when a painting gets too tight.

99

—Kristina Jurick

MORNING IN GIRONA | KRISTINA JURICK
Transparent watercolor on 140-lb. (300gsm) Arches grain fin
36" × 26" (91cm × 66cm)

A typical urban scene with not much happening, but the light and shadows captured my attention. I got frustrated when I painted the shadows, which turned out much too rigid. So I took the spray bottle to soften some edges and splattered some Ultramarine and Caput Mortuum in the wet area, which gave the nice granulating effect. Et voilà!

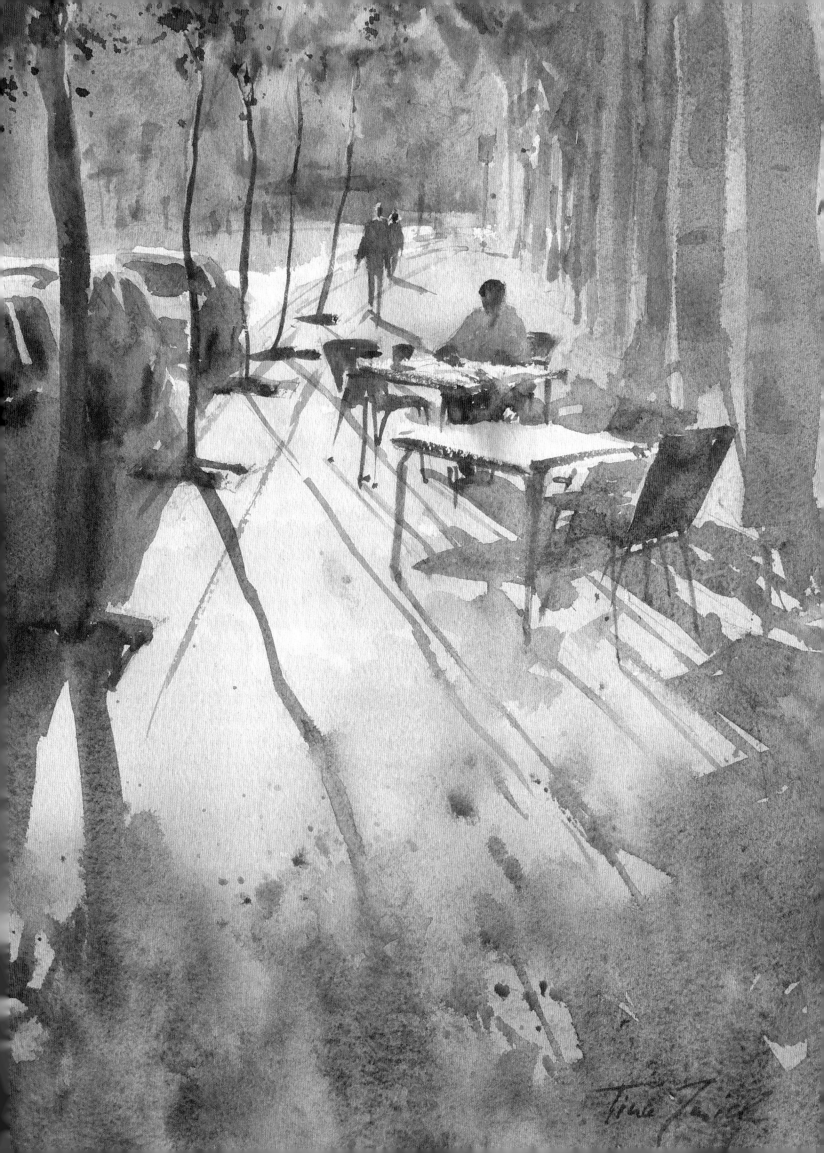

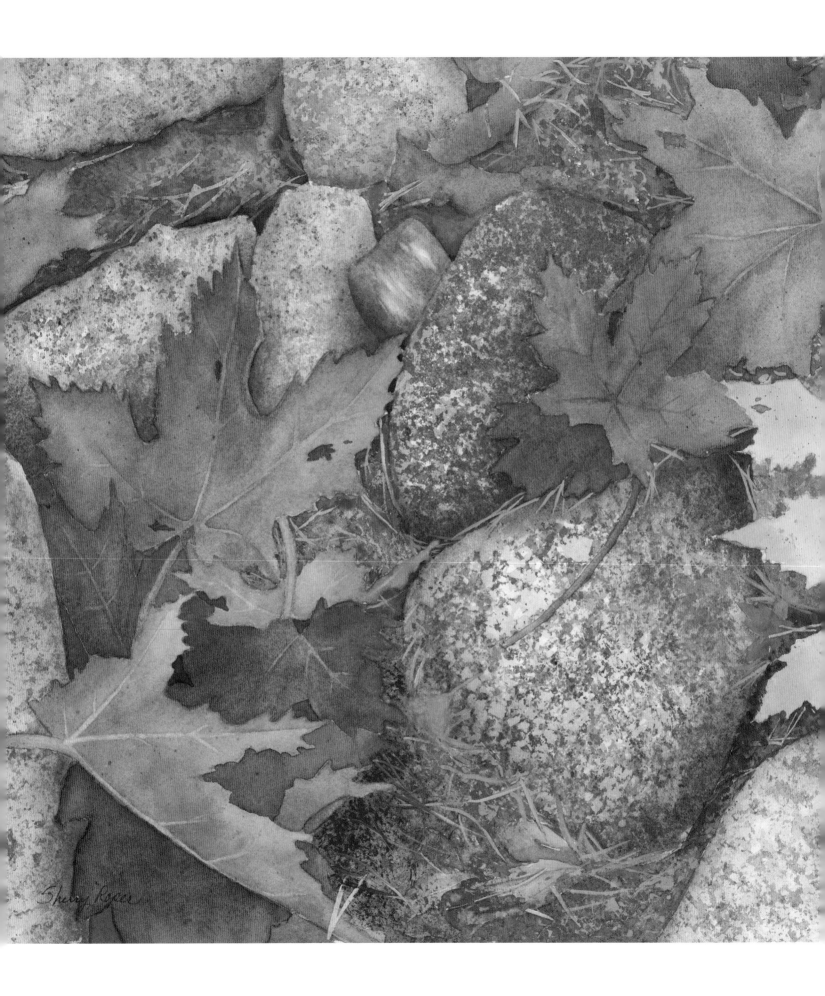

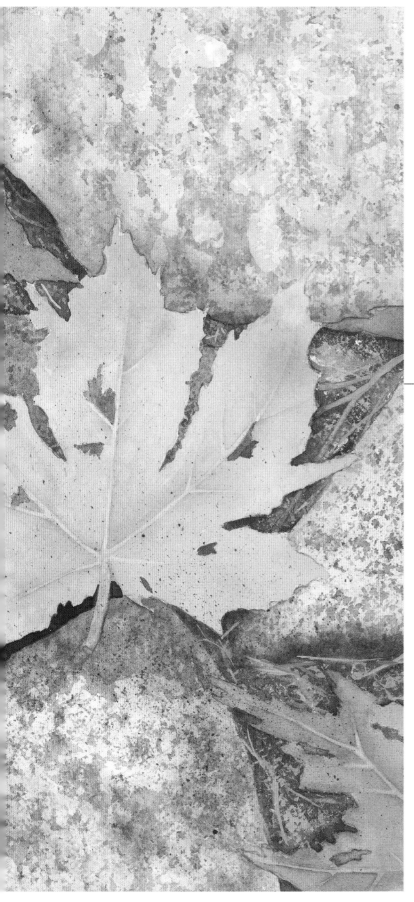

2

CLOSE-UPS

UNDER FOOT | SHERRY ROPER
Transparent watercolor with gouache accents on 140-lb. (300gsm)
cold-pressed Arches
14" × 21" (36cm × 53cm)

Hoping to photograph fall foliage at Yosemite National Park, I was disappointed to find that most of the leaves had already fallen. My attention turned to the ground, and I became captivated with the decaying leaves as well as the shapes and colors of the rocks. The mottled appearance of the rocks was created by applying masking fluid with sponges, chopped brushes and crumpled wax paper, and then dabbing on watercolor with a natural sea sponge. After the masking fluid was removed, I repeated the entire process three or four times, then flicked some watercolor on with an old toothbrush.

"

Masking fluid, applied in a variety of ways, can be a watercolorist's best friend when it comes to creating textural effects.

"

—Sherry Roper

Visit artistsnetwork.com/splash16 to download free bonus wallpapers from the *Splash* series.

23

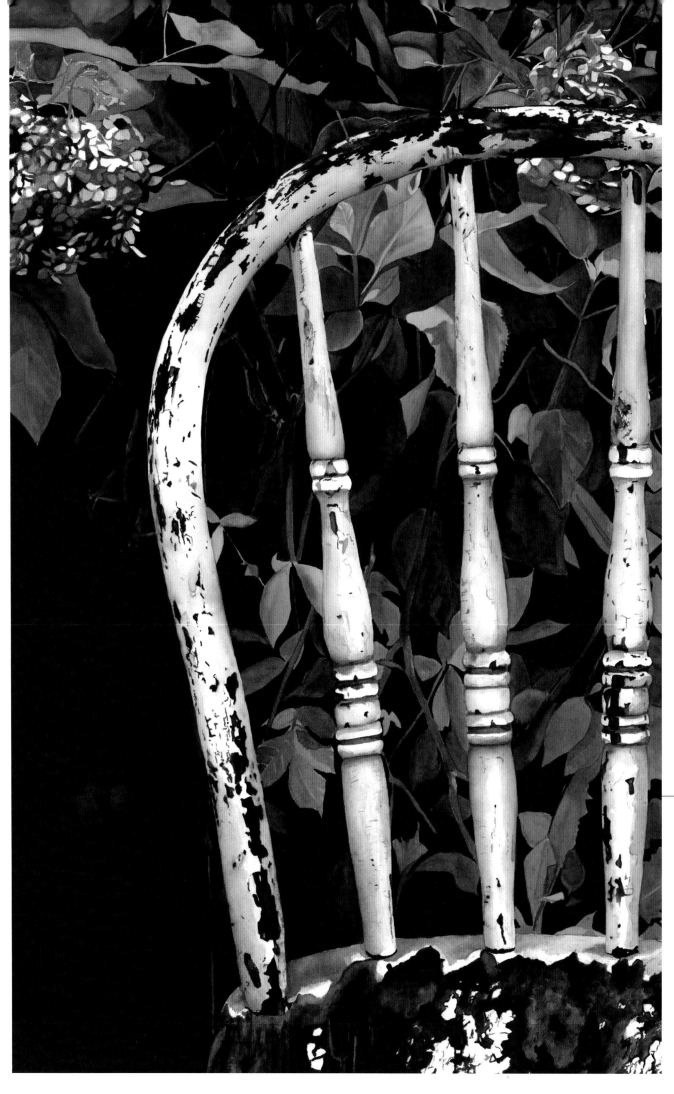

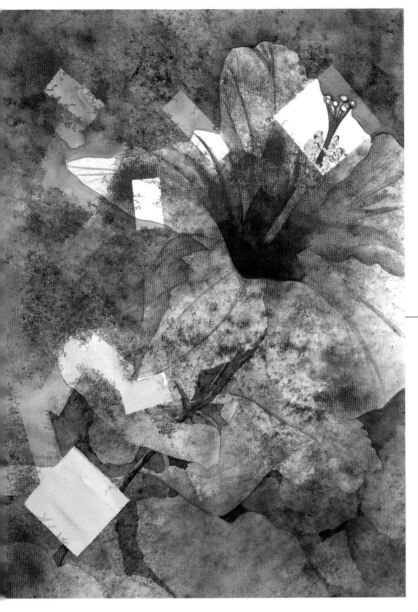

RED HIBISCUS | JANET NUNN
Watercolor on 300-lb. (640gsm) cold-pressed Fabriano Artistico
30" × 22" (76cm × 56cm)

I photographed and sketched hibiscus on a trip to Kauai and completed
this work in my studio. After drawing the flower, stem and leaves, I
applied frisket film cut into square shapes. I splattered the full sheet
of paper with yellow and a plastic needlepoint screen by tapping the
screen to send dots of paint onto the paper. While the dots were still wet,
I sprayed a mist of water to explode the small dots into larger pools of
color. After the paper dried, I added another layer of splatter. After dry-
ing again, I removed the frisket to leave the white of the paper and a few
leaks of color. The entire area around the flower was painted with Phthalo
Blue and Sap Green using a 2-inch (51mm) flat brush. The veins and sta-
men were directly painted, and the leaves were added by painting around
them with darks.

NOSTALGIA | CARRIE WALLER
Watercolor on 260-lb. (545gsm) cold-pressed Arches
37" × 24" (94cm × 61cm)

This chair sat on my grandmother's porch for my entire life. It had been
passed down from one generation to another, serving as a washtub chair,
a seat for shucking corn after a day's harvest and a step stool. Fascinated
at the chipped, peeling paint, the beauty of this chair that told such a rich
story of past lives, I set it outside by my grandmother's hydrangea bush.
The blooms on the bush were dying but still beautiful in their deteriorat-
ing state. I photographed this scene and closely cropped it, emphasizing
the texture. I used a wet-on-dry method, one section at a time, finding
myself lost in all of the colors and textures of the peeling paint.

Visit artistsnetwork.com/splash16 to download free bonus wallpapers from the *Splash* series.

25

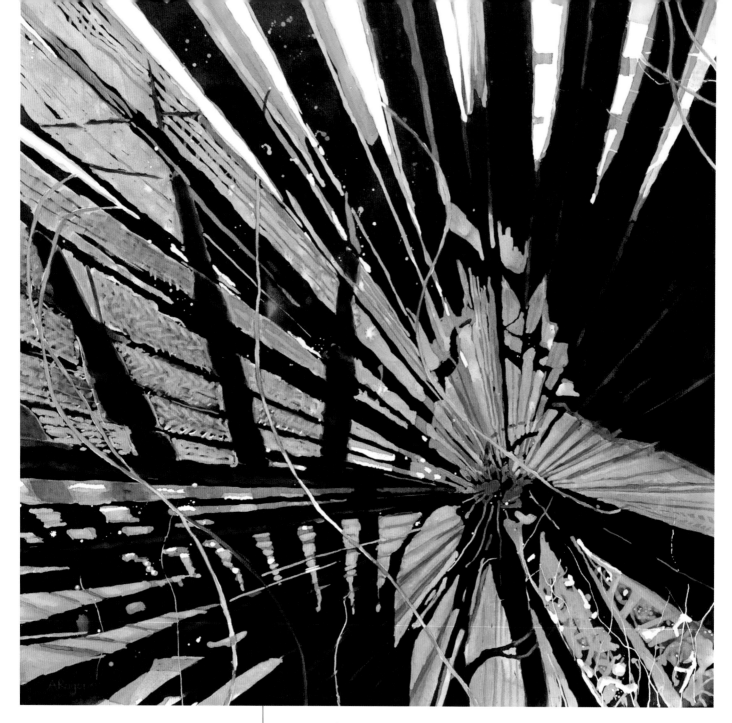

It is the element
of surprise that
is my fascination
and delight with
watercolor.

—Anthony Rogone

PALM LINES | ANTHONY ROGONE
Watercolor and masking fluid on 156-lb. (330gsm) cold-pressed Arches
30" × 30" (76cm × 76cm)

While on an early-morning walk through my neighborhood, I came across
these intriguing palm leaves. The sun was low in the sky, penetrating the
leaves with bright yellows and greens, while surrounding all with a cast of
gold. After making a few adjustments of my photograph on my computer,
I began painting. Through a combination of masking, pouring transpar-
ent watercolors and adding final touches of opaque color, I created the
multi-rhythmic textures of the palm leaves. Unmasked at last, the leaves
radiated, weaved and floated in a way I had hoped for but could not have
predicted.

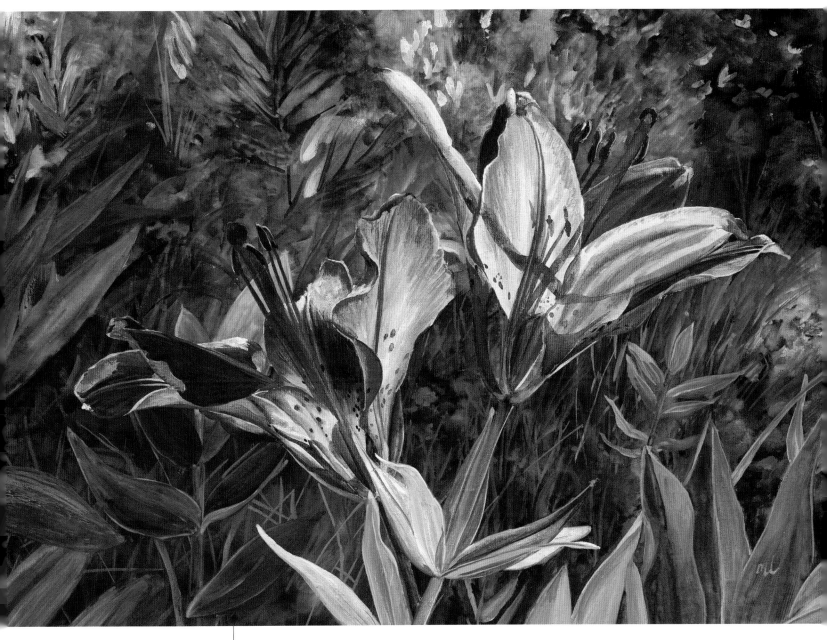

FIRST LIGHT – WOOD LILY | MARIE LAMOTHE
Opaque watercolor on canvas
10" × 14" (25cm × 36cm)

The natural world, perched between mackerel skies and the leaf litter
of a forest floor, is replete with textures. The challenge lies in allowing
some to recede gracefully and others to shine forth. For *First Light*, a
canvas substrate painted with heavier-bodied gouaches in muted colors,
applied with stiff brushes and some impasto work, translated the busy
background into an appropriately subtle backdrop without losing its
essential character. Happily, the low light of early morning highlighted
the qualities of the lily's petals, allowing the flower to pop off the page.

Visit artistsnetwork.com/splash16 to download free bonus wallpapers from the *Splash* series.

27

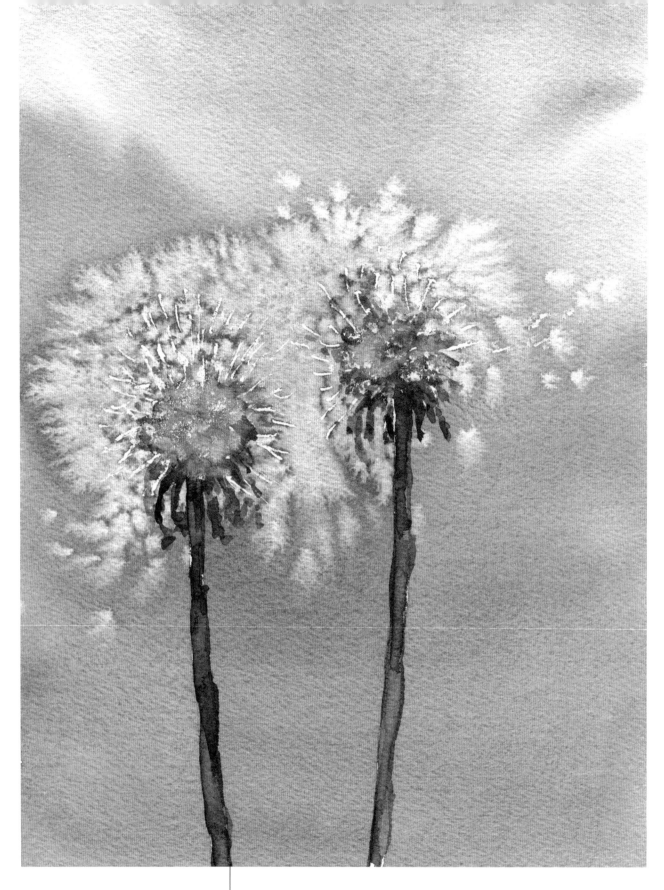

> A pinch of salt
> spices up texture.
>
> —Liana Harvath

FUZZY DANDELIONS | LIANA HARVATH
Transparent watercolor on 140-lb. (300gsm) cold-pressed Arches
9" × 6" (23cm × 15cm)

While dropping table salt in concentric rings on a wet surface, I found the result suggested fuzzy dandelions. The white lines are the paper surface reserved with masking fluid before adding color wet-into-wet. Salt was dropped in concentric arcs as the paint was drying, then details were added after the surface dried and the salt was removed. I am grateful to Susan Herron who inspires me to experiment in her Creative Watercolor classes.

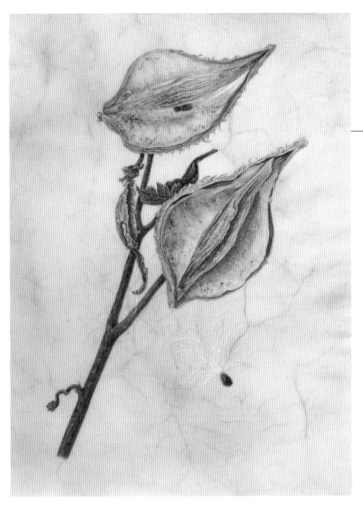

COMMON MILKWEED PODS, ASCLEPIAS SYRIACE | KAREN S. COLEMAN
Watercolor on calfskin vellum
10" × 8" (25cm × 20cm)

Common milkweed pods in fall and winter have a variety of textures—rough, hairy exteriors and smooth interiors with fibrous structures that house flat, brown seeds with attachments of white, silky hairs that provide wind transport. After starting to paint them in a vellum class taught by Kate Nessler, I brought the pods home. The warmth of the room released all the seeds to float in the air. True vellum is not porous and cannot handle very much water. I began with light washes of transparent watercolors and finished with a dry-brush technique. Final details of the hairy pod exteriors and the silky seed floss were added with opaque Chinese White.

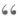

Texture is the fabric of nature.
The crinkles, divots and folds
in the natural world are what make
it astonishing.

—Jill M. Cardell

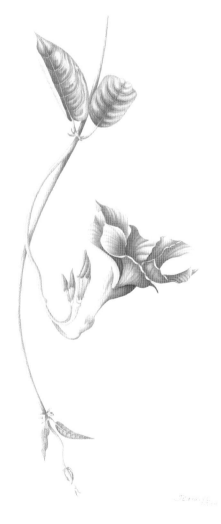

MANDEVILLA | JILL M. CARDELL
Transparent watercolor on 300-lb. (640gsm) hot-pressed Fabriano Artistico
14" × 7" (36cm × 18cm)

I start with a real flower in my hand. I want to see it up close and touch it so as to truly understand how it is made. The hot-pressed paper allows me to maintain control despite the eight to ten layers that each leaf or petal may require. I allow each layer to dry thoroughly before adding another. The key to capturing texture in nature is to replicate the pattern of highlights and shadows.

Visit artistsnetwork.com/splash16 to download free bonus wallpapers from the *Splash* series.

29

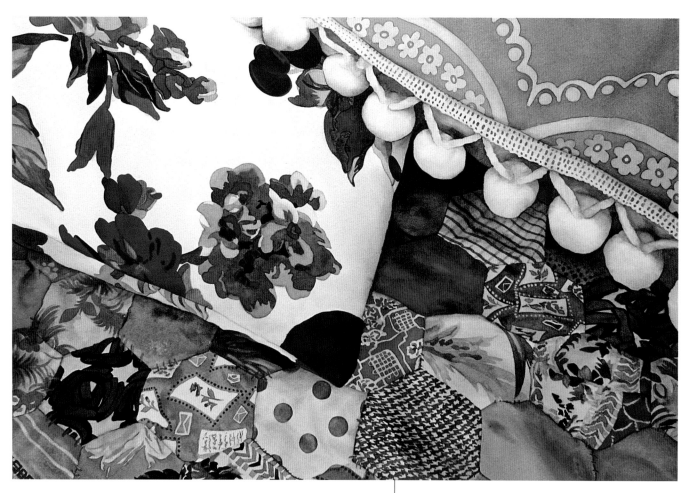

PATTERN AND ILLUSION 14 | BRITTNEY LINTICK
Watercolor on 140-lb. (300gsm) cold-pressed Arches
18½" × 27" (47cm × 69cm)

As I strolled through a flea market near Dublin, Ireland, numerous objects caught my eye, but these textiles stole my heart. The patchwork quilt paired with two vintage pillows offered the opportunity to play with a mishmash of pattern, texture and color within the painting surface. I photographed these objects as is and later drew the projected image on paper. Masking one shape after another, I exaggerated the color and texture, all while enjoying the abstractions within each section. This painting reflects my connection to a patchwork quilt my great-grandmother made for my parents' wedding. Textiles can tell a story of many lives, and I still wonder about the stories behind these particular items from the flea market.

66

In order to control watercolor, you have to let go.

99

—Brittney Lintick

66

Weave several paintings together to create a new and textured work.

99

—Jean K. Gill

POTHOLDERS | JEAN K. GILL
Transparent watercolor on 300-lb. (640gsm) rough Arches
30" × 22" (76cm × 56cm)

To create this piece, I painted three similar watercolors on vertical half sheets (11" × 30" [28cm × 76cm]) and then wove them into one assemblage. I used a paper cutter to section two of the paintings into horizontal strips. Cuts were parallel, deliberate and varied in width. These two partitioned works were then laid out side by side. I cut the third painting into vertical strips and then wove these long strips through the horizontal pieces. Because the paper was stiff and thick, the weave created high points, adding three-dimensional and linear texture to the paintings' curvilinear subject. My two inspirations were potholders woven as a child and an impression of sunlight and breeze through slatted mini blinds.

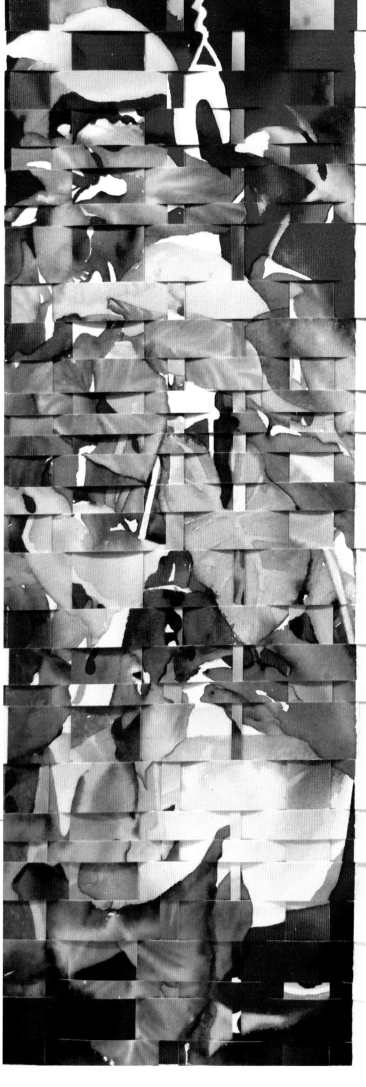
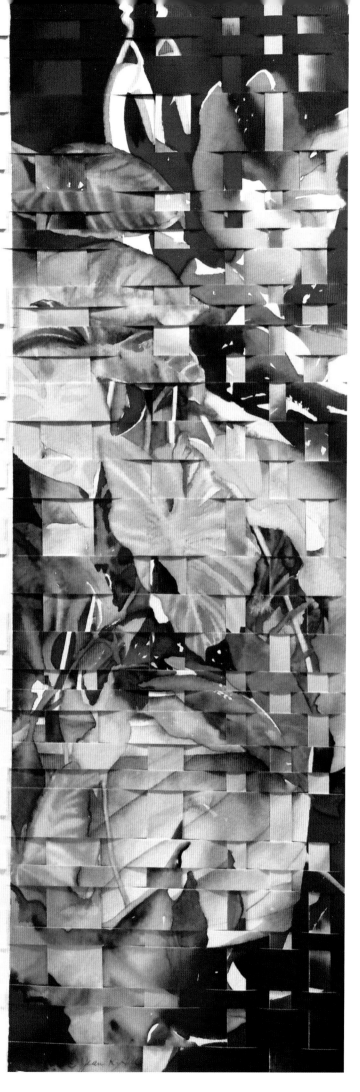

Visit artistsnetwork.com/splash16 to download free bonus wallpapers from the *Splash* series.

31

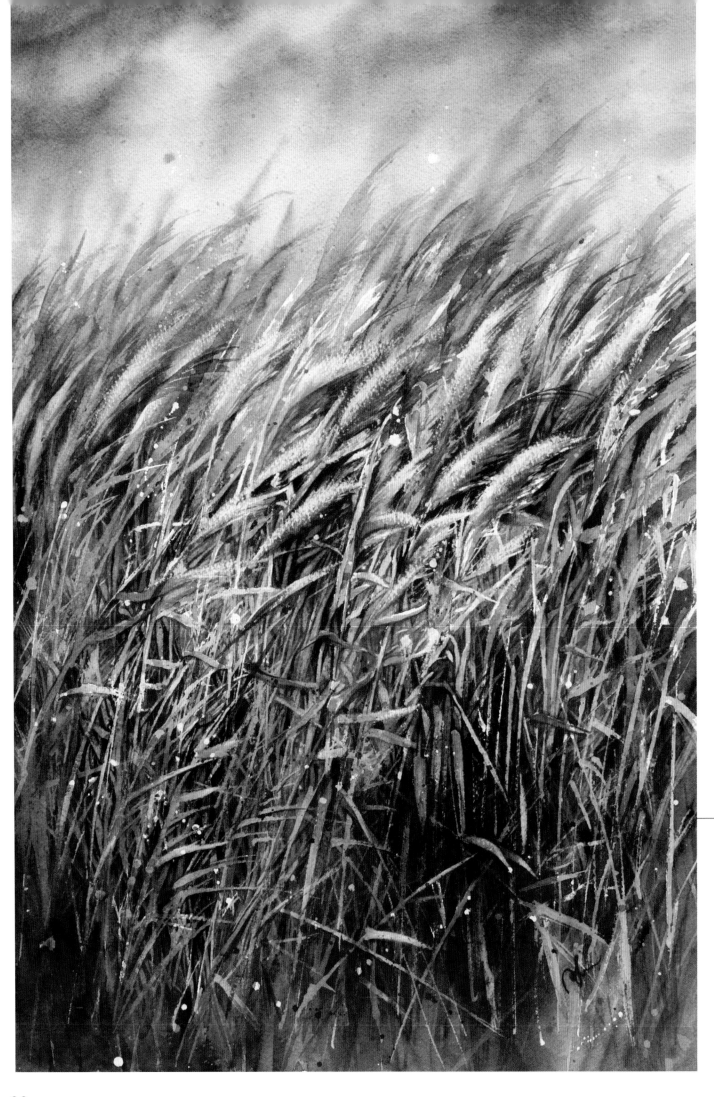

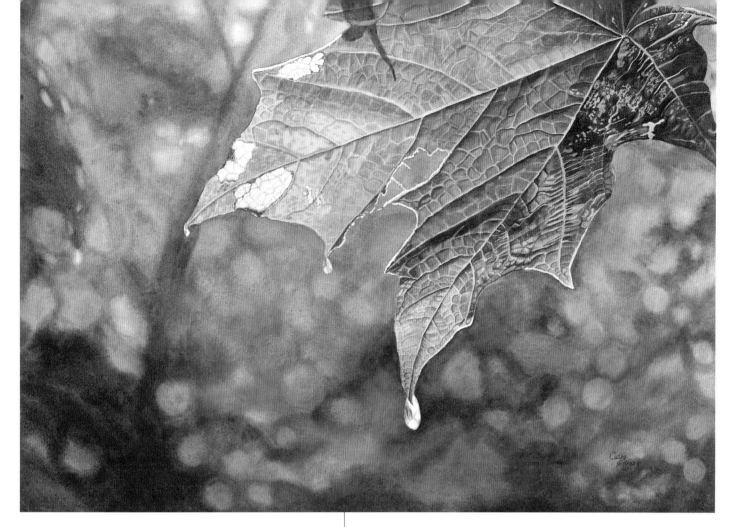

Use a computer
to enlarge small
areas of your
reference photo
when painting
detailed texture.

" "

—Cathy Hillegas

SUMMER RAIN | CATHY HILLEGAS
Transparent watercolor on 300-lb. (640gsm) cold-pressed Arches
20" × 30" (51cm × 76cm)

Bright sunlight after rain transformed my backyard. Leaves were backlit, and dripping raindrops glowed like jewels. I took a photo, drew the image and masked out the white edges of the leaf and the raindrops. The background was done wet-into-wet, drying and rewetting several times. I painted the backlit part of the leaf with a mixture of New Gamboge and Winsor Yellow. Greens were painted on top, one section at time, leaving yellow in between. Shadows on each tiny section added texture and form. The lower right area of the leaf was painted with French Ultramarine Blue, with green or Permanent Rose. Hard-edged dark and light areas make the leaf look wet. The raindrops were painted last, paying close attention to the subtle colors and shapes in the reference photo.

THE WEED | PERRY CHOW
Transparent watercolor on 140-lb. (300gsm) cold-pressed Arches
20" × 15" (51cm × 38cm)

A breeze, the breath of nature, brings the pleasure of dancing weeds. I always plan my work using a computer to adjust the hue, saturation or brightness of the original photo, exploring infinite possibilities. This allows me to render my feeling into the painting. The weeds are re-represented with the light-shadow enhancement and color shifting; the orange highlight is my favorite. The dark foreground allows for viewers' imagination. Masking fluid really helps to manage the positive and negative space. Splattering the paint simulates the magic flowing over the wind. The final touch is sanding to soften the edges to enhance the movement.

" "

Your painting should capture
a heartfelt moment.

" "

—Perry Chow

Visit artistsnetwork.com/splash16 to download free bonus wallpapers from the *Splash* series.

33

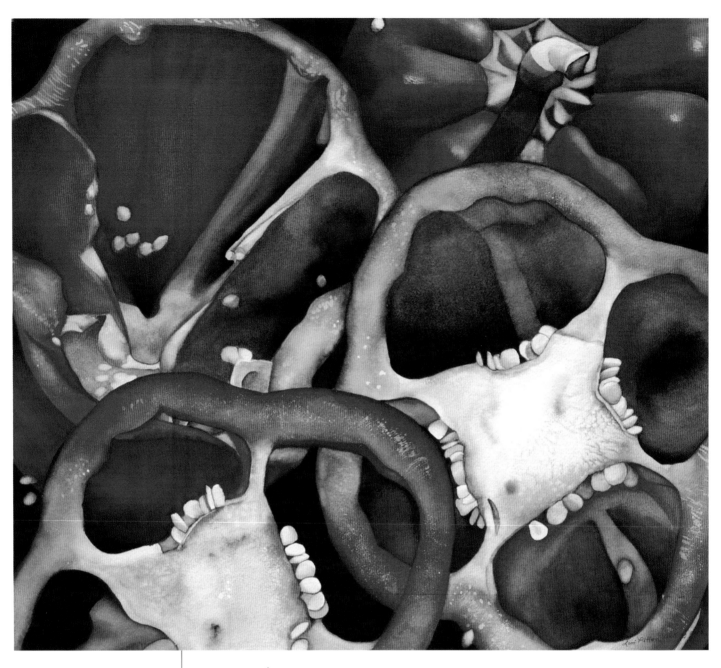

SAY AHHHHH! | LORI PITTEN JENKINS
Transparent watercolor on 300-lb. (640gsm) cold-pressed Arches
15" × 17" (38cm × 43cm)

Say Ahhhh! was inspired while shopping for peppers at the grocery store. I was fascinated by how effortlessly they change from green to red, opposites on the color wheel. I immediately dashed home to photograph this intriguing discovery. After hours of setting up, slicing and arranging the peppers, I chose my favorite picture to use as reference. I was challenged by the many textures: the rough, sponge-like appearance of the inside of the peppers, the smooth seeds and the porous white core. Salt was added to wet paint to pit the white core. Complementary colors also add to the drama of this piece. I owe the title of this painting to my daughter, Lynn. She said the painting was creepy and looked like the inside of someone's throat. I think she's right.

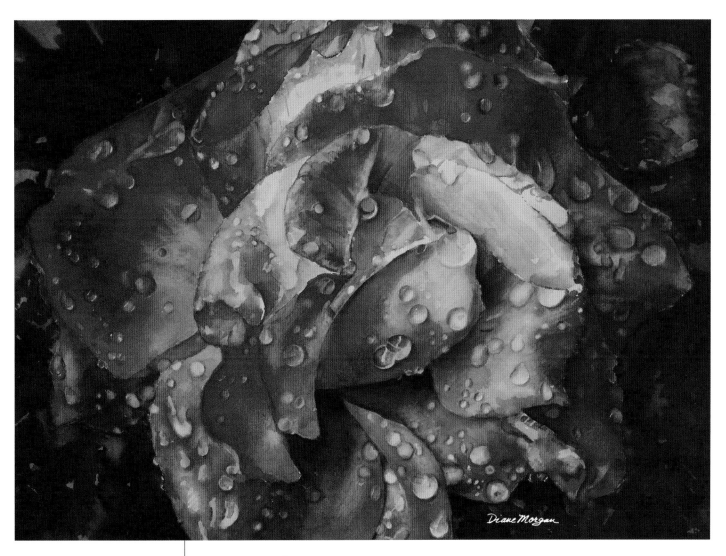

RAINY DAY ROSE | DIANE MORGAN
Transparent watercolor on 300-lb. (640gsm) cold-pressed Arches
14" × 21" (36cm × 53cm)

Rainy Day Rose is loaded with texture in the background leaves, and in the patterns of light and shadow on the surface of the petals. The heavy droplets on the rose cast shadows and patterns on the petals. Here are a few simple rules for painting water droplets. Rule 1: Do not outline the shape. Roundness is created with value, not line. Rule 2: Pay attention to the light source. The solid shape of the shadow on the side away from the light source will delineate the other half of the drop. Rule 3: Carefully observe each drop to determine the proper shape and color for the inside and for the shadow. Remember that the drop is transparent and will show the color beneath it. Rule 4: A pinpoint highlight really sets off the drop and gives it impact.

Visit artistsnetwork.com/splash16 to download free bonus wallpapers from the *Splash* series.

35

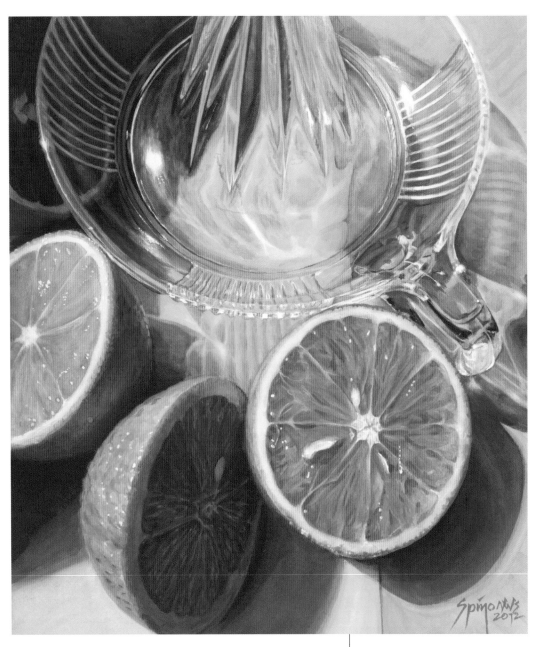

SQUEEZE ME FIRST! | FRANK SPINO
Transparent watercolor on Arches watercolor board
20½" × 17½" (52cm × 44cm)

From its inception this painting had a rhythmic quality. I could feel the oranges rolling across the page and leaping up into the juicer—1, 2, 3. But "1, 2, 3" didn't sound like much of a title. I found the correct cadence in "Ready, Set, Go" that later morphed into *Squeeze Me First!* The clear vintage juicer mirrors the half sphere of the sliced oranges; its ridges radiate out, ending in a thickened lip, and cast reinforcing shadows on the smooth, plastic place mats. In a similar way the citrus wedges expand from their centers and terminate with white dimpled rinds. Cellular texture is expressed solely by varying color, which differentiates the cell structure. This painting is really about juxtapositions: hard vs. soft, dry vs. wet, man-made vs. organic, clear vs. colorful.

COLOR WHEELS | FRANK SPINO
Transparent watercolor on 140-lb. (300gsm) cold-pressed Arches
24" × 18" (61cm × 46cm)

My title is a play on words. Every artist is familiar with the color wheel; my painting shows big, fun, colorful wheels with wedges for spokes and rinds for tires. There is a lot of movement here for such a static arrangement. My eye is drawn to the solid green lime at the top with its rough rind and corona of cream-colored grapefruit seeds. From there it radiates out to the unique cell structures of the grapefruit wedges. Like snowflakes, no two cells are alike. All wheels touch and all wheels rotate. And the "big wheels keep on turnin'."

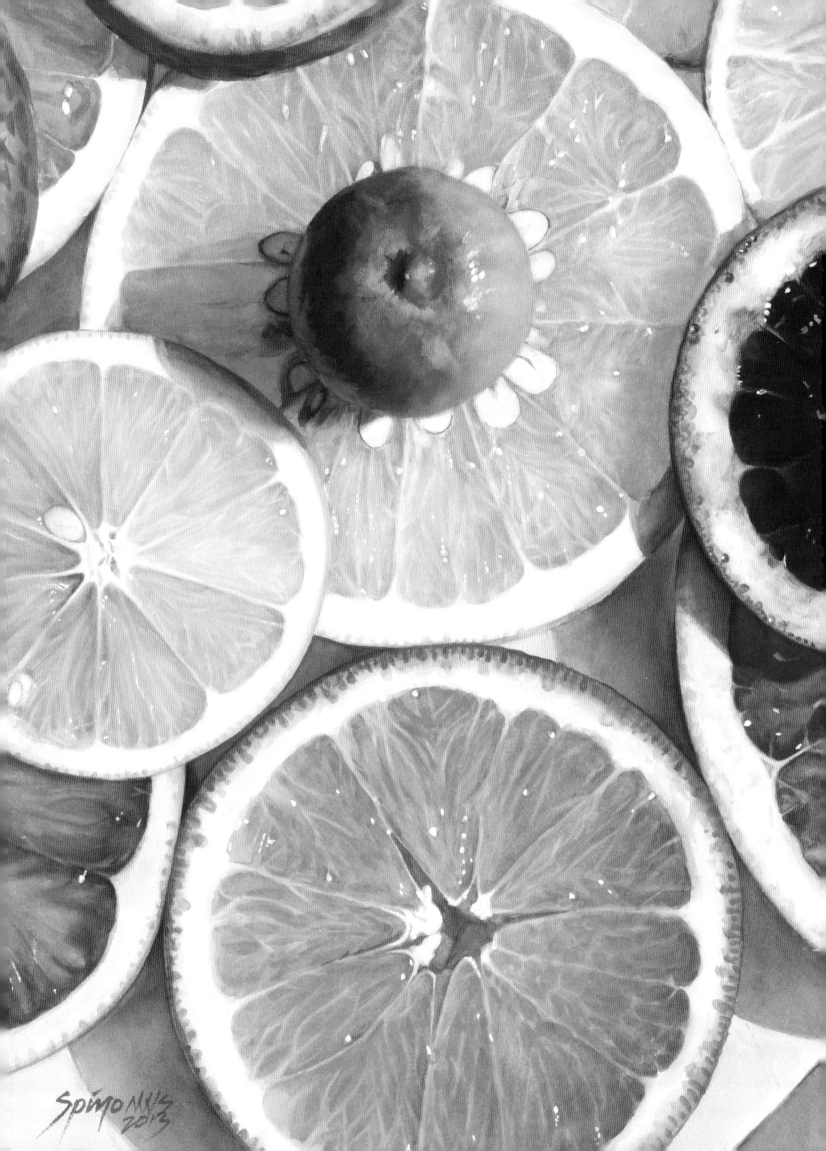

38

3

ANIMAL KINGDOM

DUE ANY DAY NOW | YAEL MAIMON
Watercolor on 140-lb. (300gsm) Fabriano Artistico
18½" × 25" (47cm × 64cm)

Due Any Day Now is part of my *Cats* series. I wanted to paint a tightly composed view of the cat. Leaving only a small area of background, I challenged myself to focus on conveying the fur texture and the cat's mass and energy. The fur texture was created by washes and some lifting. I applied both transparent glazes of color and very rich color that was later lifted in directional lines. Using a hard brush, I scrubbed areas I wished to lighten. This made the fur appear softer. My final touch was scratching the foreground with sandpaper, creating a grain-like feeling.

"

When it comes to texture, just go for it—wash, scrub, glaze, scratch and lift!

"

—Yael Maimon

Visit artistsnetwork.com/splash16 to download free bonus wallpapers from the *Splash* series.

39

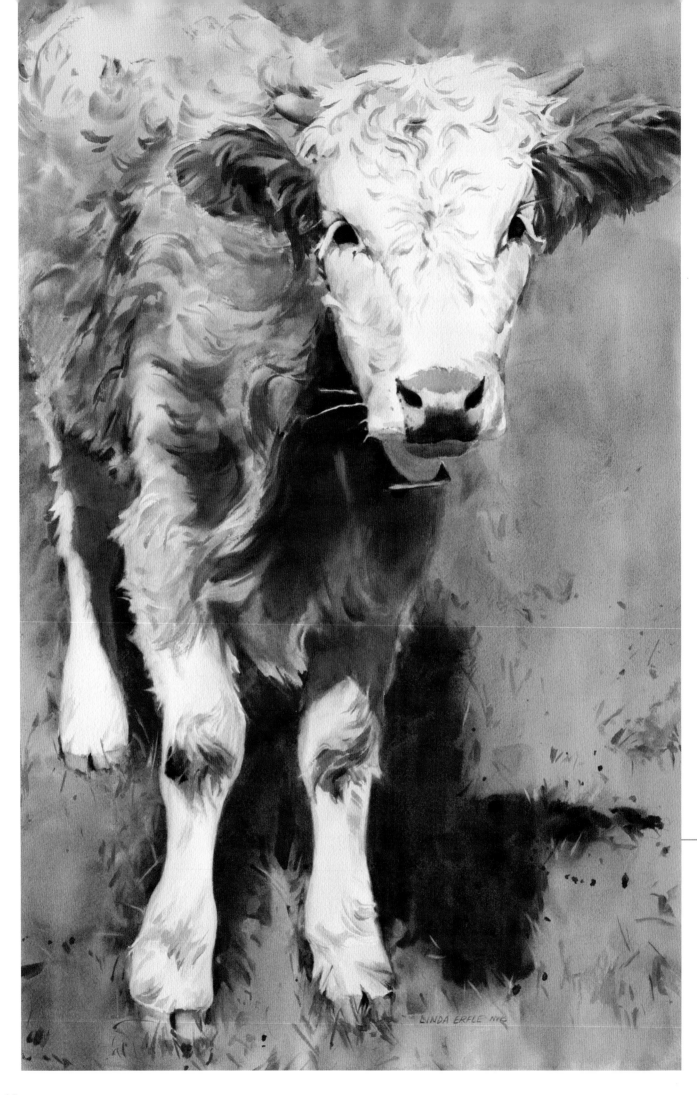

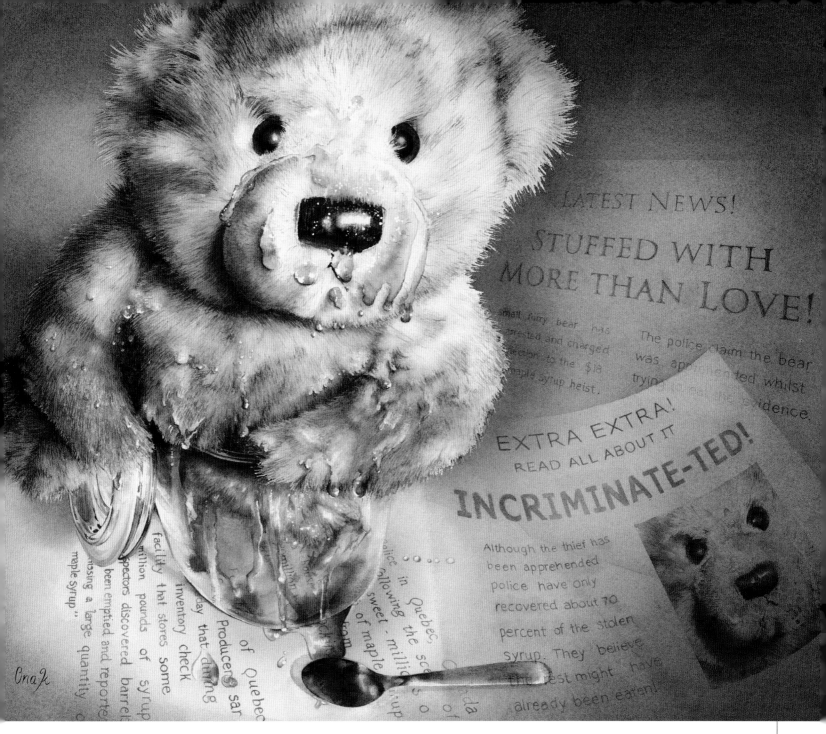

Within the illustration, the following text appears:

LATEST NEWS!
STUFFED WITH MORE THAN LOVE!

EXTRA EXTRA!
READ ALL ABOUT IT
INCRIMINATE-TED!

Although the thief has been apprehended police have only recovered about 70 percent of the stolen syrup. They believe the rest might have already been eaten!

INCRIMINATE-TED | ONA KINGDON
Transparent watercolor on 140-lb. (300gsm) cold-pressed Arches
18½" × 22" (47cm × 56cm)

COW LICKS #2 | LINDA ERFLE
Transparent watercolor on 140-lb. (300gsm) cold-pressed Arches
29" × 18" (74cm × 46cm)

One of the most intriguing characteristics of watercolor is the ability to control edges using water or dampness. When combined with the accurate placement of lights and darks, it can give the illusion of three-dimensional texture to any subject. A friend who vacationed with us in Switzerland took the source photo for this painting. Hiking there often took us through the pristine foothill pastures of the Alps where cows and their calves grazed. Back in my studio, I began the painting very damp with a large brush that allowed me to capture the textural edges of its soft, swirled coat.

The fate of this small bear lies in your hands. Is he guilty of stealing the maple syrup, or has he been framed? The "evidence" is full of contrasting textures. I particularly enjoyed creating the newspaper print. I used the granulating pigment French Ultramarine Blue to help create the speckled newspapery look. The painting also includes the texture of the smooth glass jar and the sticky discarded spoon, but it is the furry bear's guilty-looking face, covered in the incriminating maple syrup, that is my focal point. To give his nose a shiny, sticky appearance, I first masked the large highlight and painted the texture of the nose itself. Once the masking fluid was removed, I softened the edges using a Magic Eraser and scratched out the tiny highlights with a craft knife.

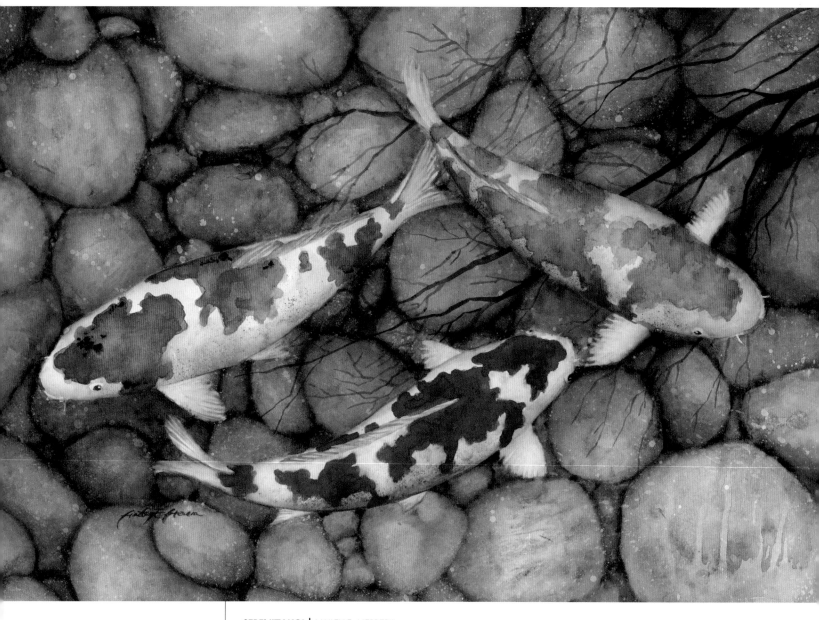

SERENITY KOI | HAILEY E. HERRERA
Watercolor with sumi ink and watercolor pencil accents on 140-lb. (300gsm)
hot-pressed Arches
13" × 19" (33cm × 48cm)

I am fortunate to have several tranquil koi ponds nearby. Using photographs
of koi for reference, I intended to capture the color, serenity and elegance
of what I had experienced during my contemplative visits. To begin I used
sumi ink for drawing the tree reflections and koi. After underpainting with
primary colors, I placed wax paper pieces randomly onto the paper, allowing
the colors to coalesce into rock-like textures. Once dry, I separated the rock
shapes with dark strokes and painted the koi with warm colors. For the koi
texturing I wet each koi and scraped watercolor pencils over sandpaper so
the shaved pigment would fall and melt onto the wet surface.

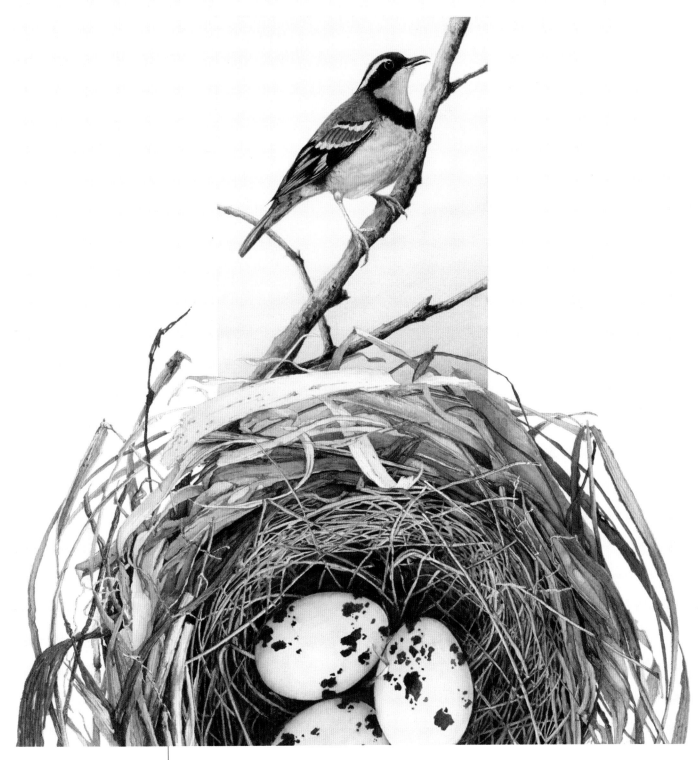

PROUD FATHER | STEVE J. MORRIS
Transparent watercolor on 140-lb. (300gsm) cold-pressed Arches
17" × 16" (43cm × 41cm)

Nature is made up of endless textures, yet too often we see them only from afar. While I enjoy a number of natural subjects, I often focus on the complex architecture of a bird's nest. On the outside are the thick, rough twigs that provide the foundation, but as you explore inside, you discover the grasses, straw and even our own discarded trash intricately intertwined among the twigs. Even deeper are feathers, down and pine needles, cushioning the delicate eggs inside and protecting the new lives that will emerge. For every piece I create, I hold my subject in my hand, exploring it through both touch and sight before I paint in order to realistically portray the multitude of textures nature has beautifully woven.

Visit artistsnetwork.com/splash16 to download free bonus wallpapers from the *Splash* series.

43

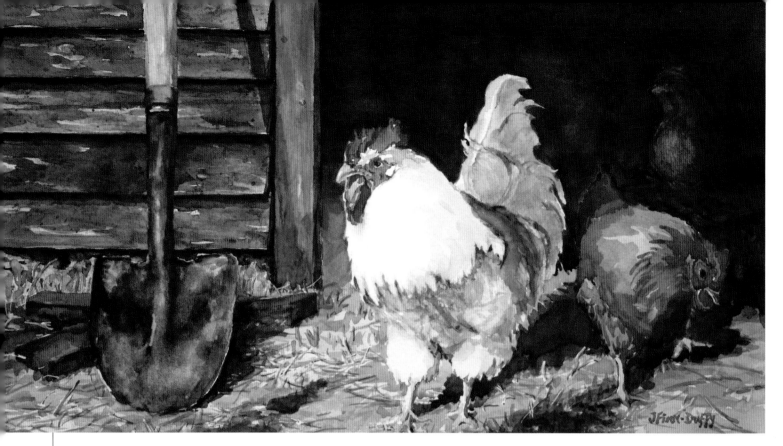

STEPPIN' OUT | JAN FINN-DUFFY
Transparent watercolor on 140-lb. (300gsm) cold-pressed Arches
14" × 21" (36cm × 53cm)

I instinctively divided my paper by areas of texture: the weathered planks of the barn, the worn shovel, the soft feathers of the chickens and the rigid pieces of straw lying on the grass. I then masked a few critical places. I painted the barn siding with wet-into-wet, glazing and spatters to give the appearance of weathered wood. Since the shovel surface is effaced from being pushed into the earth over the years, I decided to treat its image similarly by painting and lifting until the surface looked mildly abused.

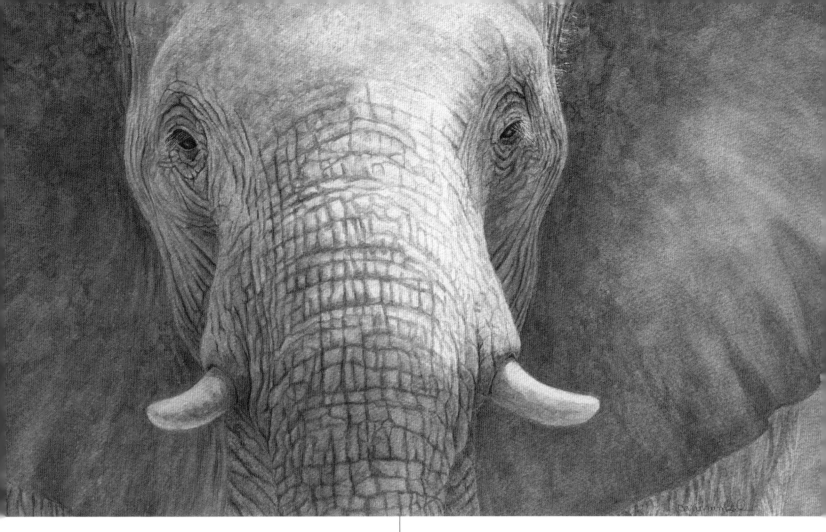

FIRST IN LINE | CARY HUNKEL
Transparent watercolor on 300-lb. (640gsm) cold-pressed Arches
12" × 20" (30cm × 51cm)

What excitement! We were in an open vehicle in the Linyanti Reserve, Botswana, when this enormous animal sauntered past, undisturbed by our presence. Drawing the elephant's head from the photograph I almost forgot to take, I mapped out the wrinkled skin with pencil. Although an overall gray, I used blues and violet in the shadows. I slowly added thin washes to bring out the rough surface including warmer yellow in the areas reflecting light from the hot earth.

"

Weave gentleness and beauty, then add a dash of focused tension.

"

—Patricia Hitchens

BREAKFAST | PATRICIA HITCHENS
Transparent watercolor on 140-lb. (300gsm) cold-pressed Arches
22" × 15" (56cm × 38cm)

Emerging light in the morning is soft and dewy as canopy inhabitants begin to stir. I started with washes of Aureolin, Quinacridone Gold and Quinacridone Rose. While the paper was damp, I followed with a glaze of French Ultramarine Blue. The soft granulation allows luminosity to come through like stained glass. I then created the general composition directly over the background in a manner that shows my respect for the power and simplicity of Asian art.

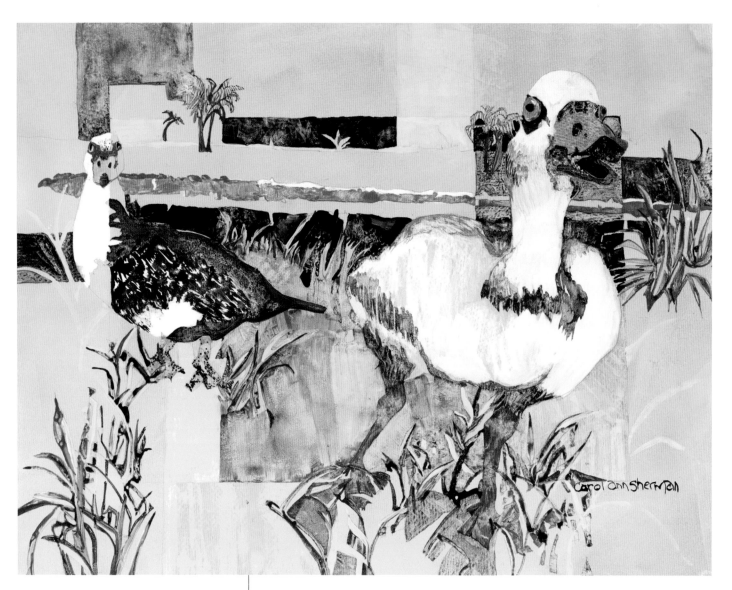

DAISY AND THE DUDE | CAROL ANN SHERMAN
Watercolor on Yupo paper
18" × 24" (46cm × 61cm)

She's a Muscovy duck, he's an Egyptian goose … so it was an ill-fated relationship, which made for an intriguing yet whimsical painting. I snapped this photo one afternoon when the odd couple came into my backyard for their daily snack of lemon cookies. The moment captured many natural textures: sunlight, water, foliage and feathers. I started with a basic line drawing eliminating the man-made structures. I then painted the entire surface with Gamboge Nova. When painting on Yupo, the amount of pigment removed is just as important as the amount applied. My favorite part of this painting is the cookie crumbs on the dude's face—a "stuffed" goose!

66

Be inspired by the unpredictable way watercolor dries, and then let it guide you to your results.

99

—Kim Johnson

I'M HERE FOR YOU | KIM JOHNSON
Watercolor on 300-lb. (640gsm) cold-pressed Arches
22" ×15" (56cm × 38cm)

The moment I took the picture, I knew I had an inspiring photo. I started out very wet and splashy, then moved into more controlled glazes and washes before adding the finishing details. I chose the cold-pressed paper because of the texture it added to the bulldog's features—the folds in his face and hind legs, the shadows in the barrel of his chest, the shine/shadow contrasts of the bells around his collar and the details of his paws against the concrete. I am still riveted to how the dog's attention was devoted entirely toward his human companion.

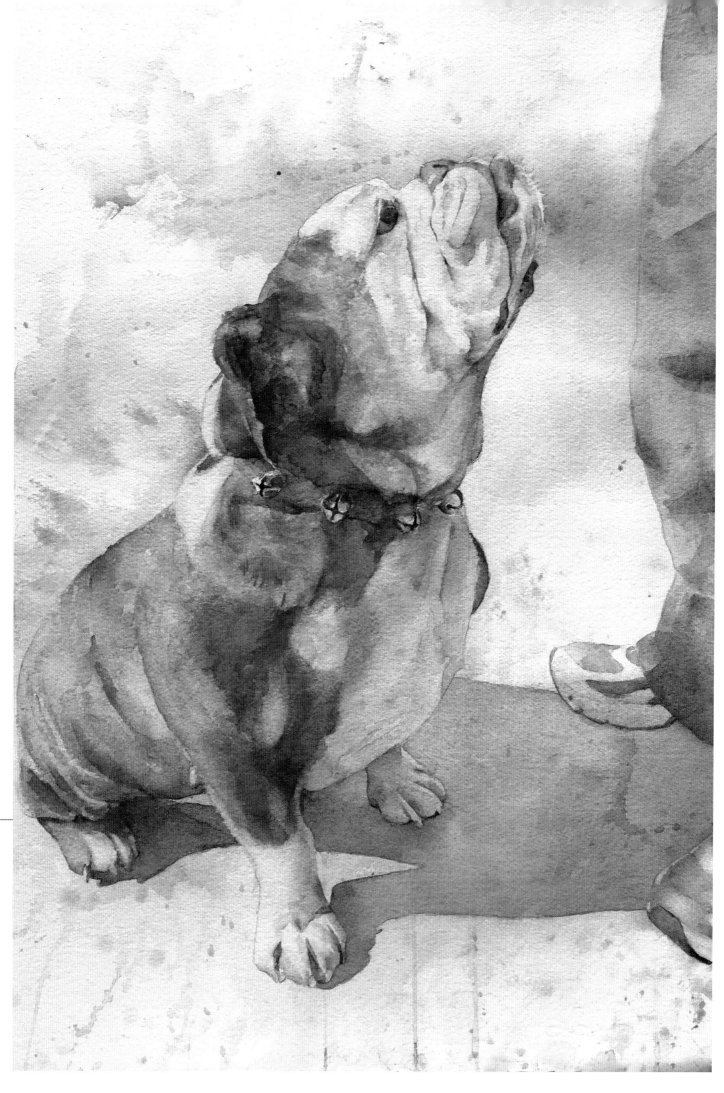

Visit artistsnetwork.com/splash16 to download free bonus wallpapers from the *Splash* series.

47

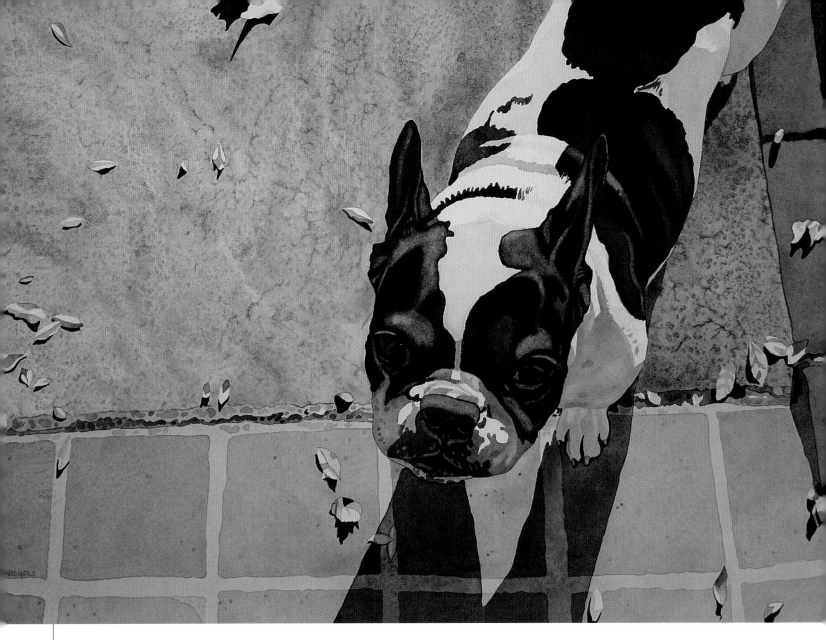

TIME FOR MY WALK | R. MIKE NICHOLS
Transparent watercolor on 300-lb. (640gsm) cold-pressed Fabriano Artistico
11" × 15" (28cm × 38cm)

This painting began with very light washes of color, which are barely discernible but helped to enliven the overpainting of blacks and grays. This palette is meant to impart a timeless quality to the subject. Surface textures were created with brushstrokes, lifting and salt to establish a feeling of hair, glossy eyes, bricks, leaves and dirt. We lost our French bulldog Lilly to cancer on May 14, 2013. She was part of our lives for more than 9 years, appearing in numerous photographs and paintings. I completed *Time for My Walk* one week after her death. Painting helped me to work through my grief and to celebrate all the joy she had brought into our lives. She loved her walks!

CRICKET | LANCE HUNTER
Transparent watercolor on 300-lb. (640gsm) cold-pressed Arches
19" × 12" (48cm × 30cm)

Cricket, my children's pet, was perched on one of his favorite spots, the back steps of my studio. Predominantly a figure painter, I snapped a few photos of him with no intention of creating a watercolor. Cricket's life was cut short a few months later. After some time had passed, those few snapshots became the basis of my effort to capture the essence of this simple but good-hearted creature. I prewet with a spray bottle for some of the textures in the vignette, and I lifted out to soften the edges of the wood grain. I often encourage my university students to paint things that have significance in the fabric of their lives. I felt compelled to follow that suggestion with this little watercolor.

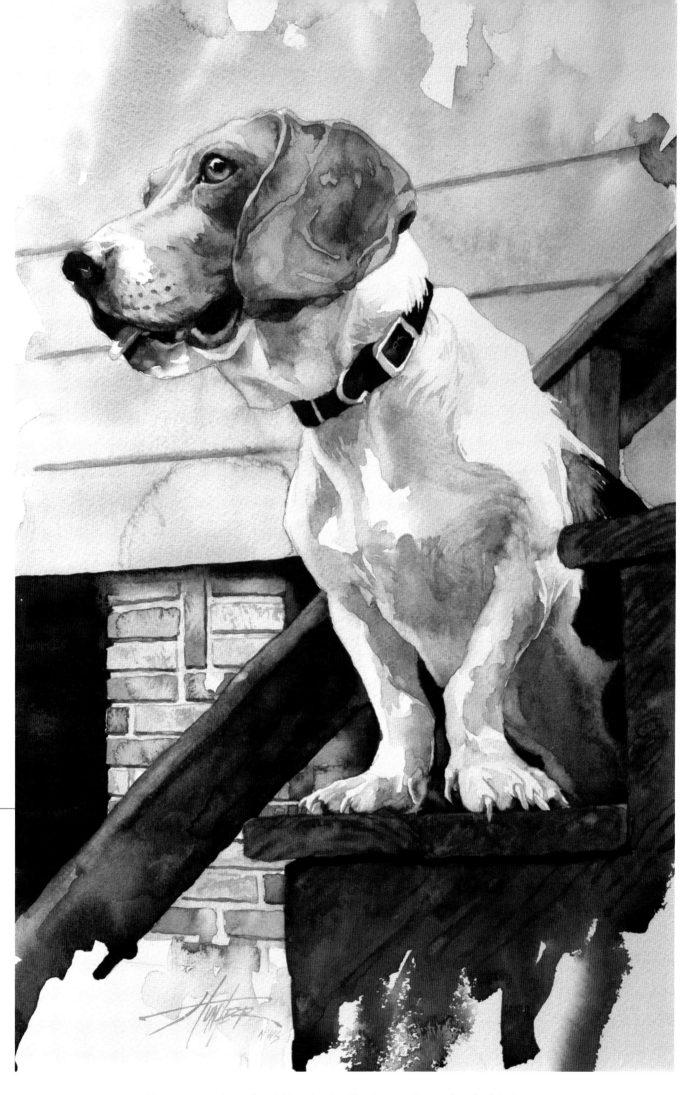

Visit artistsnetwork.com/splash16 to download free bonus wallpapers from the *Splash* series.

49

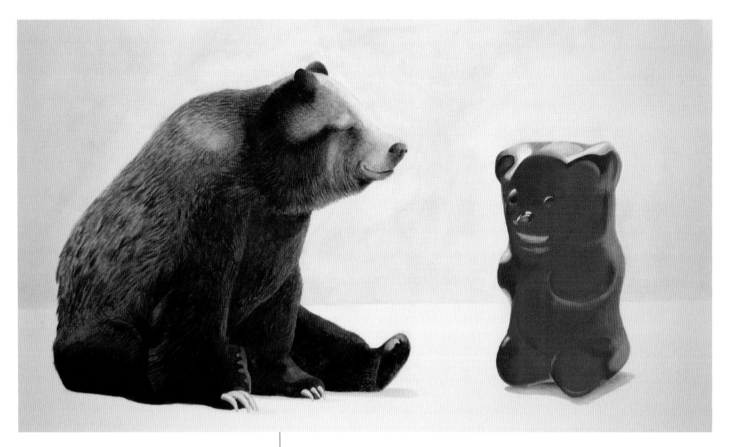

> " You have to be willing to ruin your painting in order to make it better. "
>
> —Kyle Mort

DISTANT RELATIVES | KYLE MORT
Watercolor on hot-pressed archival watercolor board
18" × 24" (46cm × 61cm)

I try to incorporate wit and humor into my paintings. I wanted to present these two bears together in the same space. They are, after all, both bears. The texture of the grizzly was built up by applying layers and layers of drybrush, each strand of fur done one at a time. These guys were meant to meet face-to-face.

> " When a painting seems to take on a life of its own, let go of expectations and follow its lead. "
>
> —Veronica P. Ritchey

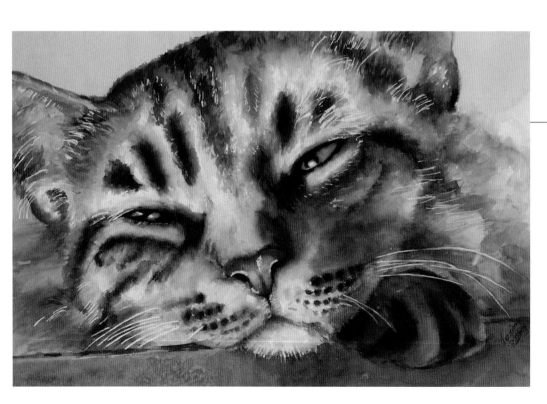

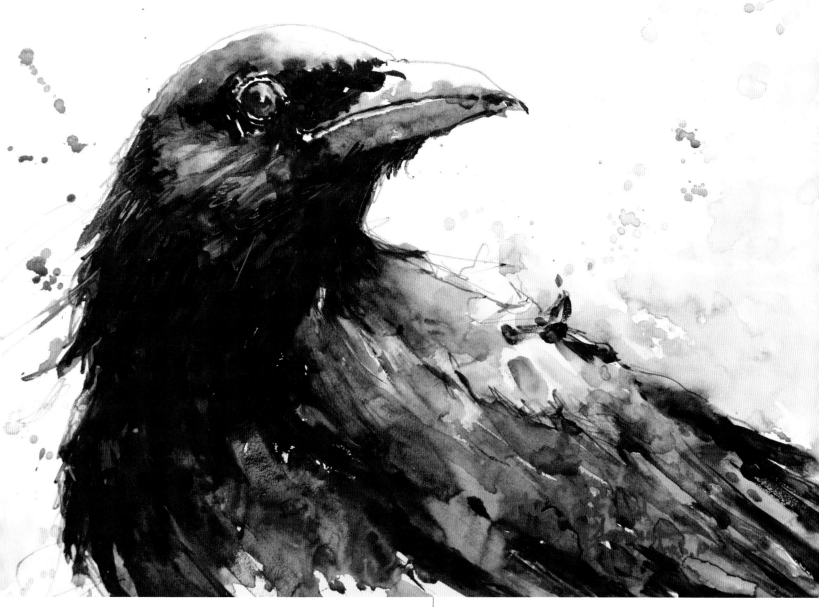

THE SENTINEL | BEV JOZWIAK
Transparent watercolor and a 9B pencil on 140-lb. (300gsm)
hot-pressed Fabriano Artistico
9" × 13" (23cm × 33cm)

There is a plethora of colors in this crow, and yet it still reads
black. I used thick, almost impasto paint in places, wet and wild
watery splashes in others, and drybrush—all done with a frantic
movement of my hand. The varied color and energetic textural
strokes are exactly what make this painting interesting. Imagine if
I had used black out of the tube and added nothing.

MYE TYE | VERONICA P. RITCHEY
Watercolor on 140-lb. (300gsm) cold-pressed Arches
14" × 21½" (36cm × 55cm)

Mye Tye was created from a photo I had taken of our cat after he
had conquered a tall stack of boxes. The look of pure contentment
captured in Tye's eyes was what inspired me to paint his portrait.
For the fur and whiskers I saved some of the highlights using
masking fluid. A base coat of Aureolin set the undertone that
would allow subsequent glazes of Alizarin Crimson, Prussian Blue
and Sepia to shimmer.

"

Paint the way you feel you must, not the
way you think you should paint.

"

—Bev Jozwiak

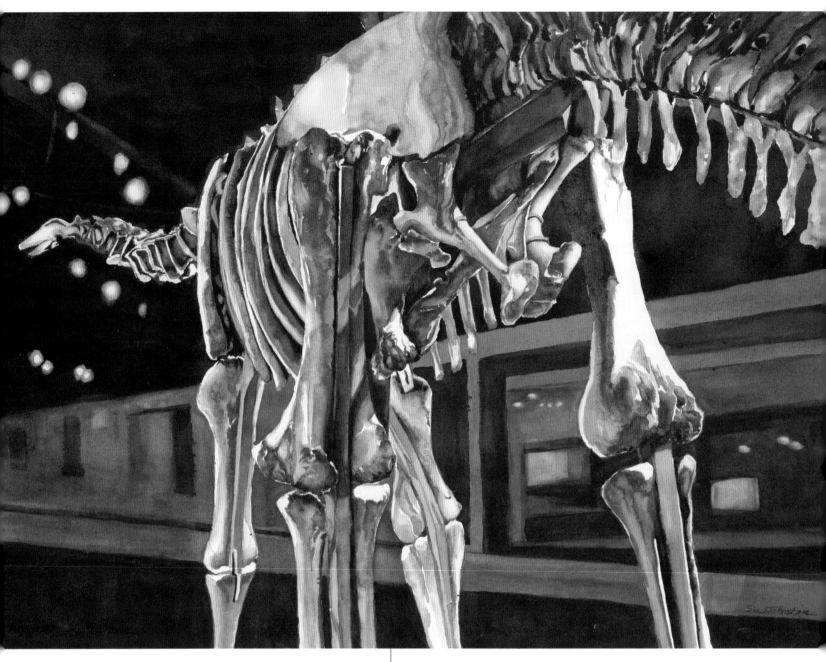

> " Creating texture on paper is an adventure that travels as far as your imagination allows. "
>
> —Sue Johnston

VEGETARIAN VACATION | SUE JOHNSTON
Transparent watercolor on 140-lb. (300gsm) cold-pressed Arches
21" × 29" (53cm × 74cm)

I was excited to explore the dinosaur exhibits at the Field Museum in Chicago. The ancient bones created wonderful shadows, and their pitted, cracked and pebbled textures had me clicking away with my camera. Later I drew the image on my paper. From my large collection of Daniel Smith pigments, I selected Bloodstone Genuine, Yavapai Genuine and Hematite Burnt Scarlet. The most difficult part of the painting was designing a background that suggested a museum. Then the fun began. Mixing colors on paper, spraying water on the wet surface, tilting and allowing paint to run and adding salt in a few places created an exciting image. The textures of old bones that I remembered from my visit to the museum came to life.

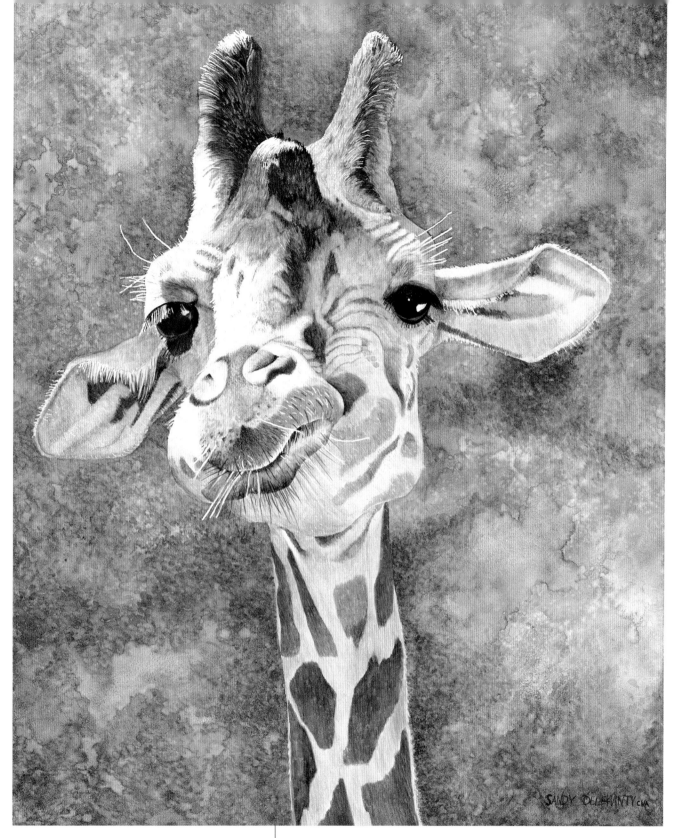

TONGUE TIED | SANDY DELEHANTY
Transparent watercolor on Aquabord clay panel
20" × 16" (51cm × 41cm)

Silly is good. With so much serious art in the world, I thought
it would be refreshing to create a series of paintings that make
people smile or giggle. Giraffes seemed to be the perfect subject
for my *Silly* series. I painted this giraffe on Aquabord because
the surface allows for details like whiskers and eyelashes to be
rendered accurately without bleeding. I wanted a textural abstract
background that only hinted at leaves, so I used a wet-into-wet
technique to drop a variety of staining pigments into puddles of
water. Dab, dab, splatter, tip the board, squirt water on it, splatter,
splatter, more dabbing! Such fun!

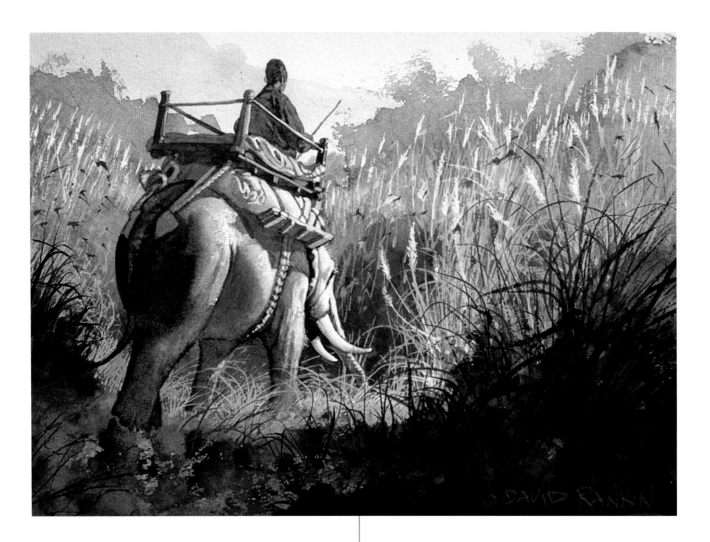

The central focus of my painting career is the wildlife of India. This is a painting from my creative efforts working in India's famous Bandhavgarh Tiger Reserve. To create drama I carefully developed intense morning sunlight illuminating the ten- to twelve-foot-tall (3 to 3.6m) elephant grass as we headed out to find tigers. In this painting, I did use gouache for the very bright green grass as well as the tall soft tops of the blades. But it was the careful use of color values, along with the delicate overlapping texture of grasses, that created the illusion of depth. It's hard to see, but the complex multilayered textured foliage is painted over soft wet layers of pigment.

Meerkats are delightful creatures. A ubiquitous feature of theirs is this distinctive posture where they stand around scanning the sky—ever watchful for their deadly nemeses—hawks. I have wildlife artist buddies who paint every strand of hair or fur. But I wanted my meerkats to feel furry—without painting one hair! This illusion of fur was achieved by starting at the top and working downward using very careful blends of beaded washes and pigment into wet brushwork, resulting in smooth fur—with no hairs! The sharp outer edges of their bodies then help define them. This is the magnificence of watercolor!

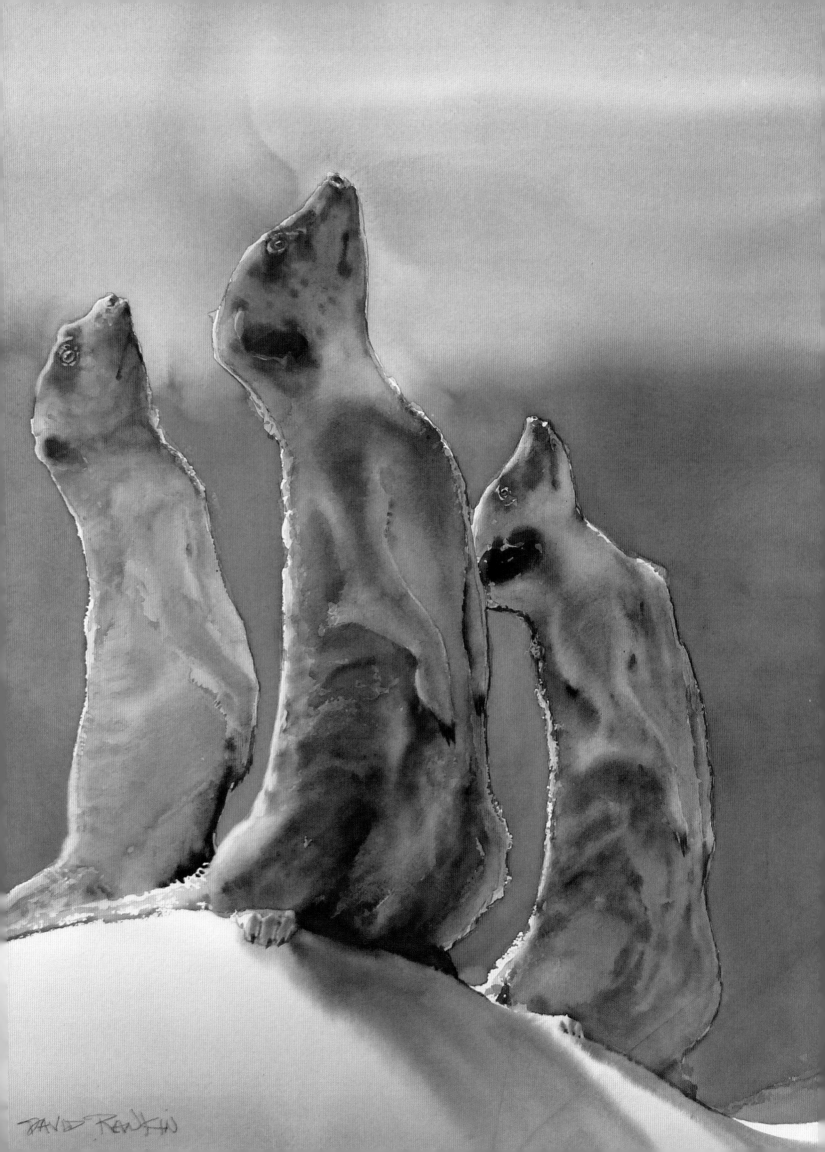

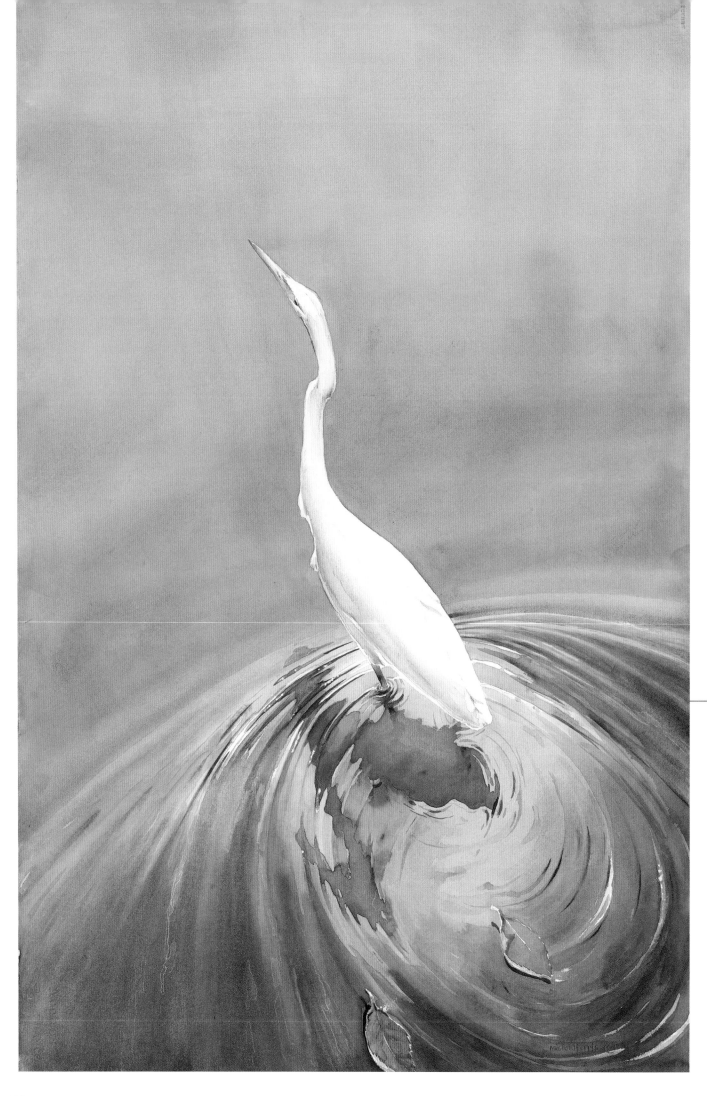

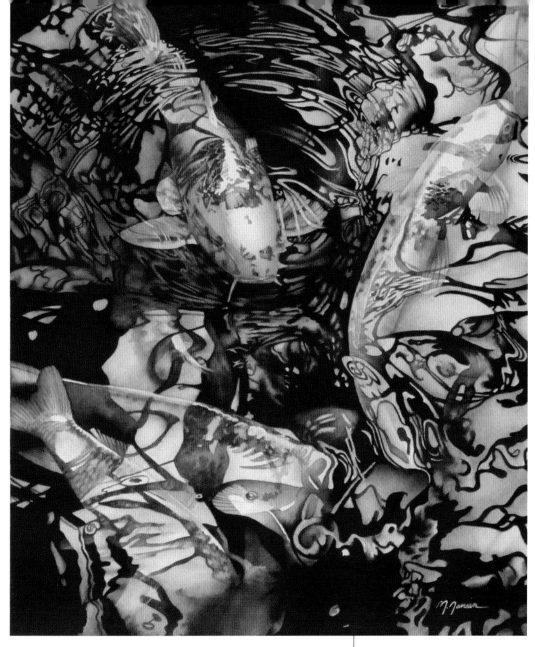

KOI AHOY | MARY M. JANSEN
Transparent watercolor on 140-lb. (300gsm) cold-pressed Arches
18" × 14½" (46cm × 37cm)

HERON AT THE MARINA BASIN | MICHAEL FERRIS
Transparent watercolor and pencil on 300-lb. (640gsm)
cold-pressed Arches
39" × 26" (99cm × 66cm)

The drawing for this painting was done from a photograph I took at the local Cairns Marina. The poise of the bird is paramount, so I made some modifications to its stance and shape. I use lots of water in my washes; the first washes on the top half (Cerulean and Burnt Umber) were done concentrically, parallel to the wake. I let these slosh around as much as I could. In the lower half of the picture the surface of the water had to be reflective and show the movement of the bird, so the washes were more focused and articulated—concentric around the bird, preserving whites for highlights. The white bird demanded subtle color and had a surprising amount of blues. To make the texture of the water sparkle, I used a small amount of Chinese White on the crest of the wake, close to the bird.

One could spend an entire day watching koi create intriguing compositions above and below the pond's surface. But fish and water don't stand still, so I take photos—hundreds of them. From these I harvest interesting shapes and textural elements. My goal in *Koi Ahoy* was to replicate the ephemeral nature of the watery surface, yet also create a sense of depth. I've left much ambiguity so as to engage the viewer in the creative process.

Visit artistsnetwork.com/splash16 to download free bonus wallpapers from the *Splash* series.

57

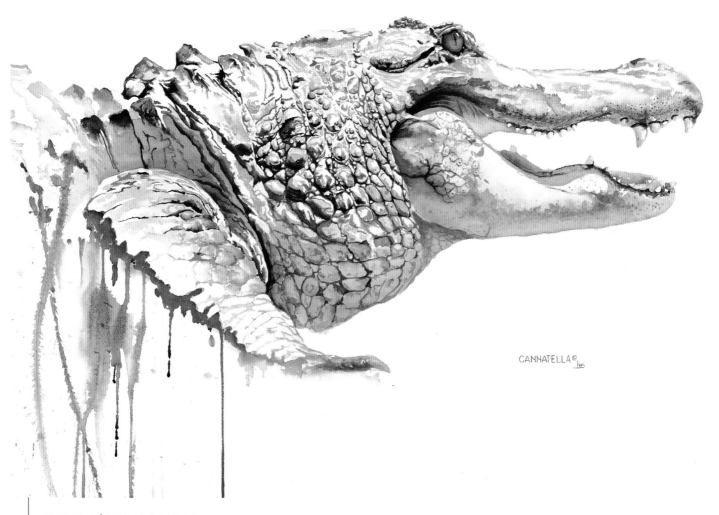

EMERGING | DEBBIE CANNATELLA
Transparent watercolor on 140-lb. (300gsm) cold-pressed Arches
22" × 30" (56cm × 76cm)

I've often been found in remote locations taking reference shots to record the natural world. In *Emerging* I was drawn to the strong textural elements of the hide, but also wanted this powerful reptile to seem as if he were emerging from the undefined watery pigment. The strong contrast of gradation in value creates the visual dimensionality of the domed armor near the head of the alligator.

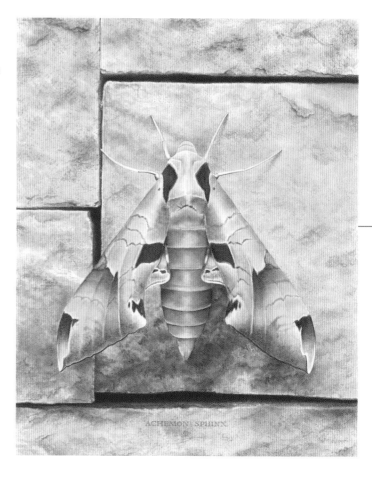

"

A composition such as this becomes my meditation as I paint, thoroughly enjoying the journey.

"

—Debbie Cannatella

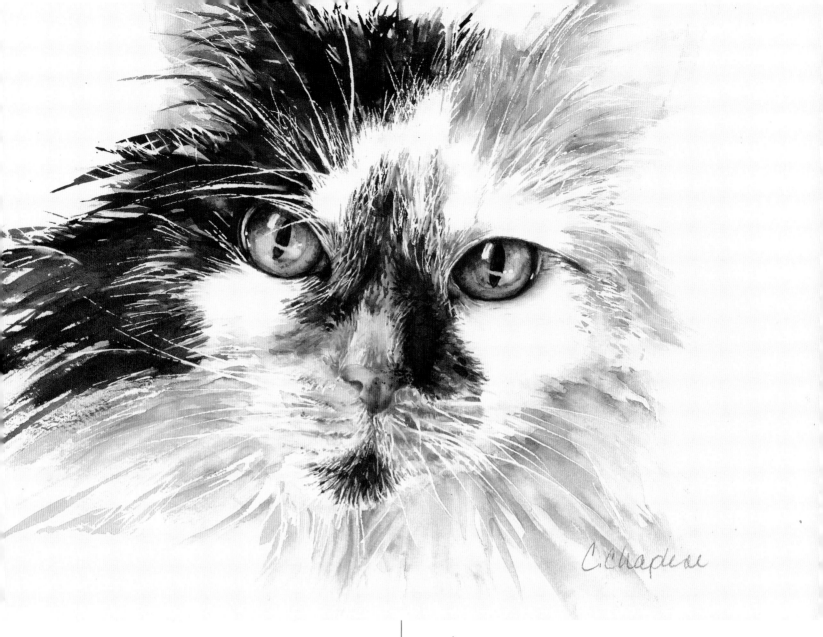

EMMA | CHERYLE CHAPLINE
Transparent watercolor on 140-lb. (300gsm) cold-pressed Arches
11" × 15" (28cm × 38cm)

Starting with a detailed drawing of Emma's eyes and a loose contour of her head, a latex resist was applied to save the white paper for specific details. Underpainted glazes developed unity and provided bits of arbitrary color throughout. The texture was enhanced by using broken line, dry-brush, fingerprinting and lifting techniques. Final touches were added to Emma's eyes to create luminance and a soulful quality that demands the viewers' attention.

66

Texture to a painting is like salt to food—each enhances one's experience of the flavor of the subject.

99

—Cheryle Chapline

66

A minimal color palette forces texture to become the driving force in a painting.

99

—Marlene Bachicha-Roberts

ACHEMON SPHINX | MARLENE BACHICHA-ROBERTS
Transparent watercolor on 300-lb. (640gsm) hot-pressed Arches
19" × 15½" (48cm × 39cm)

The Achemon sphinx is a small moth native to the Southwest. This moth chose to camouflage itself among the flagstones of my front porch. The true colors of the insect and stones are represented here. After a precise drawing I masked off the image with liquid frisket to paint the background. With a limited palette I used a sponge and a brush to paint multiple layers of transparent color, creating depth and saturation. I enlarged my reference to paint the details of the moth. The pink in the wings of the moth becomes a focal point in a sea of monochromatic colors.

Visit artistsnetwork.com/splash16 to download free bonus wallpapers from the *Splash* series.

59

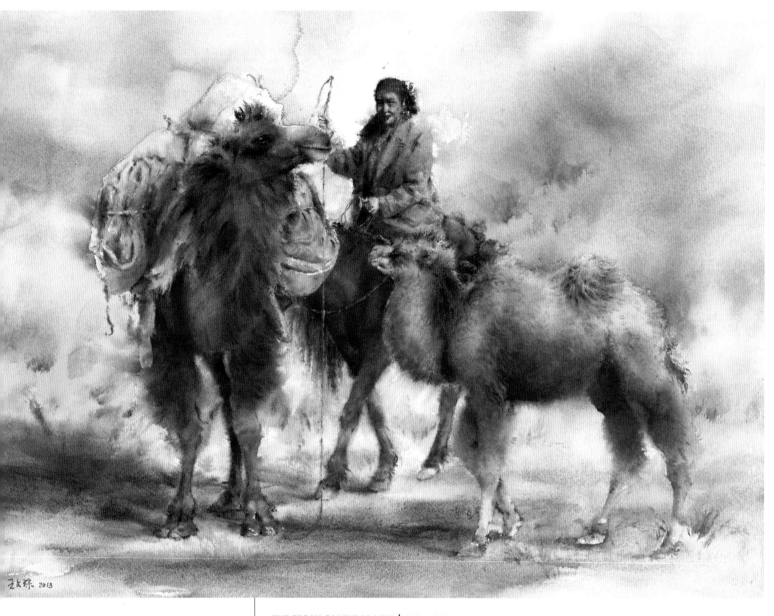

THE STORY ON THE PRAIRIE | WEN-CONG WANG
Transparent watercolor on 300-lb. (640gsm) cold-pressed Arches
22" × 30" (56cm × 76cm)

The relationship between humans and our natural environment
is appealing to me. During a trip to Northwest China close to the
border of Kazakhstan, I was strongly moved by the carefree spirit
of the nomad on the prairie. I kept the sensation in mind and used
loose, quick brushstrokes in the background to contrast with the
subject. The camels in that area have much thicker and stiffer hair.
I did a deliberate value study to plan the texture of the fur, which
was carefully developed by very little paint and water. The illusion
of depth and a great sense of authenticity can be enhanced by this
kind of detail. An assortment of hard and soft edges allows the eye
to travel through the scene.

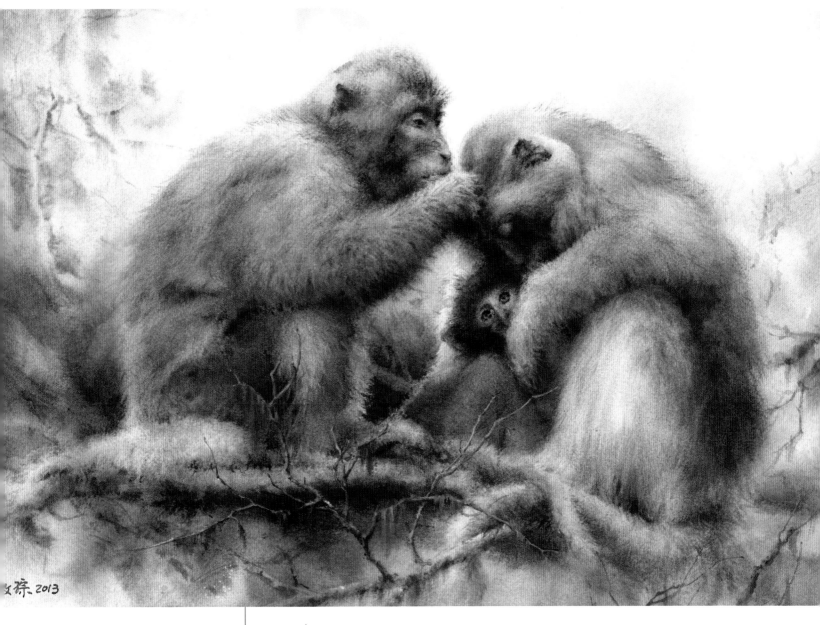

CARING | WEN-CONG WANG
Transparent watercolor on 300-lb. (640gsm) cold-pressed Arches
15" × 22" (38cm × 56cm)

Monkeys share a similar family structure as most other primates: the close, loving bond between mother and child is common. I found this wonderful family in a forest reserve and was touched by their affection. This painting was developed in the studio from a sketch and photos taken the same day. I paid special attention to the subject/environment relationship. The initial underpainting of wet-into-wet was a foundation for the tones and colors. For the soft fur, several layers of color were applied for depth and dimension. I gradually developed my piece as a whole while adding values and details. I used a smaller pointed brush to suggest some of the finer details around the monkeys as final touches.

Visit artistsnetwork.com/splash16 to download free bonus wallpapers from the *Splash* series.

61

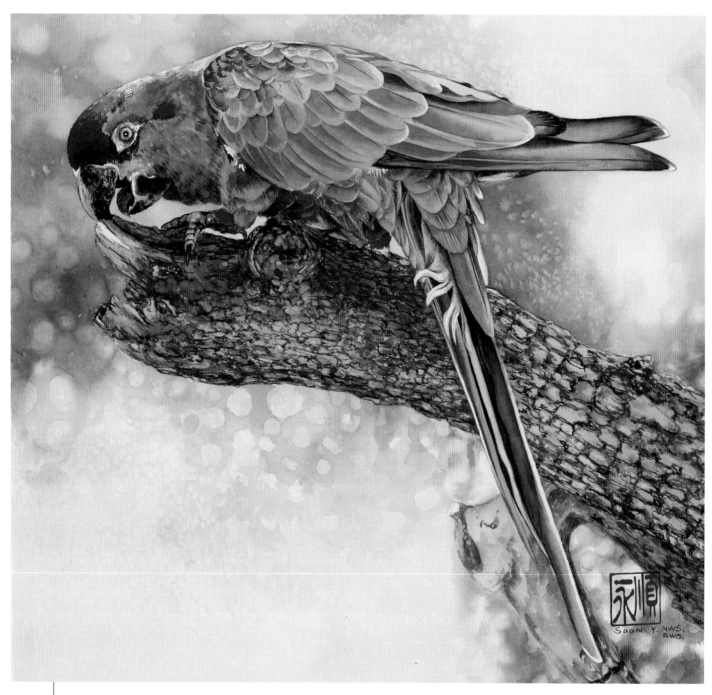

GREEN PARROT | SOON Y. WARREN
Transparent watercolor on 140-lb. (300gsm) cold-pressed Winsor &
Newton paper
16" × 17" (41cm × 43cm)

A green parrot greets me saying, "Hello!" I hear an invitation:
"Paint me." My initial thought is that these feathers are too
complicated! Fear was overcome by the exciting opportunity to
contrast the textures of vibrant parrot feathers with the pine tree
bark, clashing, yet surprisingly harmonious. The shimmering
shades of various green feathers accentuated by Scarlet Lake and
Blue Turquoise are rendered with individual layers using a glazing
application. The layers of glazing in each feather create a delicate
and soft appearance to stand against the rough pine bark. Much
of the natural outdoor setting for the parrot is left to the viewer's
imagination to focus all the attention on the parrot and branch.

NIKE | LEI CHI
Watercolor with gouache accents on 140-lb. (300gsm) cold-pressed
Fabriano Artistico
12" × 8½" (30cm × 22cm)

Nike is a shy greyhound we adopted after his career on the race-
track. I developed his portrait from a photo taken on his favorite
walk. The well-studied drawing is crucial to the painting's success.
Through drawing I became more acquainted with his character and
discovered relationships between compositional elements. Layers
of transparent washes were used to achieve the desired contrast of
light and dark. Splattering paint by rubbing a toothbrush created
the texture on the sidewalk. I used white gouache or mixtures of
gouache and watercolor for the fur and highlights.

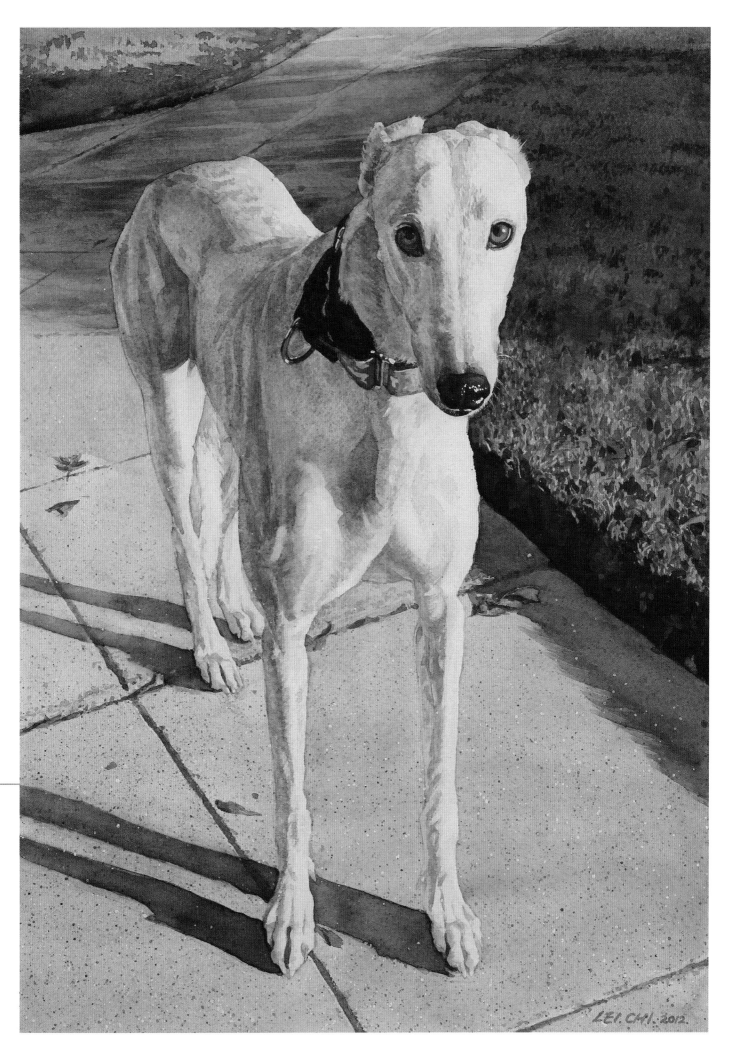

Visit artistsnetwork.com/splash16 to download free bonus wallpapers from the *Splash* series.

63

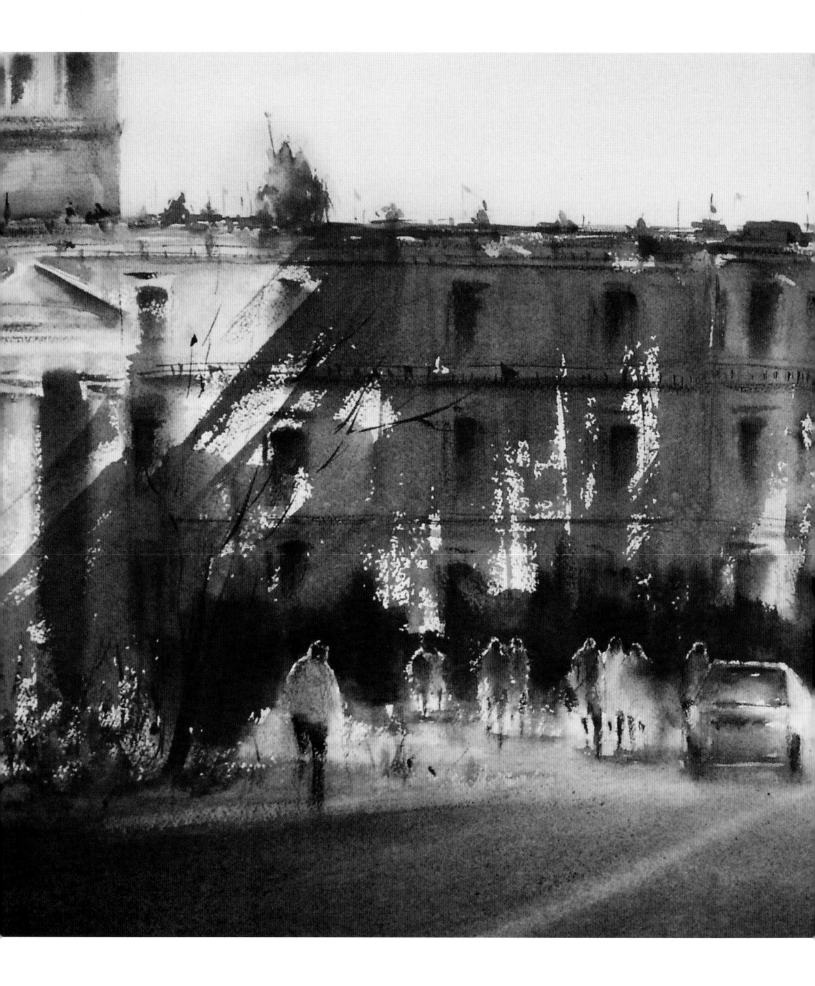

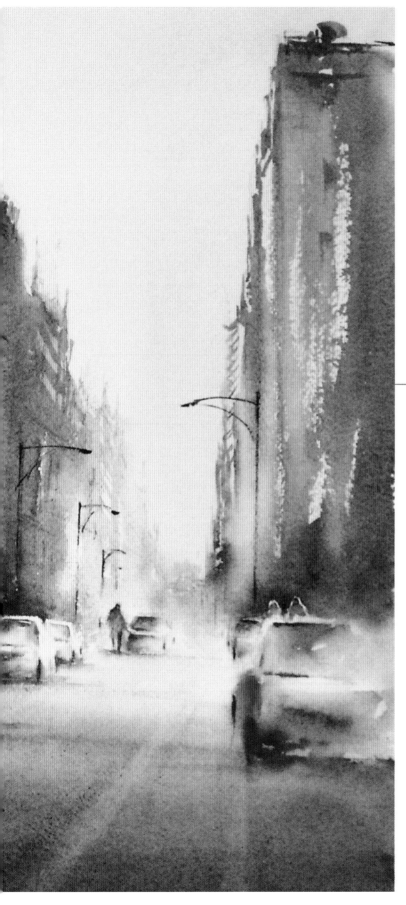

4

URBAN SCENES

COMMUTERS IN DETROIT | YUKI HALL
Transparent watercolor on 140-lb. (300gsm) rough Arches
18" × 25" (46cm × 64cm)

Being born and raised in downtown Tokyo, Japan, I am always drawn to cityscapes. This painting is based on a photograph I took when I was in downtown Detroit visiting my husband's mother. I was intrigued by the beauty of the shadow cast on the old building. I aim to capture the atmosphere of a scene rather than the actual details by focusing on the big shapes and tonal value patterns. Application of an initial wash with a big mop brush and subsequent dry brushstrokes helped me to suggest the texture of the old building and the light coming through the breaks of the large shadow.

"

Hard, soft, dry, lost and found. These different edge qualities express the texture of objects as well as the overall atmosphere.

"

—Yuki Hall

Visit artistsnetwork.com/splash16 to download free bonus wallpapers from the *Splash* series.

65

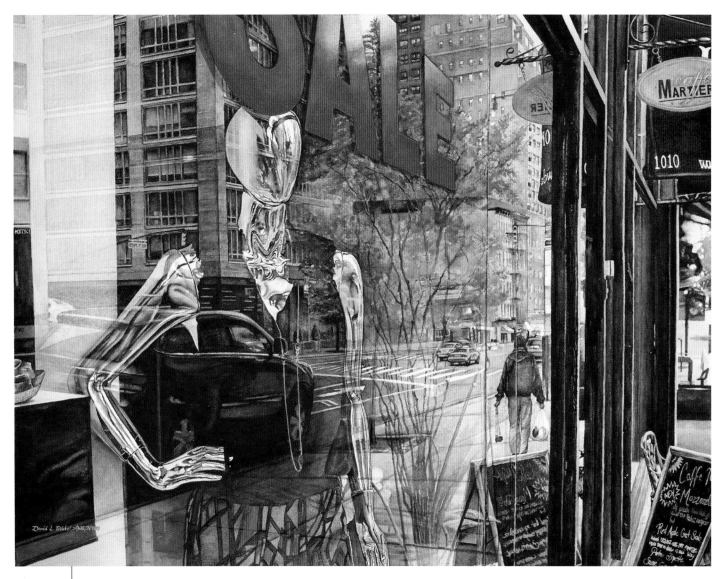

WINDOW WATCHING | DAVID L. STICKEL
Transparent watercolor on 300-lb. (640gsm) cold-pressed Arches
20" × 25" (51cm × 64cm)

I discovered this window scene during an early-morning stroll in East Manhattan, New York City. I was struck with the mannequin's shiny, reflective appearance while at the same time noticing the reflection of the car. I love the highly reflective chrome of this image bearer standing guard, peering out the window at a busy city. I painted it with a one-point perspective in mind, and find the movement leading down the street very appealing.

66

With regard to reflections, one must study carefully—image, values and especially the contrast of hard vs. soft edges—in order to be as convincing as possible.

99

—David L. Stickel

TO THE HEILIGEWEG – AMSTERDAM | IAIN STEWART
Transparent watercolor with gouache accents over graphite underdrawing on Stillman & Birn Beta Series paper
14" × 10" (36cm × 25cm)

I've been trying to capture the looseness and character of the sketches I do on-site in some of my studio paintings. It is difficult because in the studio I'm not confronted with the entirety of my subject nor the pressure of knowing there's a limited amount of time to work. *To the Heiligeweg* (or Holy Way) is an example of this exploration. One of the techniques I use in these studio sketches is that I rarely erase any line work. I block out major forms, my pencil rarely leaving the paper, over which I begin adding strength to the lines as I solidify the forms. This leaves me with a final drawing that is quite varied and textural. I work quickly and loosely with my subsequent washes as I want line work to remain visible. For me, entering the studio means "tighten up and make serious paintings." The real trick is to treat the entire process as if it were just another outdoor sketch.

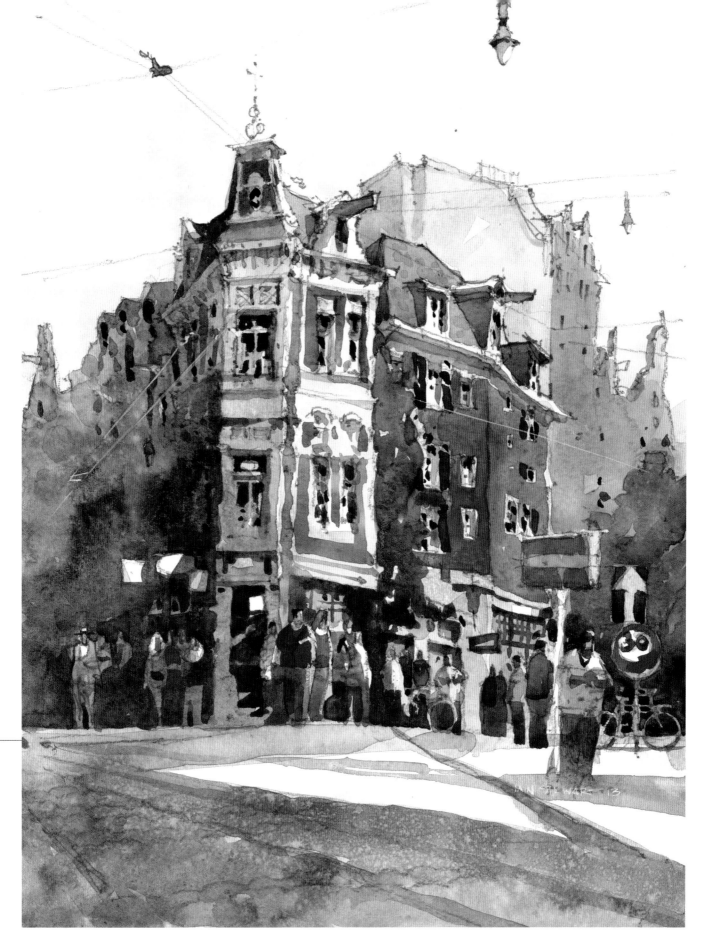

If handled correctly, texture will add life to
your work. If overdone, it will fight it.

—Iain Stewart

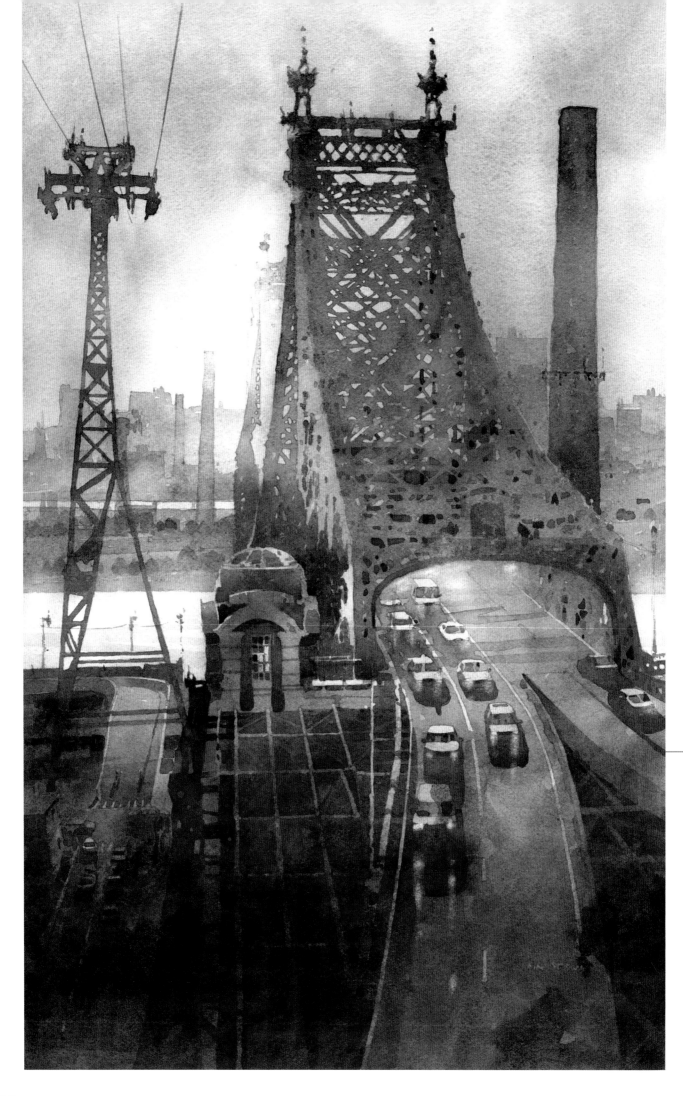

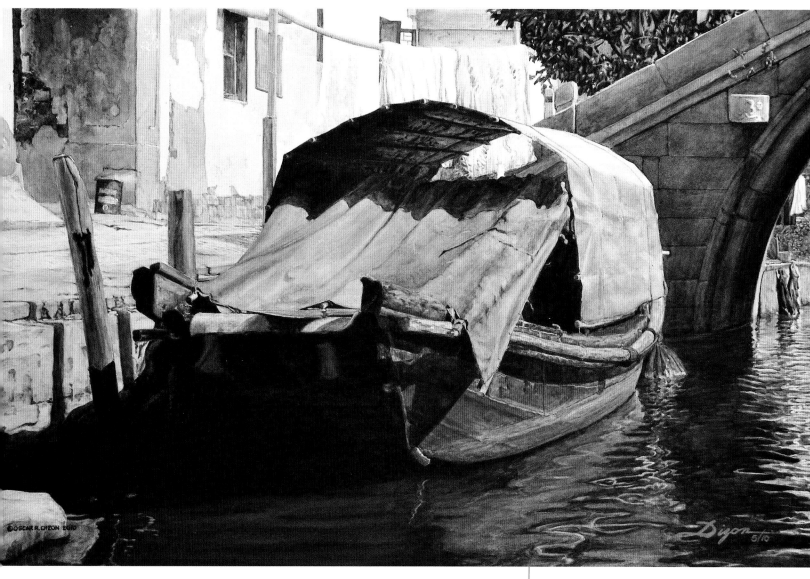

Images of weathered structures, especially those with historical pasts, interest me most. They are rich in texture that gives the subject aura and distinction. With its strong character the boat dominates the scene and gives life to this quite small water town in Shanghai. Precise drawing was very crucial in this work to achieve the goals I set after careful planning. I started with the focal point, which is the boat, and worked simultaneously on the surrounding areas to measure the color values of each element. I was able to determine how much darker I could go to complement the intense color of the boat. After I had completed working on the boat, I did the water last to visualize where the shadows should fall and what colors to reflect on the water.

> 66
> ## Texture gives the painting a character and distinction.
> 99
> —Oscar R. Dizon

TO THE QUEENSBORO BRIDGE – NYC | IAIN STEWART
Transparent watercolor with gouache accents over graphite underdrawing on 140-lb. (300gsm) cold-pressed Saunders Waterford
20" × 12" (51cm × 30cm)

I had an image in my head from the moment I stepped on the aerial skyway to Roosevelt Island in New York. I wanted the intricate layers of beams and supports to read as more of a singular entity, almost like lacework with light shining through. After painting in the lightest areas of the sky and water, I masked off all areas of light and began building layers that flowed from cool to warm hues within the bridge itself. After more glazing and painting I began to lose my original idea. When confronted by this, I turn a painting to the wall and let it sit for a few days or, in this case, a couple of weeks. I then decided it needed a very strong foreground. The next moves would either finish the painting or ruin it. So, in with the bold darks in the foreground! A little lifting for the highlights on the cars, and in a couple of hours it was finished.

Visit artistsnetwork.com/splash16 to download free bonus wallpapers from the *Splash* series.

69

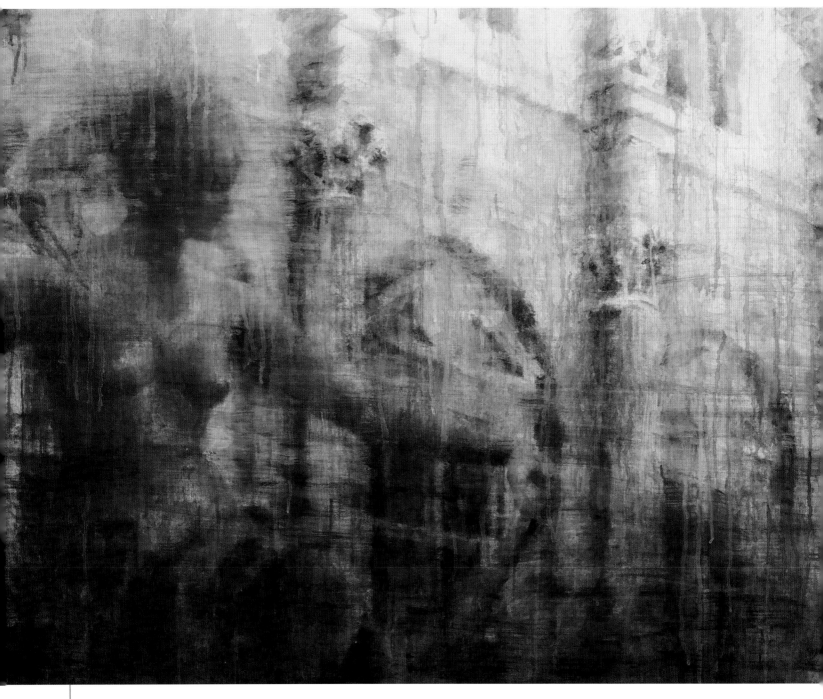

MELODIOUS PARIS | CHIZURU MORII KAPLAN
Watercolor on rough Arches
52" × 67" (132cm × 170cm)

This was my first large-scale painting. Working on such a scale requires greater physical movement. Spattering and splashing and dripping the pigment all become larger actions. I work with gravity, standing my paper on an easel. I turn it so the paint drips horizontally and vertically like weaving a tapestry. Textures of history, memories and emotion intersect each other, and I begin to hear the melody of Paris from a summer I lived there some years ago.

FDR DRIVE, NYC | CHIZURU MORII KAPLAN
Watercolor on rough Arches
37" × 52" (94cm × 132cm)

Where are they going in such a hurry? Cars hurtle down too narrow lanes—a wall on one side, girders on the other—the restless, chaotic energy of driving down the FDR. Working from a photo I took from a car, I splatter, splash, vigorously drag the big brush full of thick black pigment across the paper to get the energy I want—that pulsing tumult within the dirt and grime of this New York City experience.

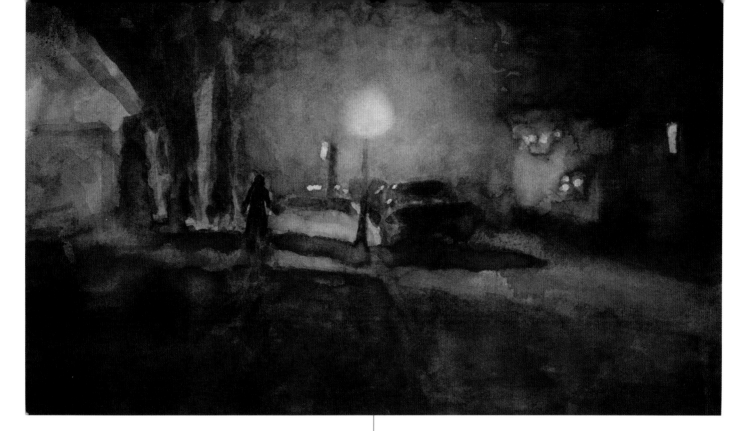

FOG LIGHT | ROBERTA J. BOLT
Transparent watercolor on 140-lb. (300gsm) cold-pressed Arches
16" × 20" (41cm × 51cm)

A warm, quiet early-spring night, heavy in fog and streetlights. The atmospheric textures were palpable. I snapped several shots as we walked down the street, and I made mental notes of how the evening air felt. To capture the mood in abstract shapes and textures I used light washes, quick brushwork, spraying, turning, then building of thick paint, adding shots of color, and wiping off and blotting. All in an effort to tell the story of the wonderful, mysterious spring night.

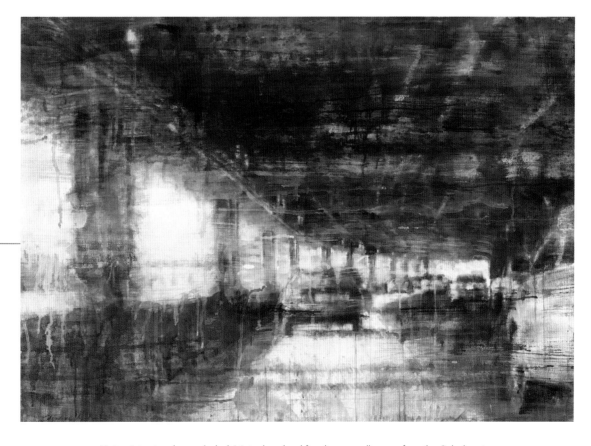

Visit artistsnetwork.com/splash16 to download free bonus wallpapers from the *Splash* series.

71

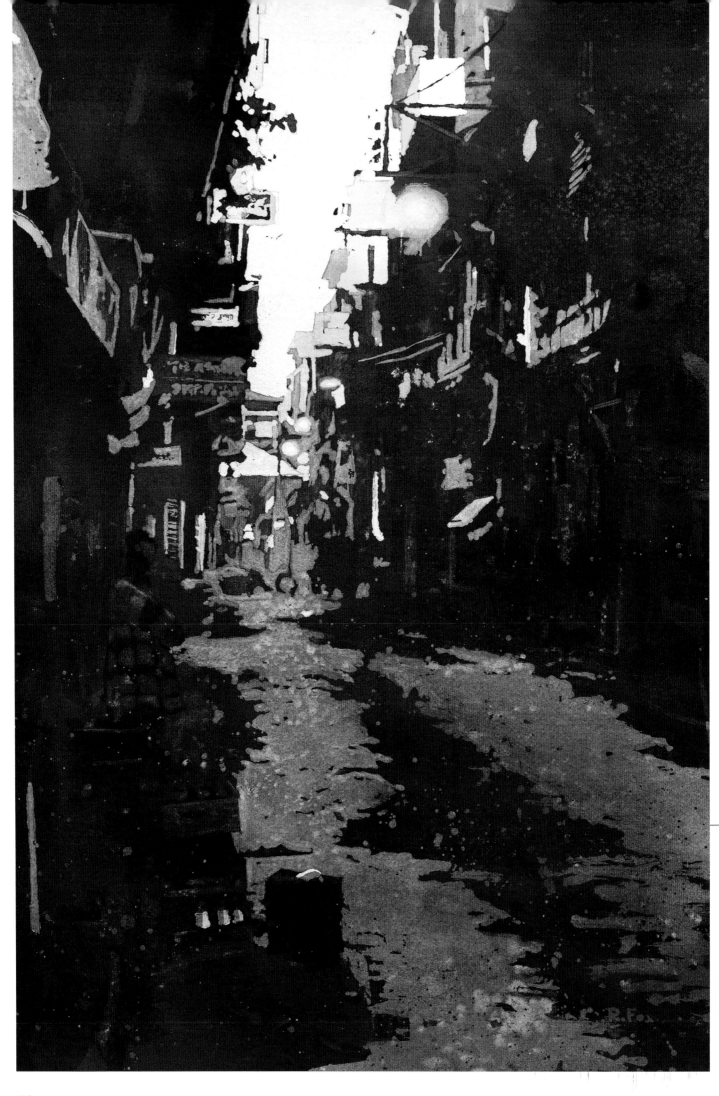

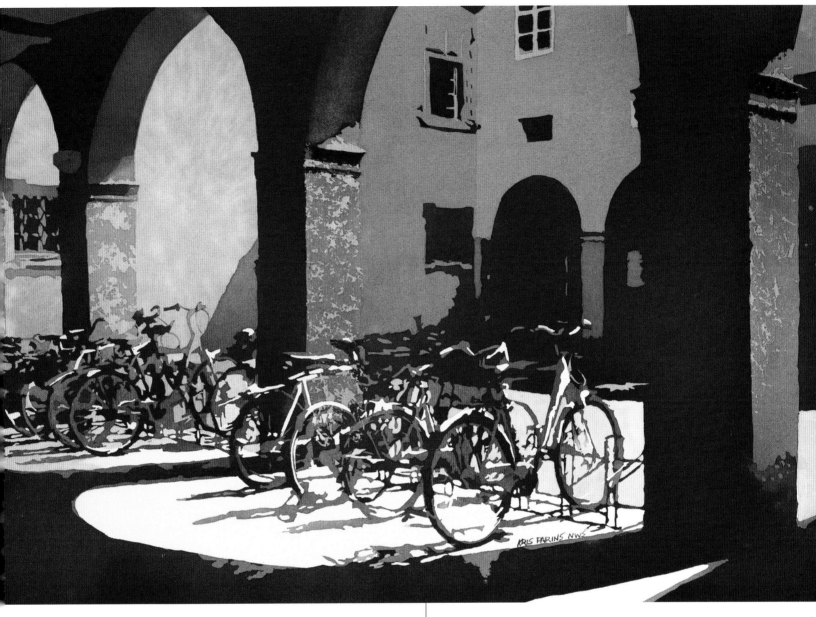

NINE BICYCLES | KRIS PARINS
Transparent watercolor on 140-lb. (300gsm) Canson/Arches cold-pressed watercolor board
19½" × 29½" (50cm × 75cm)

While traveling in Austria, I glanced into a courtyard and was struck by the contrast of a contemporary tangle of bicycles against ancient arches. A quick photo served as a reminder for a future studio painting. My intention was to use minimal detail to describe the scene and let the viewer's eye supply the rest. Using a technique of masking and pouring, I was able to merge value shapes to eliminate the detail of the bicycles while still communicating the sense of arrested motion. With only a suggestion of rough plaster on the columns, the architecture remains quiet and timeless in the background.

WALK DOWN THE STREET | RYAN FOX
Transparent watercolor on 140-lb. (300gsm) cold-pressed Arches
21" × 15" (53cm × 38cm)

I worked outside of my comfort zone for this painting, using masking fluid and poured paint, techniques I rarely use. The viscosity of masking fluid makes it difficult to apply in fine continuous lines. I used a watered-down version (with longer drying time) so I could spatter mask on top of previous layers or paint it on with a watercolor brush. First I masked graphic shapes to suggest architecture and followed by pouring primary colors onto the surface. I repeated this process several times until I reached the desired values. I added salt to wet paint to liven negative areas. The finished artwork is a representational abstraction of a city scene.

Visit artistsnetwork.com/splash16 to download free bonus wallpapers from the *Splash* series.

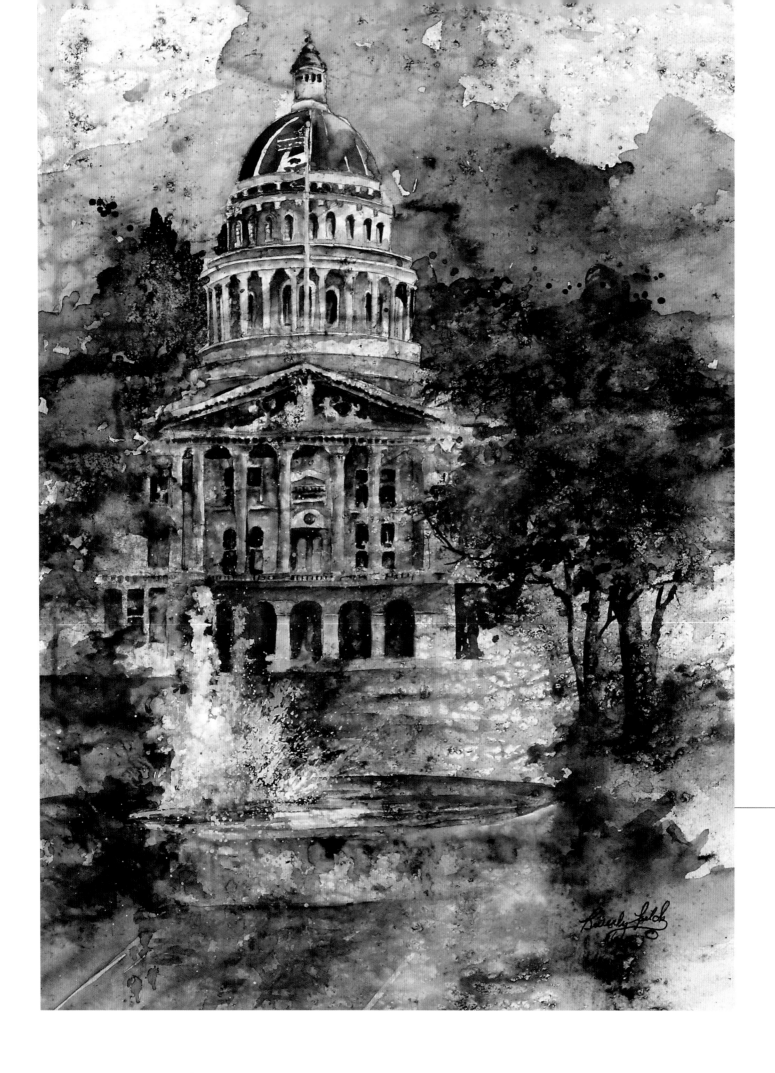

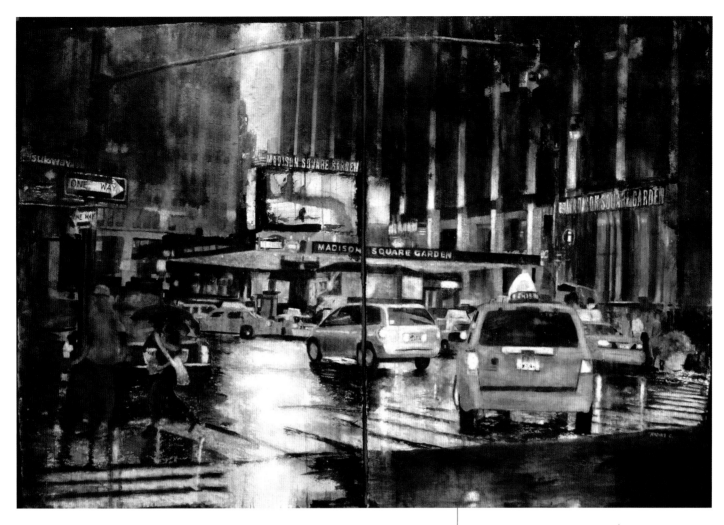

AROUND THE GARDEN | NADINE CHARLSEN
Watercolor on 150-lb. (320gsm) handmade Khadi paper
30" × 46" (76cm × 117cm) diptych

"

In order to appreciate light, there must be dark.

"

—Beverly Fields

My emotion and state of mind attract me to my subjects and tell me what to paint. One evening as I walked out of Madison Square Garden, the rain was falling and made this painting. I simply had to paint it. My love of large-scale watercolor painting allows me to explore subjects with areas of detail and textures using drips and puddles. The heavy-weight paper allows me to scrub and scratch and repaint as much as I desire. I want my viewers to experience the painting and feel the story of the moment as I did when I painted it.

CAPITAL DREAMS | Beverly Fields
Watercolor and powdered graphite on archival watercolor board
22" × 15" (56cm × 38cm)

I wanted to capture a scene between imagination and reality. I used a limited palette to set the mood, and I kept the values close. *Capital Dreams* began with a wet-into-wet underpainting. The textured background was achieved by spraying a mist of water on the surface of archival watercolor board that had been sprinkled with powdered graphite. After the powdered graphite dried, I began to draw in my subject. Finding the lightest area on the paper, I drew the white capital into the arbitrary abstract light shapes. I limited my palette to warm and cool transparent watercolor. Whites were saved rather than masked. The flag was first painted with white acrylic rather than with watercolor.

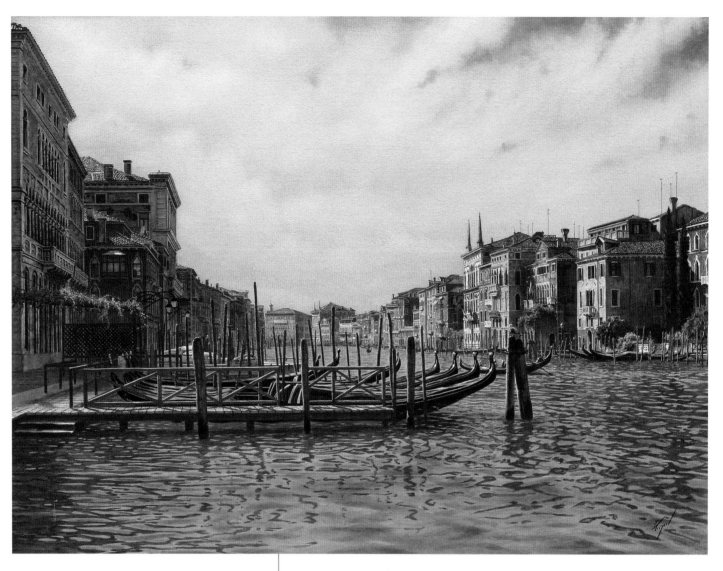

> Texture gives your painting a sense of believability. Light, shade and atmosphere influence how you observe texture.

—James Toogood

THE GRAND CANAL | JAMES TOOGOOD
Watercolor on 300-lb. (640gsm) cold-pressed Arches
22" × 30" (56cm × 76cm)

This scene looks southwest from the Rialto Bridge toward Ca'Foscari, Italy, in the distance. Over several visits, I did numerous studies, both drawing and photographing. I want all the information possibly needed before beginning the painting in my studio. Numerous layers of paint are then applied to achieve proper color, value and texture. Removing figures and most modern elements gives the painting a quiet, timeless quality. Colorful timeworn buildings, shiny black gondolas, the water with its reflections and the sky all contribute distinct, interwoven textual elements that offer a clear sense of place.

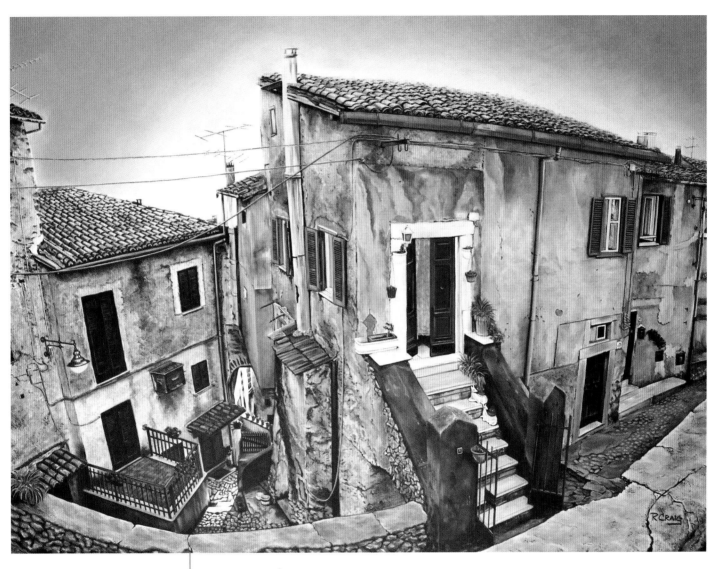

CINQUE TERRE | RON CRAIG
Acrylic on gesso board
30" × 40" (76cm × 102cm)

Years of decay and repair add strata of texture and character to these structures. Centuries of stories are hidden here. With the hillside setting creating depth, I decided to exaggerate the focal points to give more of a dramatic effect. Exploring the various textures seemed limitless; every glance offered something new. My preferred paints are liquid acrylics, but when I need more working time for blending, I'll use open acrylics. The combination of painting on gesso board and the liquid acrylics gives me the smooth surface finish I strive for in a finished product.

Visit artistsnetwork.com/splash16 to download free bonus wallpapers from the *Splash* series.

77

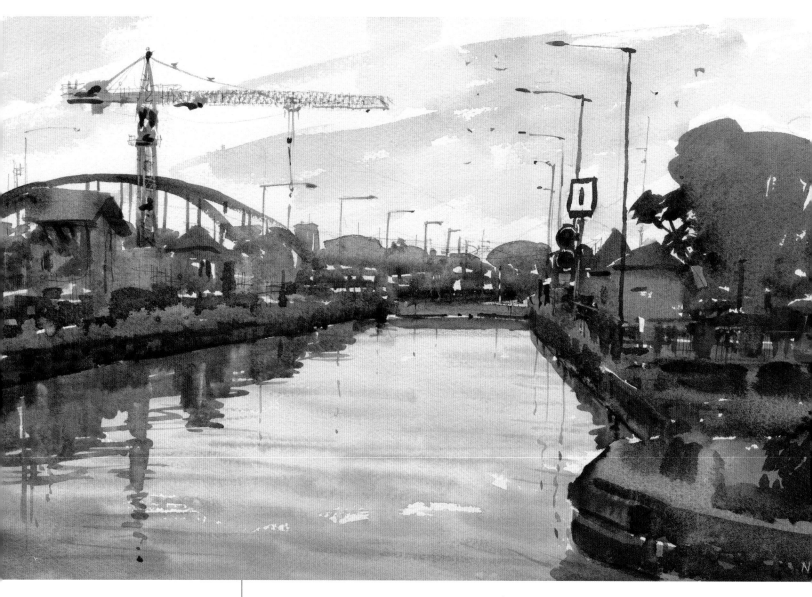

WATERGATE ON DORTMUND-EMS CANAL, MUENSTER | DANIEL NAPP
Watercolor on 140-lb. (300gsm) cold-pressed Saunders Waterford
10¾" × 16" (27cm × 41cm)

It was a cold day in October, so I had to paint alla prima. Without
sunshine the subject was a bit flat, so the compensation of water for
reflections was crucial. Back at my studio I painted the surface of
the water from imagination. The texture was achieved by carefully
layering two washes. I started with a light wash of the reflected sky,
putting in some waves while it was still wet. After the paper had dried
completely, I painted the reflections of the buildings. To make them
look more realistic, I blurred the colors together.

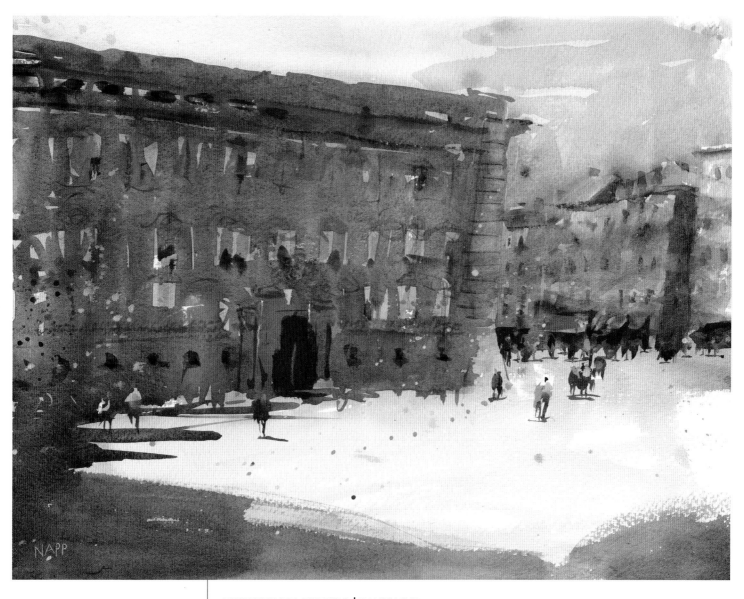

RESIDENZPLATZ, SALZBURG | DANIEL NAPP
Watercolor on 140-lb. (300gsm) cold-pressed Saunders Waterford
12½" × 17½" (32cm × 44cm)

The Residenzplatz is a crowded square in the heart of Salzburg,
Austria's historic Old Town. While I was painting there, it was hard
for me to answer all the tourists' questions while at the same time
struggling with the quick-drying washes. But fortunately, those
paintings sometimes turn out to be the best.

Visit artistsnetwork.com/splash16 to download free bonus wallpapers from the *Splash* series.

79

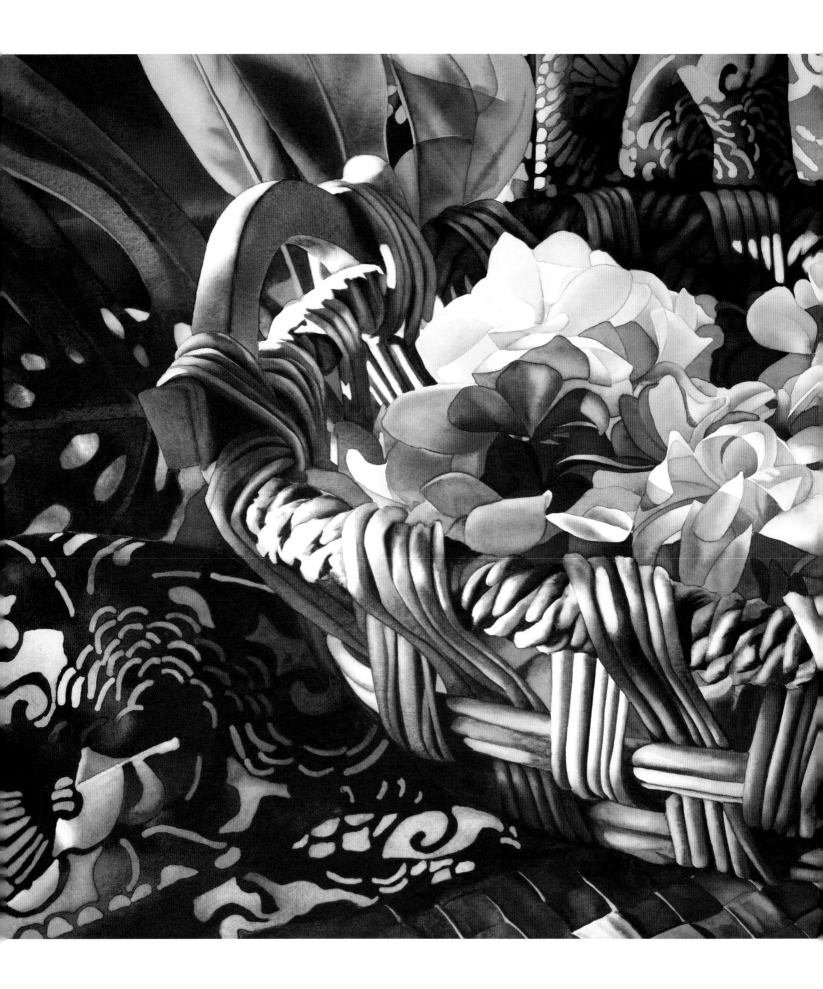

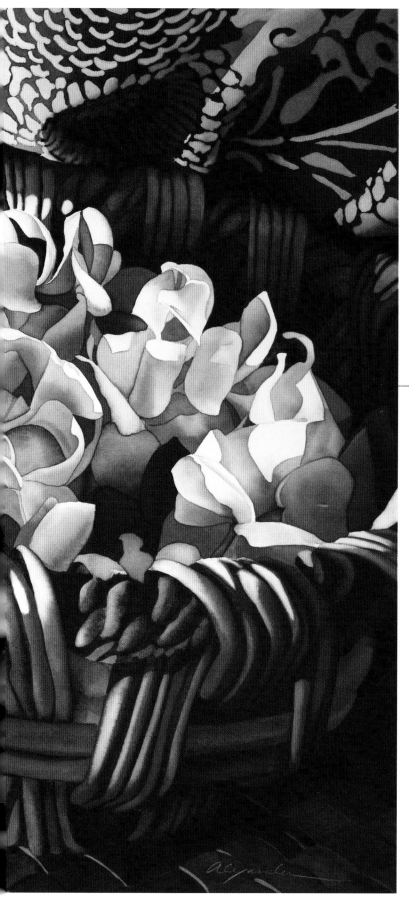

5

THE STILL LIFE

MAKANA HELE (FAREWELL GIFT) | KATHLEEN ALEXANDER
Transparent watercolor on 300-lb. (640gsm) cold-pressed Fabriano Artistico
26" × 39" (66cm × 99cm)

My photographed still life included my neighbor's basket, fabric purchased specifically as a prop and other items from around my house. I waited until the sun was low in the sky, creating interesting shadows and giving everything a golden glow. I painted the darkest areas first with sepia, softening edges as needed, and then added the midtones with Quinacridone Gold and Quinacridone Burnt Orange, among other colors. The fabric was painted primarily with indigo in varying values to create the folds and the pattern.

66

Don't be afraid to paint large!
(And use more paint!)

99

—Kathleen Alexander

Visit artistsnetwork.com/splash16 to download free bonus wallpapers from the *Splash* series.

81

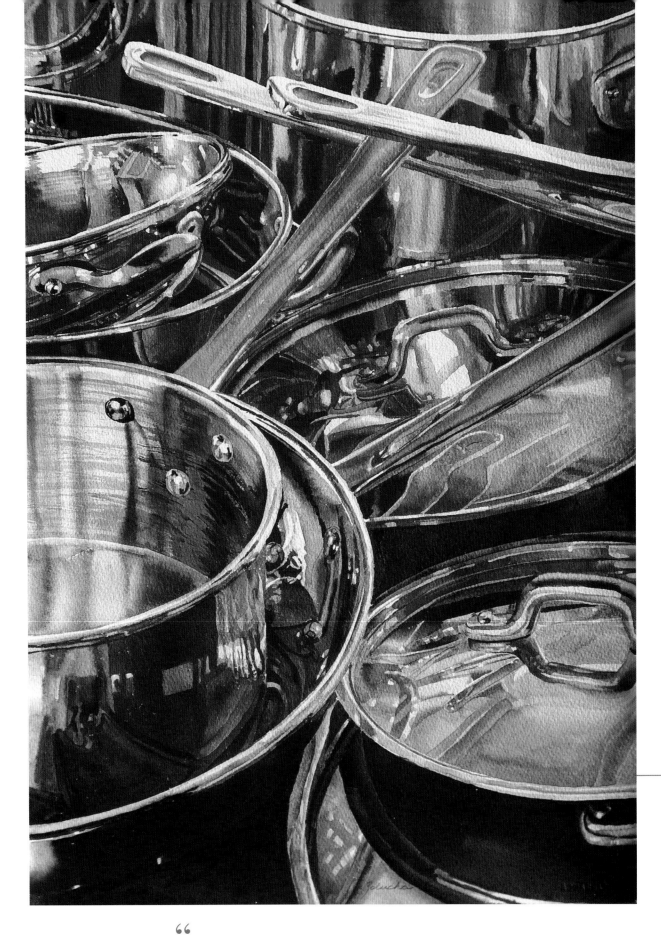

"

When painting a reflective object, the world
around it is also represented, creating an
image with a wide scope of information.

"

—Peggy Flora Zalucha

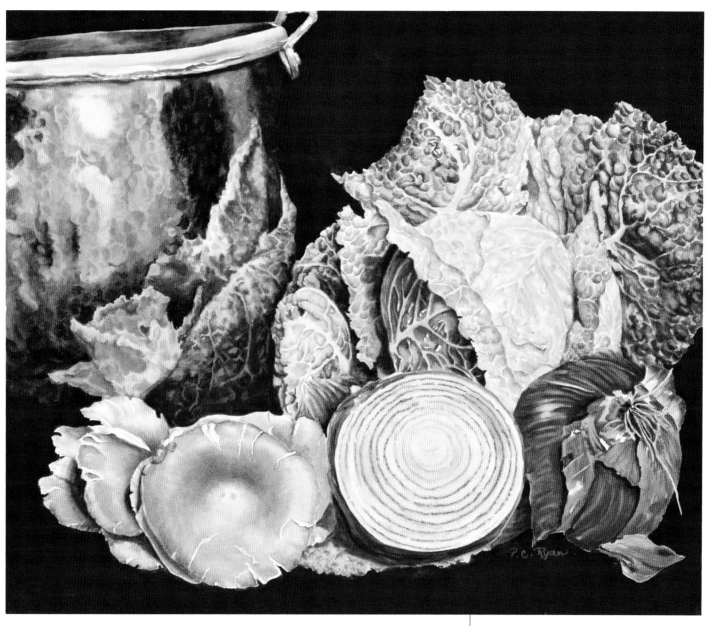

VEGAN FARE | PATRICIA RYAN
Watercolor on 300-lb. (640gsm) hot-pressed Arches
16" × 20" (41cm × 51cm)

COPPER POTS REFLECTED #9 | PEGGY FLORA ZALUCHA
Transparent watercolor on 140-lb. (300gsm) hot-pressed Arches
22½" × 15" (57cm × 38cm)

A camera was placed in my hand at a very early age, so I got used to looking at the world through lenses. My dad put a black-and-white darkroom in our basement, and I learned to interpret everything via values and two dimensions. Using photographs in my work distills everything down to those basics for me. When approaching a complicated subject with shiny texture, I examine the photo and mentally break it up into small manageable sections—a handle, a lid or a bolt. Painting these sections one at a time and side by side (like a puzzle) eventually creates a whole composition. Reflective, glossy surface texture is created by hard lines next to hard lines. The strength of contrasting areas, creating the illusion of polished metal, is my passion.

The many meals that I have prepared for my family and friends in my copper pot were the inspiration for this painting. I set up the still life, then took a picture and painted from the photo, as the vegetables would have started to wilt long before I could finish the painting. To my surprise, capturing the reflections of the vegetables in the surface of the pot wasn't as hard as painting the smooth texture of the mushroom. I wet the whole mushroom, then dropped the color around the middle and watched it spread. Building up the crinkly texture of the cabbage was great fun though it took many layers of paint, starting with the lightest and building to the darker greens.

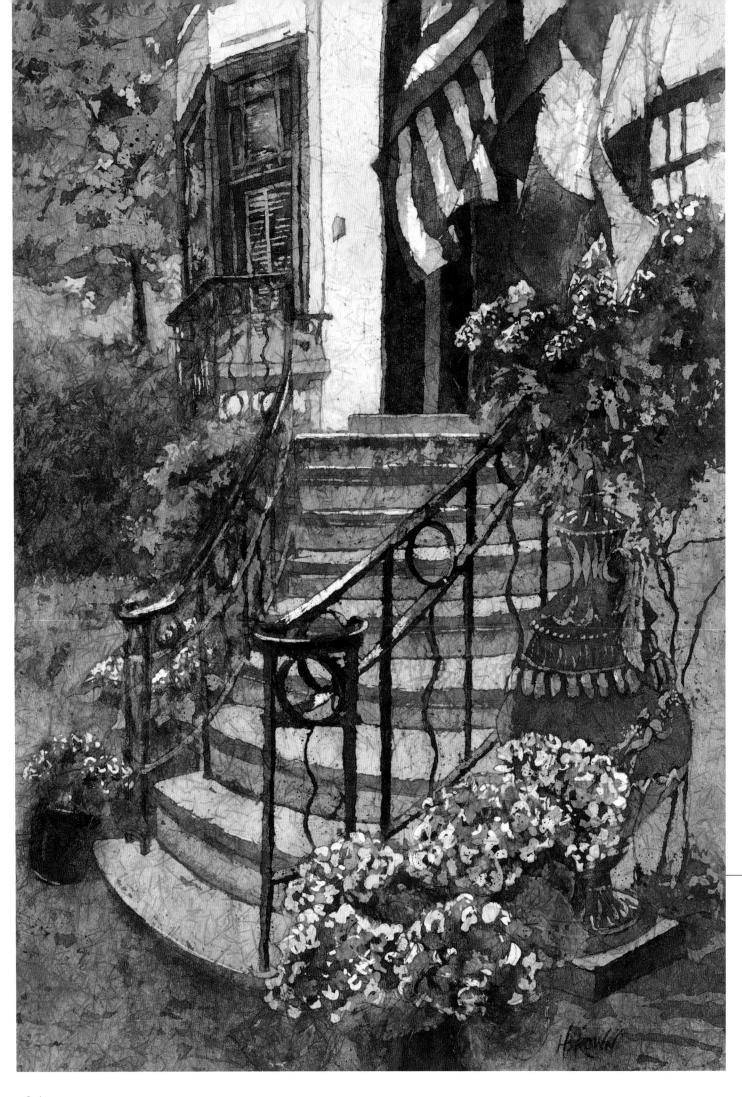

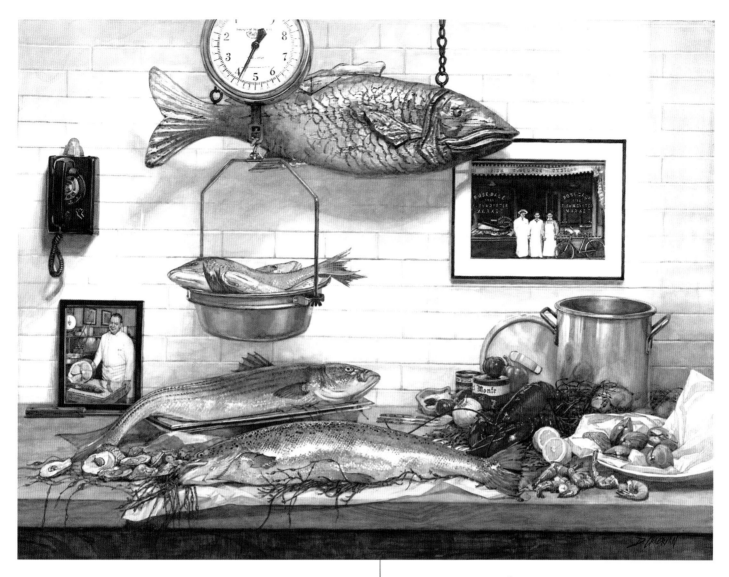

Textures reveal what
time does to an object
... telling the story of
its life.

—Deborah L. Chabrian

ROSEDALE FISH MARKET | DEBORAH L. CHABRIAN
Watercolor on Strathmore Bristol board
24" × 33" (61cm × 84cm)

This painting was a commission for a man whose family owned a fish
market in New York City for nearly 100 years. He had a collection
of artifacts from the family business and wanted me to use them in
what I call a "personal narrative still life." I gathered all the items
together: the hand-carved wooden and gold-gilded fish sign, the fish
scale, photos of the market circa 1902 and 1970, along with pots,
phone and, yes, fish. My client delivered three boxes of fresh fish that
were typical of his family's market. I spent a day arranging the still
life in my kitchen and taking numerous photos. This painting had
an incredible variety of textures to explore: the cracked and peeling
paint of the sign, the shimmer of the fish, the subtle reflections in the
soup pot and the flat quality of the old black-and-white photos. I am
inspired to paint personal themes and complicated textures.

CURB APPEAL | HELEN BROWN
Transparent watercolor batik on rice paper
22" × 15" (56cm × 38cm)

The stately, historic homes of Savannah, Georgia, recently caught my
interest. I took a photograph of this elegant home, hoping to express
its character using rice paper and watercolor in my Oregon studio.
The rice paper is extremely absorbent, so when painting wet-into-wet,
I use molten wax as a resist. The rice paper works well for landscapes
and natural scenes, but I especially like the effect of its texture, which
softens the man-made surfaces of buildings and urban scenes.

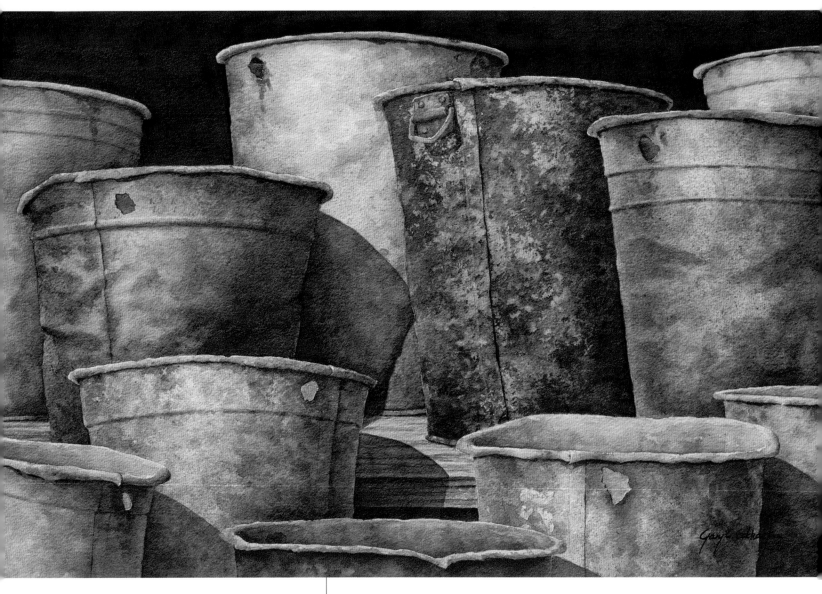

BUCKETS 5 | GARY C. ECKHART
Transparent watercolor on 300-lb. (640gsm) cold-pressed Saunders Waterford
18" × 28" (46cm × 71cm)

The original maple sap bucket was discovered under brush while
clearing land to build my house, studio and gallery. Further searching
uncovered additional buckets of various sizes, shapes and degrees of
deterioration. Immediately the question arose of how to capture the
enormous range of textures and the multiplicity of colors on paper.
Experiments with various means of paint application and removal,
along with countless color and value studies, ensued. During the
painting, a combination of staining and nonstaining pigments was
applied with plastic wrap, terry cloth, oil painting brushes, kitchen
sponges, natural sponges, toothbrushes and my fingers. Spattering,
drybrush, sanding, scraping and masking were worked on wet and dry
surfaces. This is the fifth in a series of bucket paintings.

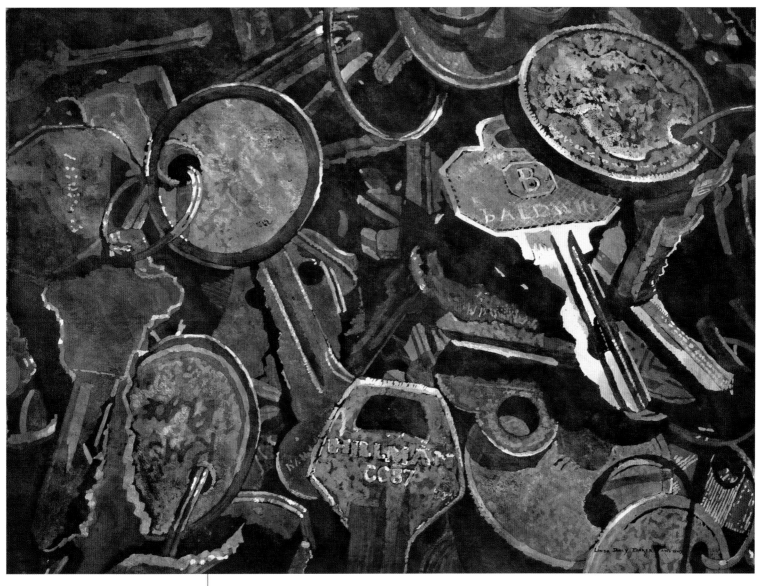

HIS KEYS | LINDA DALY BAKER
Transparent watercolor on 300-lb. (640gsm) cold-pressed Arches
22" × 30" (56cm × 76cm)

When my husband passed away unexpectedly, it was obvious to me that I couldn't keep all of his vehicles, buildings, storage units or even tool-boxes. So what I kept were all of his keys, realizing that he had touched each one every day. They were an intimate part of his private life I wanted to remember. In the creation of *His Keys*, I used the actual bowl of keys for my drawing. They sit on my coffee table. This painting is a series of alternate layers of drawing gum and paint. I start by saving my lights with masking and then pour, scumble, pipette and directly paint the layers until I get the richness and intensity that I desire. In this case I was seeking a depth of emotion, so I chose slightly cool colors.

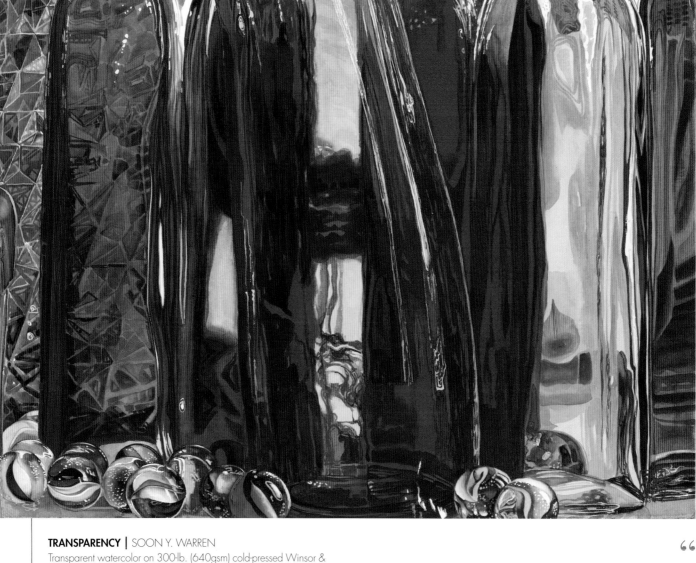

TRANSPARENCY | SOON Y. WARREN
Transparent watercolor on 300-lb. (640gsm) cold-pressed Winsor & Newton paper
22" × 30" (56cm × 76cm)

To depict luminous colored-glass bottles, I apply many layers with different colors, starting with the light shades and working to the darks. My process started with masking the highlights so I could apply layers of glazing using long, bold brushstrokes rather than timidly painting around the highlights. Next, to unify the field behind the individual bottles, I applied a light wash of Aureolin, excluding the area for the blue bottle. Then the many colorful layers were applied to give definition to each bottle, still maintaining their individual transparency. Finally, the exaggerated dark reflection was glazed. The representational marbles in the foreground set the scale and create a realistic contrast to the impressionistic bottles.

66

Each individual object must be examined carefully to determine its textural essence.

99

—Sally Baker

STILL LIFE WITH GREEN COLANDER | SALLY BAKER
Transparent watercolor on 140-lb. (300gsm) cold pressed Arches
17½" × 13" (44cm × 33cm)

I set up my still lifes and take multiple photographs to determine the composition. My drawing is done from both the setup and the photographic studies. To create the feel of round objects on a flat plane, each object must be studied individually. Is it shiny, rough, glossy, soft, etc.? To create the enameled colander, I used seven layers of Schminke May Green. I masked the white highlights and, after several layers, masked the rest of the highlights, allowing them to be midrange in value. The salt and pepper shakers (from my antique Japanese collection of several hundred) needed to be glossy. The sharp white highlights helped create this illusion. For the metal handles I put the darkest darks next to the lightest lights.

MUSICAL PEARS | JANE FREEMAN
Transparent watercolor on 300-lb. (640gsm) cold-pressed Arches
21" × 29" (53cm × 74cm)

Transparent watercolor is merely veils of color layered and manipulated to create the illusion of texture. In this painting I used lifting of color, drybrush and line work to create the feeling of weathered wood. This becomes a ballast of weight and visual contrast. I broke up the horizontal line of the wood by adding an old nail with a tag on it. It is a little area of interest that keeps the eye entertained. *Musical Pears* is a play on the game musical chairs. The frog has a look of surprise when a pear finds it has nothing to perch on and falls.

66

Telling a story can be the creative challenge that pushes you to use your imagination to create.

99

—Jane Freeman

90

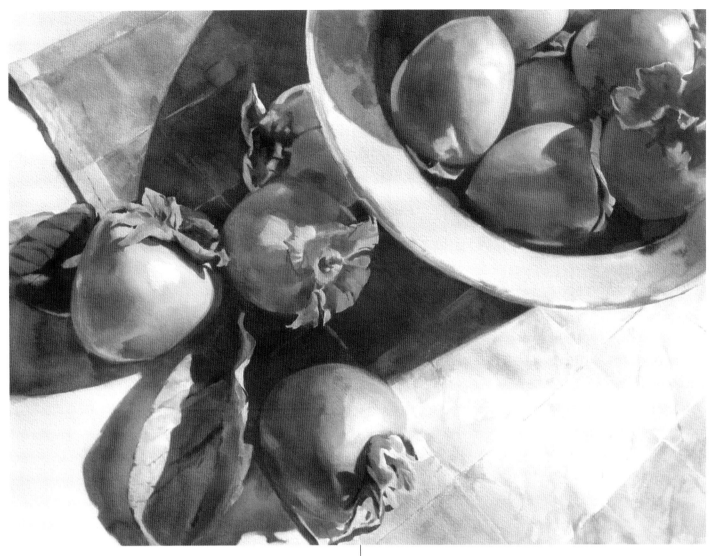

PERSIMMONS AT SUNRISE | LINDA ERFLE
Transparent watercolor on 140-lb. (300gsm) cold-pressed Arches
17" × 23" (43cm × 58cm)

After arranging and rearranging, then shooting multiple photos outdoors as the sun was low on the horizon, I selected this composition of persimmons with a ceramic bowl for my painting. By varying the amount of moisture I am able to create harder or softer edges to denote the textures of the objects that make up my painting. For example, I was careful to save the white of the paper for the sunlit reflections on the fruit. Because they have a smooth skin, these areas of light will have a harder edge to them than the sunlit fabric beneath.

CITRUS | IRENA ROMAN
Transparent watercolor on 140-lb. (300gsm) cold-pressed Arches
26" × 17" (66cm × 43cm)

Juxtaposition of objects enhances textural quality. In *Citrus* the glass dish looks glassier against the tablecloth, the tablecloth appears silkier next to the glass, and somehow the lemons feel more organic resting on the glass surface. Careful composition plays a key role. When setting up objects outdoors, I look for interesting patterns, highlights and shadows that help reveal each element's essence. Sunshine is the ultimate unifying factor. So much depends upon that brief moment when alchemy happens, turning the most ordinary objects into exquisite jewels.

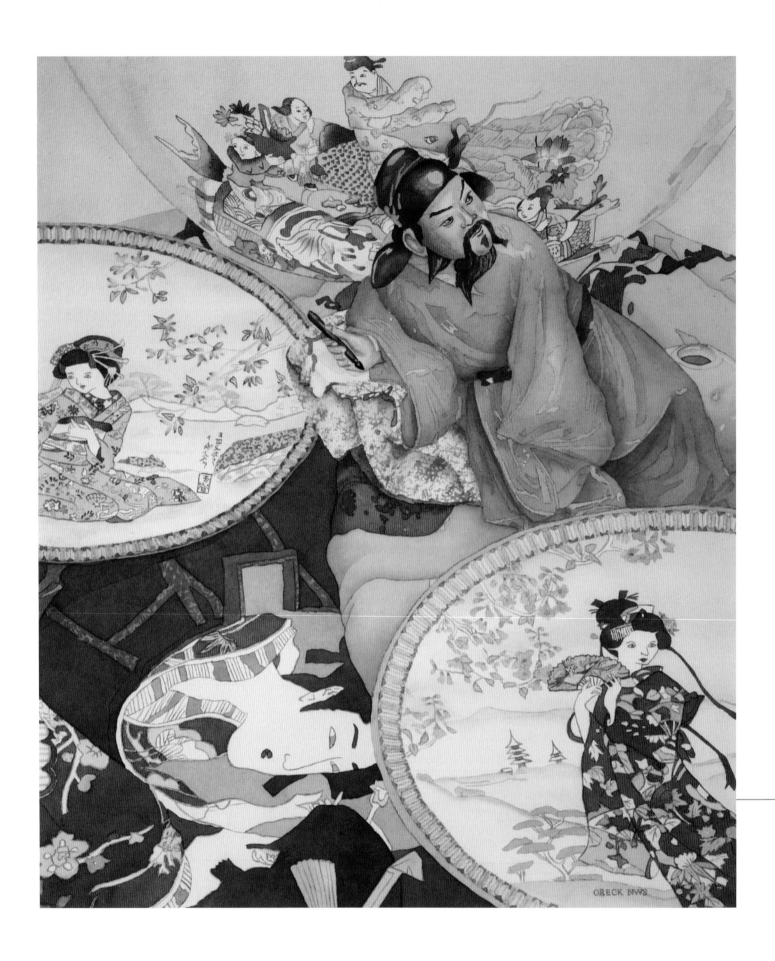

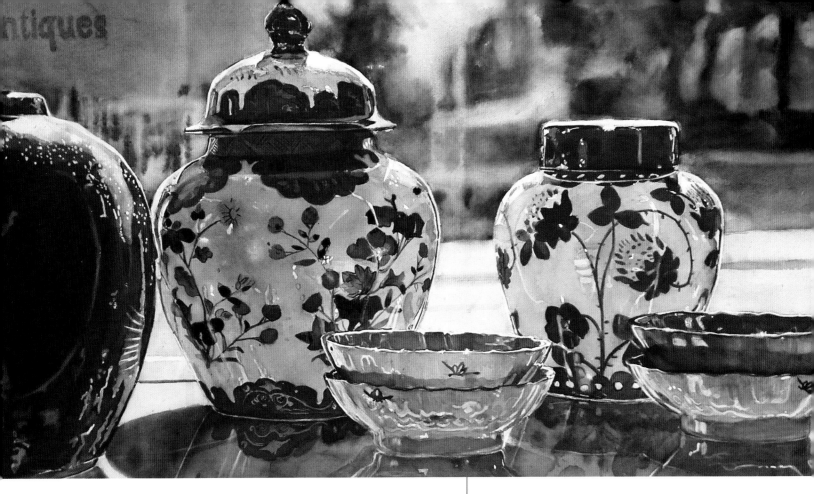

ANTIQUES | ANNE HIGHTOWER-PATTERSON
Watercolor and casein on 300-lb. (640gsm) cold-pressed Arches
22" × 38½" (56cm × 98cm)

I took this reference photo with my little Fuji point-and-shoot camera. Two aspects of this image attracted me: first, the smooth and shiny porcelain jars highlighted by the backlight coming through the window; second, the fuzzy blur of the background contrasted against the smooth jars. I drew the Chinese porcelains with careful detail and used liquid mask to preserve the bright highlights. I painted the shadows on the jars first, using complements for added glow. When dry, I began painting the patterns on the jars in a light-to-dark manner. For the background I preserved the clean edges of the jars with mask, then began dropping in the color for the fuzzy background. To soften the background even more, I scrubbed areas to increase the soft feel of the images across the street. One of the most useful tools for softening areas is to scrub them with an original Mr. Clean Magic Eraser.

THE ORIENT CAME TO ME | KAAREN ORECK
Transparent watercolor on 300-lb. (640gsm) cold-pressed Arches
21" × 18" (53cm × 46cm)

The objects in *The Orient Came to Me* were lovely gifts from friends and family who knew they might find their way into a painting. The majority of the painting was done using transparent washes. The texture under the statue's arm was applied during the final stages of the painting. I used masking tape and sealed the edges with Maskoid to protect the surrounding areas. I then dipped a sea sponge into a puddle of paint, blotted the excess off on a test paper and printed the pattern it created. The little red flowers on the upper plate were done with a ruling pen filled with paint. It disturbed the paper surface, causing the darker spots. I used a water-filled brush while the spots were still damp to fill in the rest of the petal.

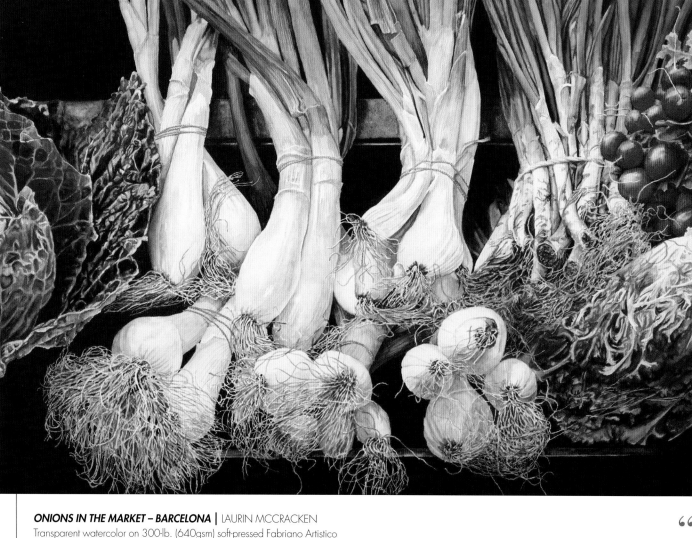

ONIONS IN THE MARKET – BARCELONA | LAURIN MCCRACKEN
Transparent watercolor on 300-lb. (640gsm) soft-pressed Fabriano Artistico
18" × 26" (46cm × 66cm)

An early-morning walk down the Rambla took me into the food market. The sun lying across the intricate textures of the root systems of the bunched onions, anchored by the strong textures of the cabbages at either end, captured my attention. I had no idea how challenging it was going to be to get the texture of these roots to look real. The contrast of the multiplicity of the root systems against the solid bodies of the calçots was the story I wanted to tell my audience.

66

The grand textures of the vegetables and the repetition of shapes seemed a promising watercolor subject.

99

— Laurin McCracken

66

In painting, as in life, sometimes an accident solves a problem.

99

—Judy Nunno

FOWL PLAY | JUDY NUNNO
Watercolor on 300-lb. (640gsm) cold-pressed Arches
29" × 22" (74cm × 56cm)

Fowl Play is one of a series that pairs crystal figurines with edible items. It depicts a variety of opposing textures: man-made vs. organic, translucent vs. opaque, hard vs. fleshy and smooth vs. bumpy. As I was setting up this still life, the crystal ducks kept sliding off the juicy melon, and I finally had to use toothpicks. Working from my photo, I did a detailed drawing and saved the whites with masking fluid. Then I began the tedious task of painting the crystal facets and the cantaloupe with layers of transparent watercolors. I was having difficulty creating the roughness of the netted rind of the melon until I removed my first attempt with a Magic Eraser and accidentally solved my problem. The paper was roughed up just enough to help simulate the texture of the rind when new paint was applied.

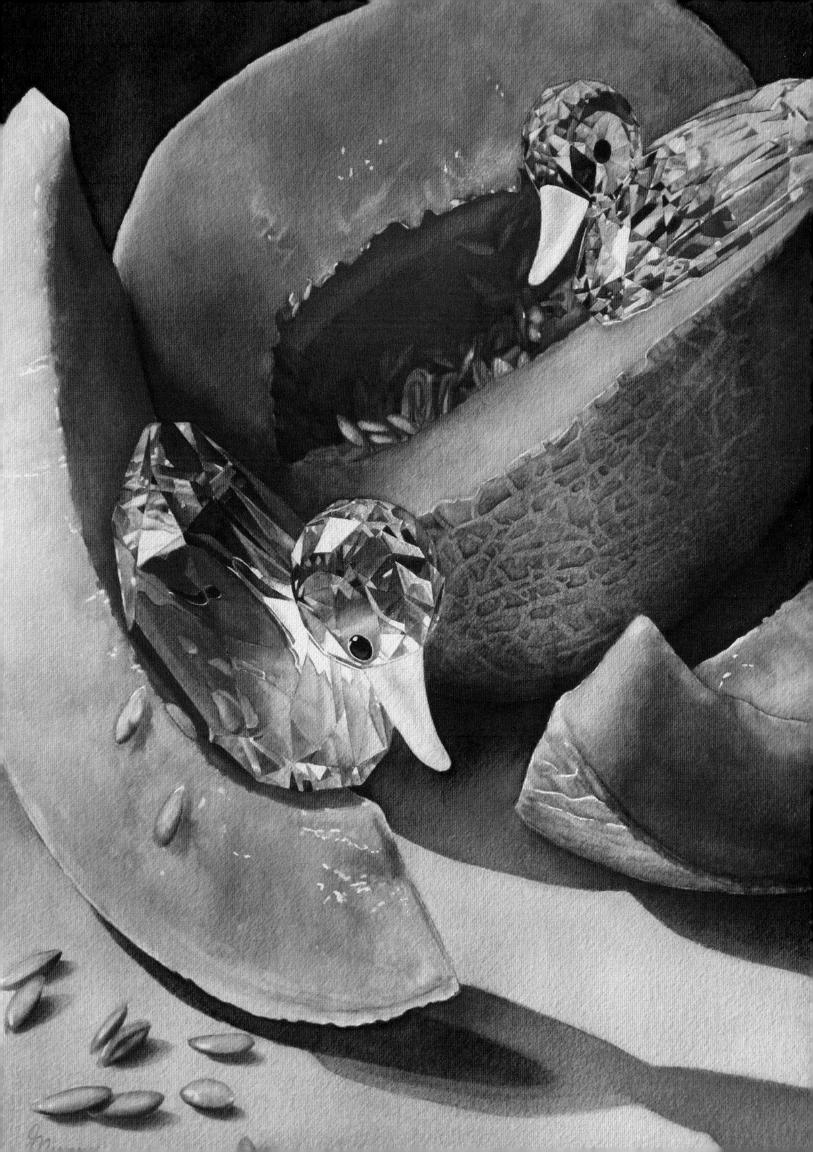

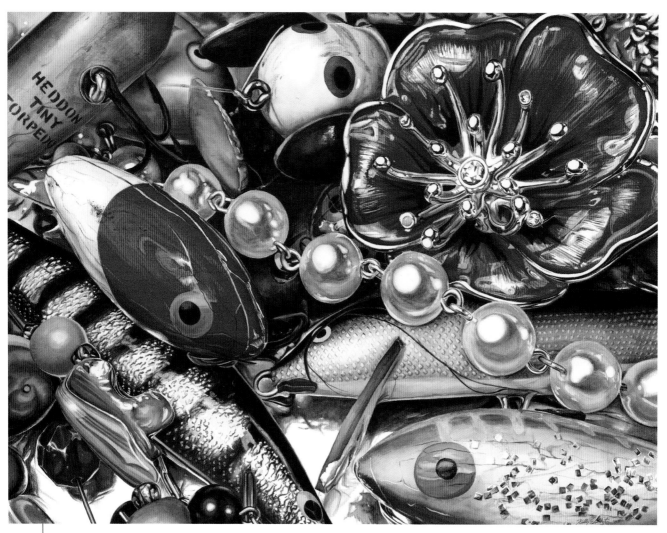

ALLURE | KELLY EDDINGTON
Transparent watercolor on 140-lb. (300gsm) cold-pressed Arches
21" × 29" (53cm × 74cm)

I remember being fascinated with my father's tackle box when I was a girl. Everything in it looked like adorable little toys. Dangerous toys! Last summer Dad gave me some of those old lures for this still life. I was charmed by the cracked and glittery paint jobs. I added some of my flashiest jewelry for contrast and for how it resembles bubbles and underwater plants. The tiger-striped lure in the lower-left corner is as big as my forearm and took an entire day to paint. I used spots of masking fluid to preserve the lumpy, raised texture as I glazed over it repeatedly, and later I fine-tuned each bump individually. But honestly, as is the case with some of my best work, I have no real idea of how I managed to paint this!

66

It is nothing for me to have at least one hundred hours in a painting, so it is necessary to work on at least three pieces at one time. This helps me to slow down and avoid fast-stroke mistakes.

99

—Cindy Brabec-King

IVORY DICE | CINDY BRABEC-KING
Transparent watercolor on 300-lb. (640gsm) rough-pressed Arches
30" × 22" (76cm × 56cm)

Replicating realism is exciting and rewarding but, with the endless possibilities, careful planning is needed. Balance between busy and eye-rest areas is important. Focusing on three, five or seven textures helps the development. The pattern of the stitches in *Ivory Dice* was created basically by drawing repetitive strokes using a variety of small round brushes, working the layers from light to dark. I painted around light areas for the design of the ceramic dishes. Then I washed over it with grays to blur the blue line work and give the appearance of glazed pottery. Texturing the red fabric was primarily from the paint itself: mixing Alizarin Crimson with Burnt Sienna causes separation and a grainy effect.

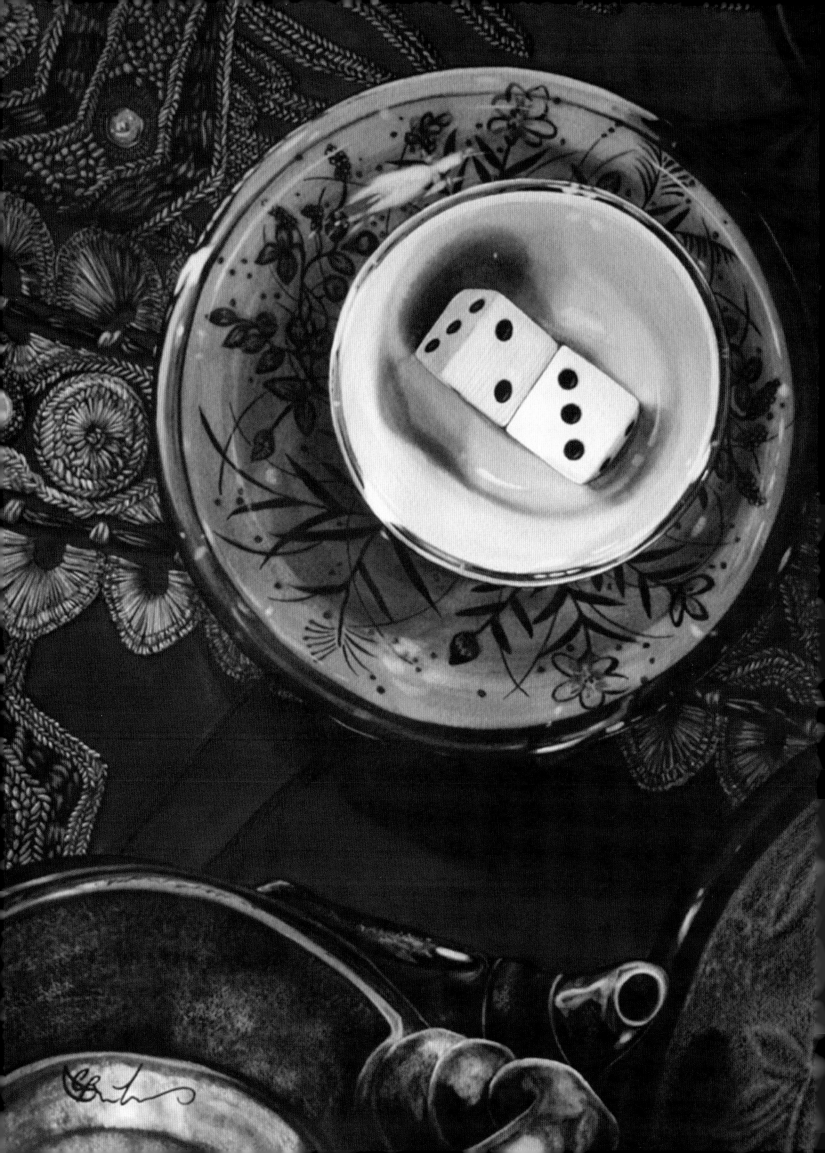

ARABESQUE | CHRIS BECK
Transparent watercolor on 140-lb. (300gsm) cold-pressed
Winsor & Newton
9" × 10½" (23cm × 27cm)

To bring my whimsical salt shakers to life, I saved the brightest parts of the highlights with masking fluid and finished by gently scrubbing and blending the margins to create believable shine and reflections. I also lifted color from fully painted areas for more subtle highlights to reinforce the three-dimensionality of the forms. Placing them against a very flat, patterned background enhanced the illusion of glossiness. My resource photo was quite different from the finished painting: The birds were actually bland looking, and the best light happened to be in my laundry room! I captured the shine and reflections in my photo and invented the rest.

GIN UP THE BLUES | KAY STERN
Transparent watercolor on 300-lb. (640gsm) hot-pressed Fabriano Artistico
28" × 19" (71cm × 48cm)

The challenge was to produce a painting in a blue color with a happy mood, avoiding coldness to the blues. The triangular composition was set up underneath a sun-filled skylight on a white marble top that diffused and warmed the light. To establish a warm, sunlit blue effect, analogous colors were used with each complement: Phthalo Blue, Cobalt Blue, Ultramarine Blue and Ultramarine Violet. The texture is shown along the edges as smooth, hard and shiny surfaces in contrast to the foreground of loose and lost edges. Many glazes were incorporated all over the painting. Some yellows, oranges and reds were intermingled to add some warmth.

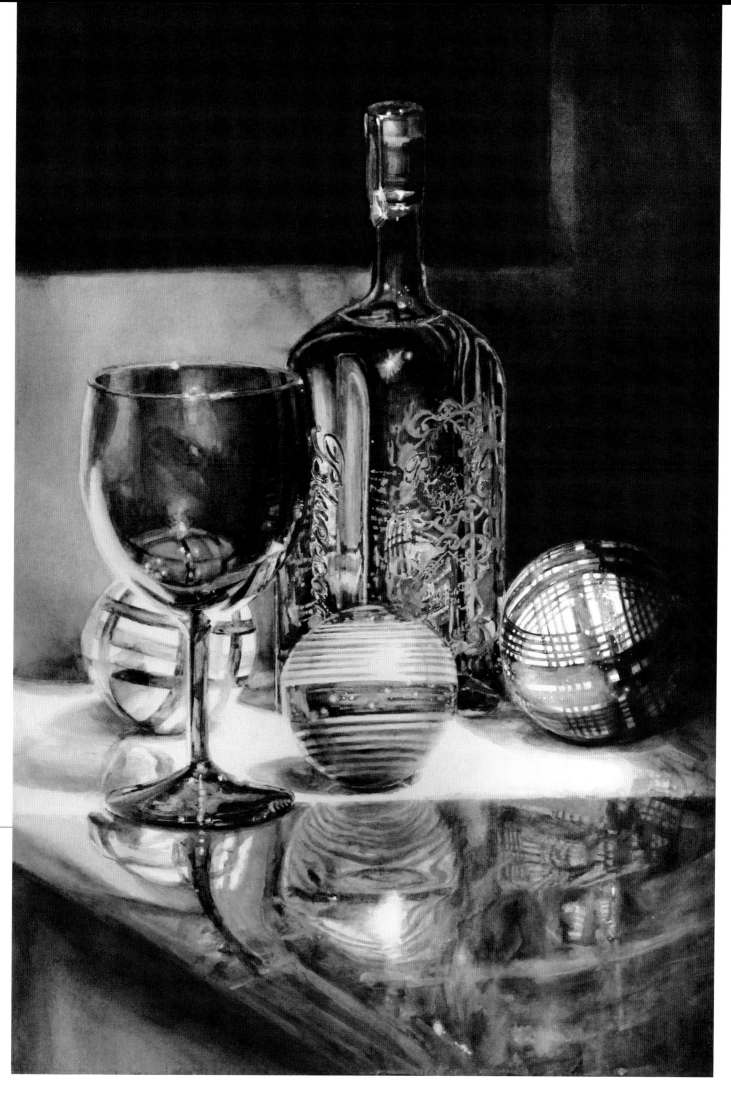

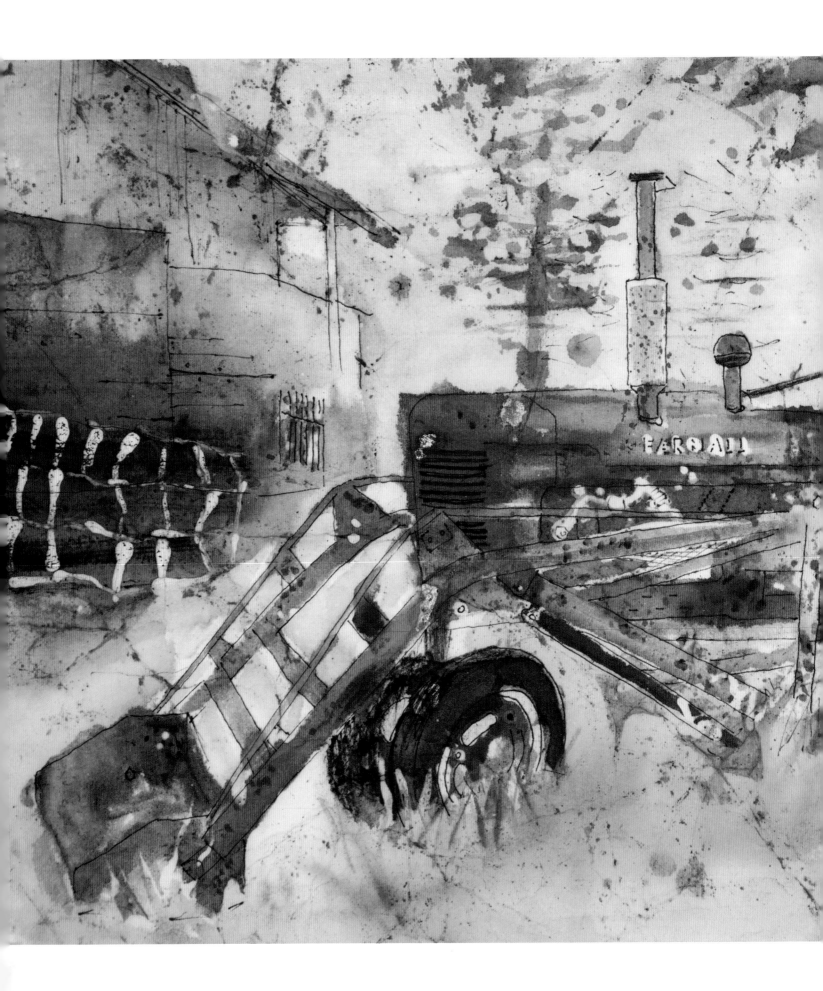

6

MACHINES AND CONTRAPTIONS

RETIRED | ANTERPREET NEKI
Watercolor batik with ink accents on Japanese rice paper
10" × 14" (25cm × 36cm)

I have an affinity toward old, abandoned machines. After a lifetime of hard work, they are retired without pension or benefits. This rusty tractor found next to an Ohio barn was painted in studio from my photographs and sketches. I drew the outline in permanent black ink and subsequently laid light to dark washes. Each wash was allowed to dry completely and then saved with molten wax. Eventually when the whole paper was covered with wax, it was crumpled and then laid out flat. One last dark wash was pushed into the cracks of wax before the paper was placed between sheets of newspaper and ironed to remove the wax.

"

Watercolor batik on rice paper works well for weathered texture with its vibrant, yet soft finish.

"

—Anterpreet Neki

Visit artistsnetwork.com/splash16 to download free bonus wallpapers from the *Splash* series.

101

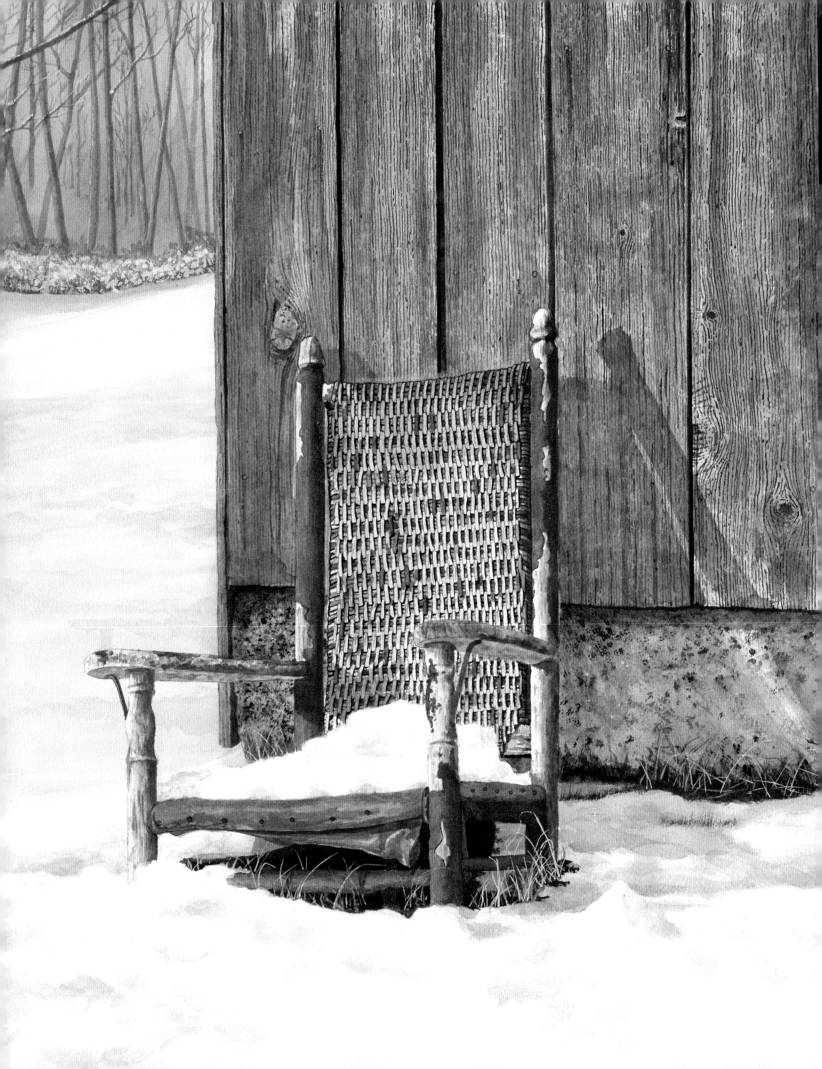

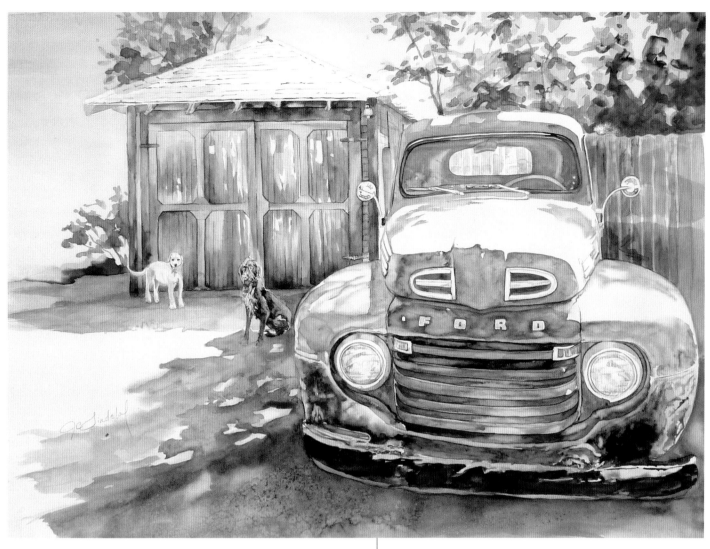

GUARD DOGS | JC LINDELOF
Transparent watercolor on 140-lb. (300gsm) hot-pressed Fabriano
15" × 20" (38cm × 51cm)

I've been painting a series of dogs and trucks. On my many walks old trucks often drive by. Most trucks are well worn and well loved, and with every truck there is a dog. I suppose the man never gives up on the truck, and his beloved dog never gives up on the man. This worn Ford truck with its rust and old paint was fun to paint, using hard and soft lines with wet washes. The dogs had just wandered out of the alley and seemed to be guarding this prized truck from me. I photograph these scenes whenever I see them to save for painting reference.

BETTER DAYS – WINTER | TED HEAD
Transparent watercolor on 300-lb. (640gsm) Arches
24" × 18" (61cm × 46cm)

While traveling, my wife spotted this chair in the snow and told me to pull over. I fell in love with the textures and have since painted the scene in the other three seasons using the photo and my imagination. For the intricate webbing and the lines on the wood I used an Incredible Nib fiber pen dipped in watercolor. It started off with a fine point and eventually wore down where I could press and lift to give variations in the wood grain. I masked the blades of grass using a ruling pen. The pen can adjust from hairline to thick, and the liquid masking wipes right off it. Because of the strong light source, all the textures have obvious shadows. Even the chipped paint needed shadows to complete the illusion.

Visit artistsnetwork.com/splash16 to download free bonus wallpapers from the *Splash* series.

AMAZON PACKAGE SENT BY ROBERT | GEOFFREY MCCORMACK
Transparent watercolor and gouache on 140-lb. (300gsm)
cold-pressed Arches
18" × 24" (46cm × 61cm)

What are the cues a viewer needs to immediately see cardboard? I
thought the corrugated texture would tell all one needed. But with
experimentation it was clear that color was most important, followed
by shape and folds. Beginning *Amazon Package Sent By Robert*
I wanted to contrast the background's small-grain texture with
the large, rhythmic texture of the box's labeling. So the cardboard
needed to be a medium, subdued texture. I masked the background
and stained it with a kitchen sponge, building layers until I liked
the saturation. Then using a piece of cardboard with exposed
corrugations, I stamped texture on the painting's cardboard surface.
When the stamped texture dried, I sponged more cardboard color
over it to soften it. To finish the painting I relied on my years as an
illustrator to do the labels and box lettering.

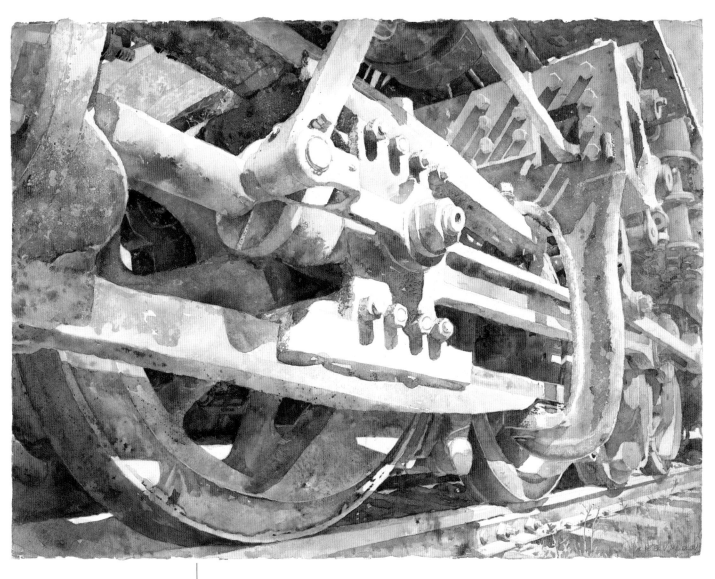

ENGINE 8380-CROSSHEAD | PETER V. JABLOKOW
Transparent watercolor on 300-lb. (640gsm) hot-pressed Arches
22" × 30" (56m × 76cm)

Texture expresses the weathered richness of age. I start by photographing from numerous perspectives and distances to understand all details of my subject, then pick a composition that grabs me. Then comes a detailed pencil drawing. To start painting, I mask a section with drafting tape and cut the exact shape with a craft knife. In fluid areas, such as the left foreground wheel, various colors are splattered with a toothbrush until the paper is saturated, then tilted this way and that, causing the paint to run together. In more-textured areas, such as the upper left, masking fluid is splattered with a toothbrush (or mouth atomizer) followed by the splattering of paint on top. When dry, the mask is rubbed off and re-splattered, repeating as much as necessary. Lost whites are pulled out by masking an area and scrubbing.

Visit artistsnetwork.com/splash16 to download free bonus wallpapers from the *Splash* series.

105

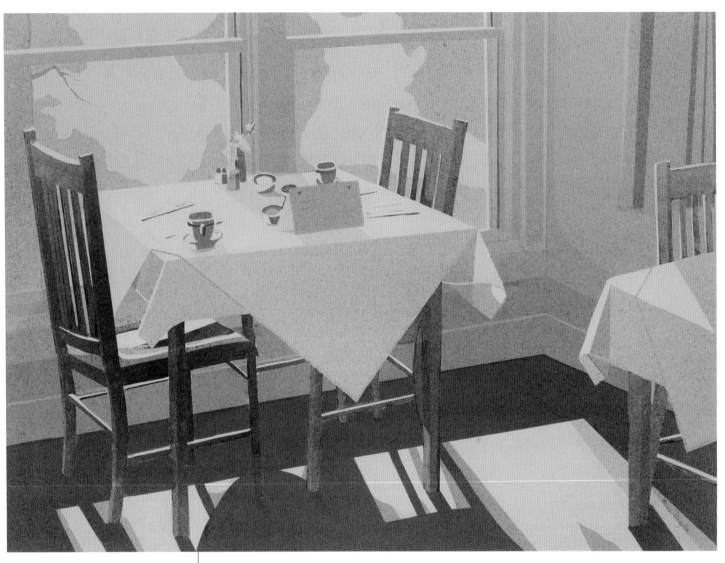

SET FOR BREAKFAST | MINA ANGELOS
Transparent watercolor on stretched 140-lb. (300gsm) hot-pressed Arches
20" × 27" (51cm × 69cm)

Morning light streaming through the windows was my photographic
inspiration. I felt that a mouth atomizer would best capture the subtle
light-filled colors with a texture of tiny dots. The shapes and values
are worked out with 5B graphite on tracing paper, which is taped to a
table. The backing of frisket film is removed, and the sticky side is laid
over the tracing paper. The graphite lines are burnished with a spoon.
Now the image is on the film, which is then placed over stretched
hot-pressed watercolor paper. Working from dark to light, shapes are
cut out with a no. 11 craft knife. Diluted watercolor paint is blown on
the paper. With each succeeding value cut, the previously cut areas
become darker. The paper is covered with frisket film a second time to
preserve the warm colors while adding color for the blue shapes.

Celebrate! Music is what feelings sound like, and paintings are what feelings look like.

”

—Judi Betts

RENDEZVOUS | JUDI BETTS
Watercolor on 140-lb. (300gsm) cold-pressed Arches
20" × 30" (51cm × 76cm)

As I paint I hear music and feel the rhythm of the various shapes, colors and textures. Each color and shape emits a unique sound. *Rendezvous'* large, magical foliage shapes create a tempo that feels like a happy clarinet or flute. The drama of irregular tilted patterns, as seen in the shadows, sounds like and resembles a xylophone. The dense, dark green and deep purple shutters echo resonating tuba notes. The open spaces in the chairs produce a clearer sound than the tightly woven areas. I paint as an energetic symphony conductor, orchestrating order among the sounds, textures and vibrations to create a melodious composition. This pulsating piece was painted in my studio from hundreds of Southern porch drawings and photographs of wicker chairs.

Visit artistsnetwork.com/splash16 to download free bonus wallpapers from the *Splash* series.

107

THE BRUSH OFF | BARBARA OLSEN
Transparent watercolor on 140-lb. (300gsm) cold-pressed Arches
6½" × 9½" (17cm × 24cm)

Looking around for inspiration, I glanced down and saw my
brushes lying in disarray in their holder. The rise and fall of the
brushes' heights, combined with their apparently random lay-
out, seemed to mimic the rich, undulating texture of our human
relationships. Like the brushes, some of the people in our lives
we'll reach for again and again, others will be there when we
need them, while still others will be lost along the way. Taking
advantage of the effects of granulating pigments, I applied
Ultramarine Blue to my paper, dropped in Quinacridone Burnt
Orange and let the colors mingle. Mixing mostly neutrals,
loosely applied, for the holder and brushes, I then added bright
colors for contrast, pencil marks for character and spatter for
a sense of whimsy. In keeping with the relationship theme, I
titled the painting *The Brush Off*.

66

Take advantage of the inherent nature
of your pigments to complement the
story you want to tell.

99

—Barbara Olsen

VILLA D'ESTREES | VIE DUNN-HARR "VISAGE"
Watercolor collage on 140-lb. (300gsm) cold-pressed Arches
14" × 12" (36cm × 30cm)

This painting began without thought to its outcome. It was all about
exploration of color, shape and texture and the "what-ifs." There
came a moment when I knew the collage needed something more.
As I considered the possibilities, I spotted a paper coaster in my
studio from the Villa d'Estrees where I had recently stayed in Paris.
I separated the layers of the coaster and strategically applied them
into my collage. The circular shapes became a motif I built on. The
walk down memory lane began, and the painting became more per-
sonal. The layered textured papers, the somber and vibrant spaces,
the fluid movement all started to represent the many facets of the
Paris I fell in love with.

Visit artistsnetwork.com/splash16 to download free bonus wallpapers from the *Splash* series.

109

The best way to paint textures is to know your subject. Feel it, climb around it, get scratched by it, know it, then paint it.

—Robert Highsmith

NARROW GAUGE | ROBERT HIGHSMITH
Transparent watercolor on 300-lb. (640gsm) cold-pressed Arches
21" × 30" (53cm × 76cm)

At a visit to the train museum in Antonito, Colorado, I found these wonderful, old weathered cars. For this composition I used parts of two separate cars in order to contrast the smooth, yellow-painted siding with the very weathered wood of the cattle car. Unlike in my landscape work, precise drawing was crucial here, and I used T-squares, ruler and triangles. First, I applied liquid frisket in the text areas on the cattle car and for the background snow. Next, washes for the sky and background landscape. The texturing of the wood was done by layering and drybrush. I used house-painter type bristle brushes for most of the work. To keep the straight lines of the slats, I used masking tape. Most of the detail comes in the last stages. There is far less detail than you would think; a stroke here and a stroke there give the illusion.

REVOLUTIONS OF FIVE | L. S. ELDRIDGE
Transparent watercolor on 300-lb. (640gsm) cold-pressed Arches
28" × 19" (71cm × 48cm)

I ran across this relic—revolutionary in its era—while surveying flood damage. Covered in debris, its character was evident even in the worn patterns on the distressed and flaking bodywork. The intermittent sun revealed a toilsome history. Even though this tired iron has surrendered its usefulness, its dignity endures. In order to depict the flaking layers, I covered an organic interlocking shape with masking fluid. I then painted the area with every shade of yellow on my palette and let it dry. I continued layering in this manner, adding Burnt Sienna, Brown Madder and Indigo. To complete this section, I lightly tapped paint from my brush and used darker values on some of the edges for depth and interest.

Visit artistsnetwork.com/splash16 to download free bonus wallpapers from the *Splash* series.

111

HOG HEAVEN | MONIQUE WOLFE
Transparent watercolor on 140-lb. (300gsm) cold-pressed Arches
18" × 22" (46cm × 56cm)

A 1954 French Motobécane was a bit of a departure for me, so I started with a couple of detailed sketches using gray markers to establish value patterns and to help me decide on a basic plan for this painting. The wheel spokes were of particular interest to me, and I needed to work out whether to show them as negative or positive shapes. I painted the helmet first because it needed more water to depict the smooth surface, and I wanted to avoid this bleeding into previously painted areas. A drier paint application simulates the worn leather seat, with some moist brushwork in places for softer transitions. The reflective chrome of the headlight is comprised of many small shapes and colors, each kept within the appropriate value range. The final touch came from my dad when he named it *Hog Heaven*.

DASH TO THE PAST | CHERYLE LOWE
Transparent watercolor on 300-lb. (640gsm) cold-pressed paper
17" × 24" (43cm × 61cm)

While I was visiting a collection of classic cars, the elegant details of
their design inspired me to do a painting. I took several photographs,
trying to capture the best light and strongest composition. *Dash to
the Past* is a 1936 Cadillac. It is the first of four paintings in a series
of chrome and reflections. Using transparent watercolor, I layered
several colors to build up rich lively darks, creating strong contrasts
to achieve a dramatic look. I exaggerated the colors that reflect off the
smooth texture of the chrome. I used small circular brushstrokes to
create soft edges that blend into the white of the paper. It took about
twelve weeks to complete this painting.

Visit artistsnetwork.com/splash16 to download free bonus wallpapers from the *Splash* series.

113

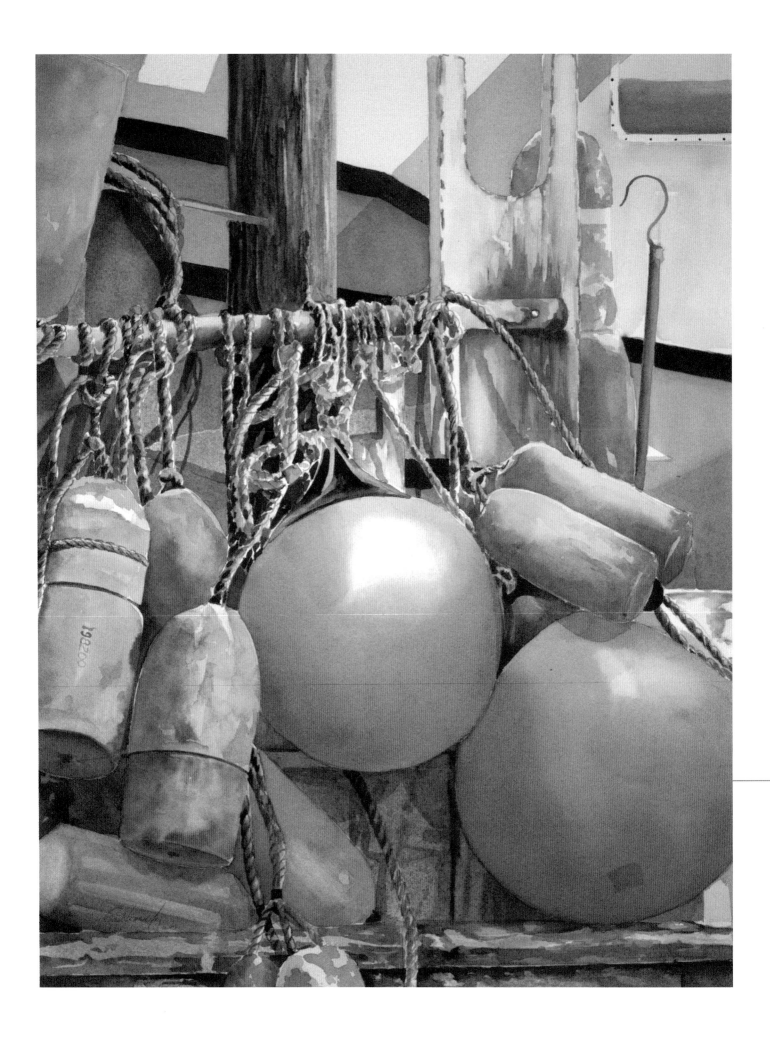

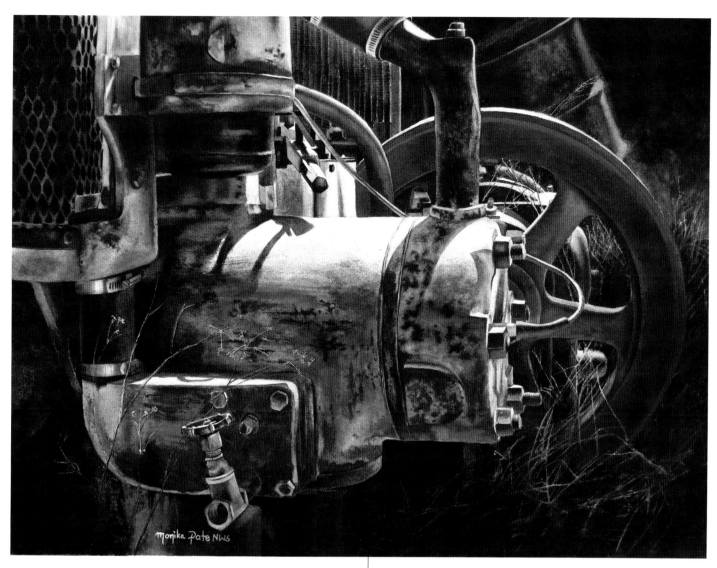

ABANDONED | MONIKA PATE
Transparent watercolor on 300-lb. (640gsm) rough Arches
21" × 29" (53cm × 74cm)

I have always been fascinated with texture and light, constantly searching my surroundings for inspiration. While driving, I spotted this rusty engine in an outdoor repair shop. After explaining to the surprised owner my intense interest, I snapped photo after photo from various angles. The rusty engine with chipped, bright blue paint nestled against the grass and weeds provided plenty of textures to explore. The bright sunshine made the textures even more pronounced. I painted this engine by applying multiple layers of transparent watercolor, working from light to dark and dark to light. The rough surface of the watercolor paper enhanced the texture of the rusty metal.

ALL TIED UP | CATHERINE HEARDING
Transparent watercolor on 140-lb. (300gsm) cold-pressed Arches
28" × 20" (71cm × 51cm)

I saw this group of ropes and buoys tied to a fishing boat in Gloucester, Massachusetts, and was intrigued by the repetition of shapes and colors and the abstract sense of line. For the smooth surface of the red buoys, I worked wet-into-wet, adding colors and letting them blend. The rough wood post was scraped with a palette knife, and rust was created by dropping several colors into a wet surface. After the objects were painted, I realized that some elements needed to move back in space. I covered all foreground areas, mixed three primary colors and used an atomizer to apply paint to background areas. The neutral color helped push these elements into the background.

Visit artistsnetwork.com/splash16 to download free bonus wallpapers from the *Splash* series.

115

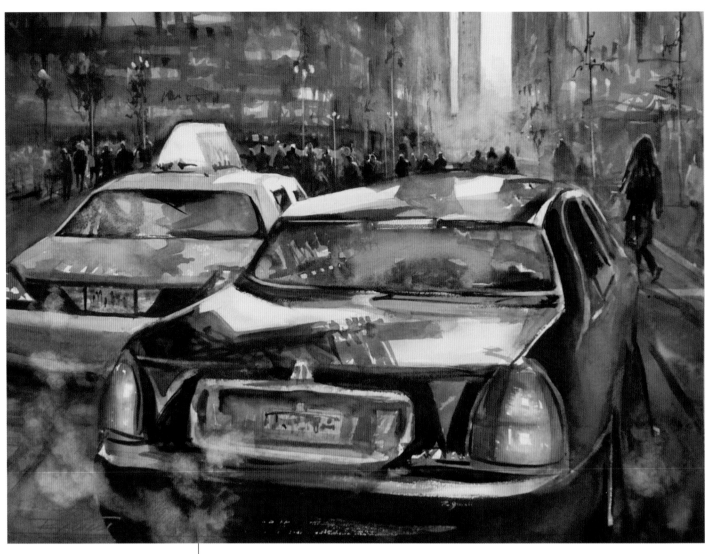

TAXI! | RUSSELL JEWELL
Watercolor on Arches watercolor board
17" × 23" (43cm × 58cm)

Taxi! is an exploration of atmospheric textures offered by the constant flux of city life. The composition comes from multiple photographs I took during a stroll around New York City. The painting reads from the glowing plastic dome of the hard-edged yellow taxi guiding the viewer toward the upper-right negative space, strategically placed according to the rule of thirds. This negative vertical gives way to soft smoke and smog accentuated by the New Yorkers' high contrasting dark winter clothing. From the crowd, the eye gently cascades down the reflective black sedan toward its glowing rear taillights. It is now the foreground exhaust that wafts the eye back to the yellow taxi, and the journey begins anew.

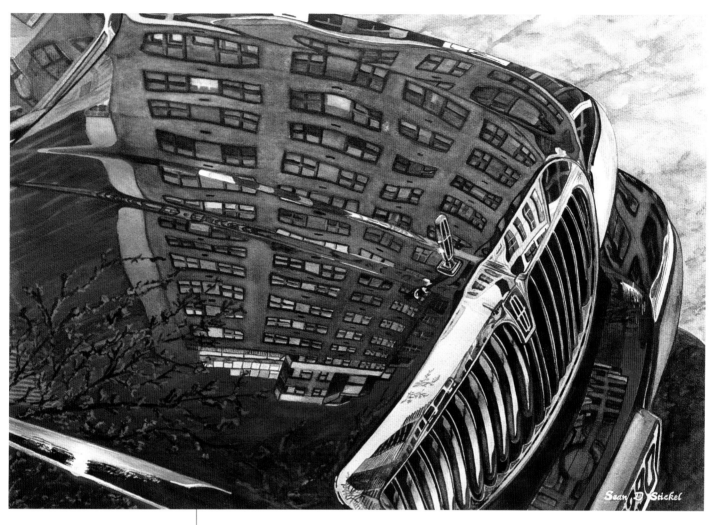

REFLECTIONS OF THE HOOD | SEAN D. STICKEL
Transparent watercolor on 180-lb. (380gsm) cold-pressed Arches
14" × 20" (36cm × 51cm)

The hot, smooth surface of a car hood as it transfers its heat to your fingers; the coarse ridges of a brick as you run your hand along a brick building. These are familiar textures I portray in *Reflections of the Hood*. I started with a pencil drawing inspired by a New York City photograph, then used a number of washes to acquire the desired depth of colors. I added darks to contrast and create details. The textures depicted in this painting include cement, glass, brick and reflective chrome. My eye has always been drawn to reflections, an interest I developed from my father, David Stickel, also featured in this book (see page 66). He is known as the Artist of Reflection. I have a fantastic teacher.

Visit artistsnetwork.com/splash16 to download free bonus wallpapers from the *Splash* series.

117

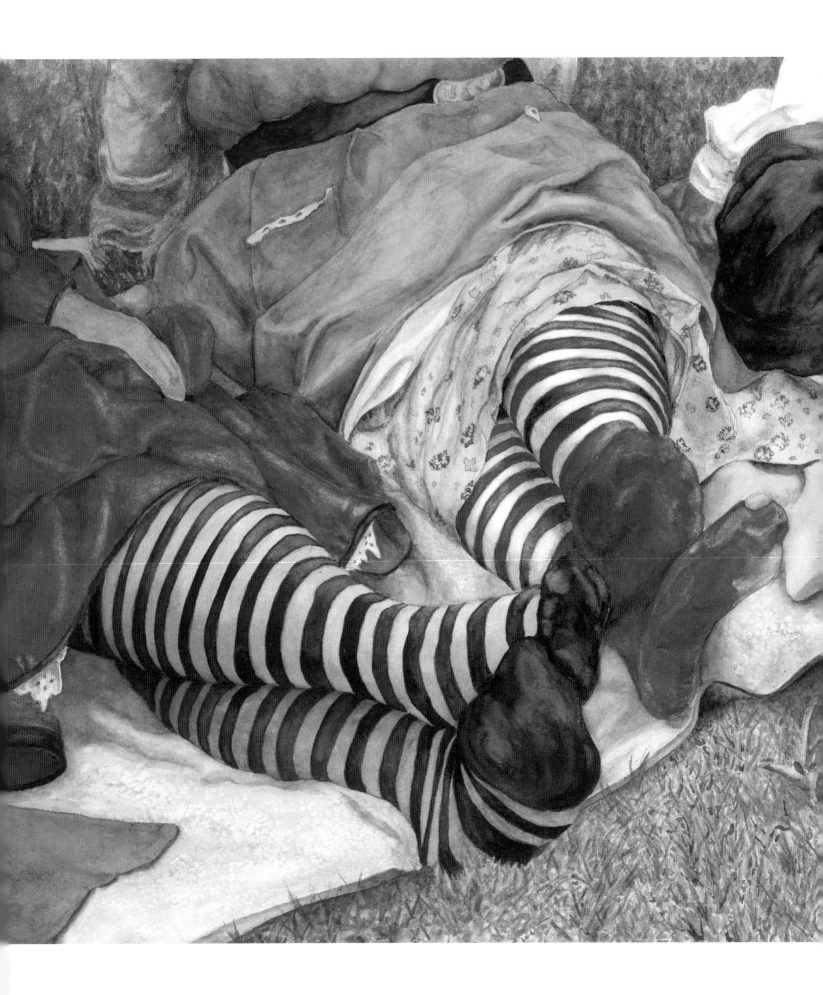

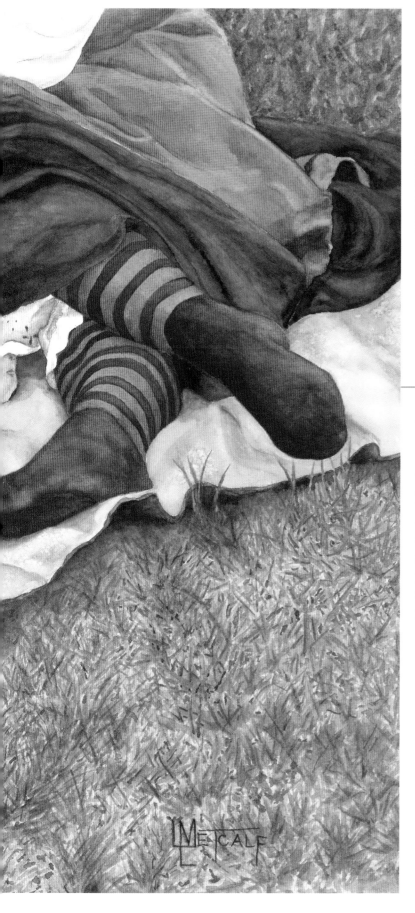

7
PEOPLE EVERYWHERE

HUSSIES | LINDA L. METCALF
Transparent watercolor on 140-lb. (300gsm) cold-pressed Arches
16" × 22" (41cm × 56cm)

At one time, showing one's ankles was less than ladylike! In a photograph I caught my daughter and friends resting on a hot day at a Civil War reenactment. Focusing on the striped stockings, skirts pulled up to soft folds, dry scratchy grass and a soft cloth laid down was a way to reflect the multiple textures of that hot day. A wash over the soft sculptured forms of their legs was painted wet-on-dry, adding more pigment and shadowing to develop contour. To complete the folds of fabric, a wash of color with subsequent layers of pigment on damp paper produced the desired values.

Visit artistsnetwork.com/splash16 to download free bonus wallpapers from the *Splash* series.

119

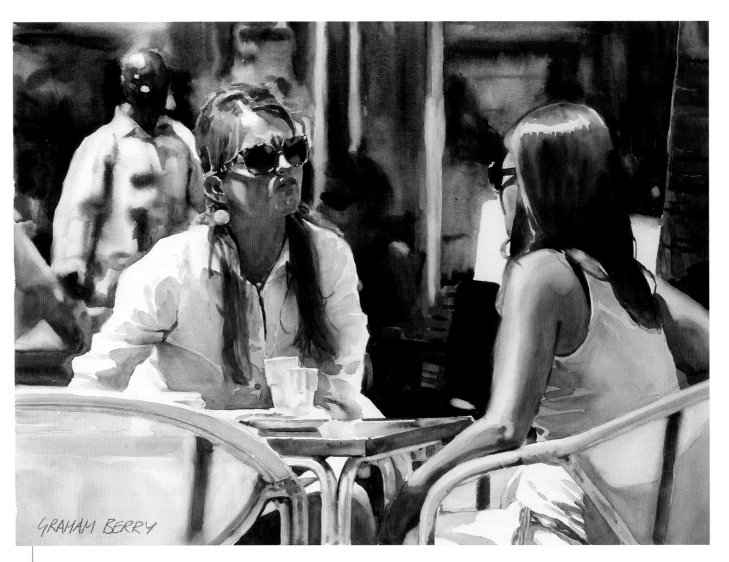

GRAHAM BERRY

COFFEES IN THE SUN | GRAHAM BERRY
Transparent watercolor on 140-lb. (300gsm) cold-pressed Arches
20" × 27" (51cm × 69cm)

Painted in my studio from photos taken on a winter sun break
in Tenerife, Spain, the memory of the scene was still fresh in my
mind. This was important as I wanted to capture the light of the
scene and the energy of the girls in animated conversation. The
bright sunlight intensifies the colors and contrast, and to show
the different textures I had to control the edge quality. Paying
attention to reflected light also adds dynamism to the figures. The
background was painted wet-into-wet, allowing colors to mix on
the paper. This helped propel the figures forward. As a painting
progresses, besides making decisions related to visual content, I
always ask myself, "Does the painting tell a story?"

66

Like a journalist, I always look for a good story.

99

—Jacky Pearson

SEAMSTRESS | JACKY PEARSON
Transparent watercolor and gesso on medium 100% cotton Crescent Board
50" × 30" (127cm × 76cm)

I knew I had a good story when I saw Laura sewing in her dress
design business. Her face, hands and sewing machine formed a
triangle. I ended up cropping a mannequin out of the scene as a
sacrifice for a better composition. I made a pathway into the paint-
ing by contrasting the delicate watercolor washes of the figure
with bold abstract strokes of gesso. I used a variety of edges to
enhance the sense of space. The actual scene was a little different:
I invented the pale windows and placed a pair of scissors and pins
for activity reference.

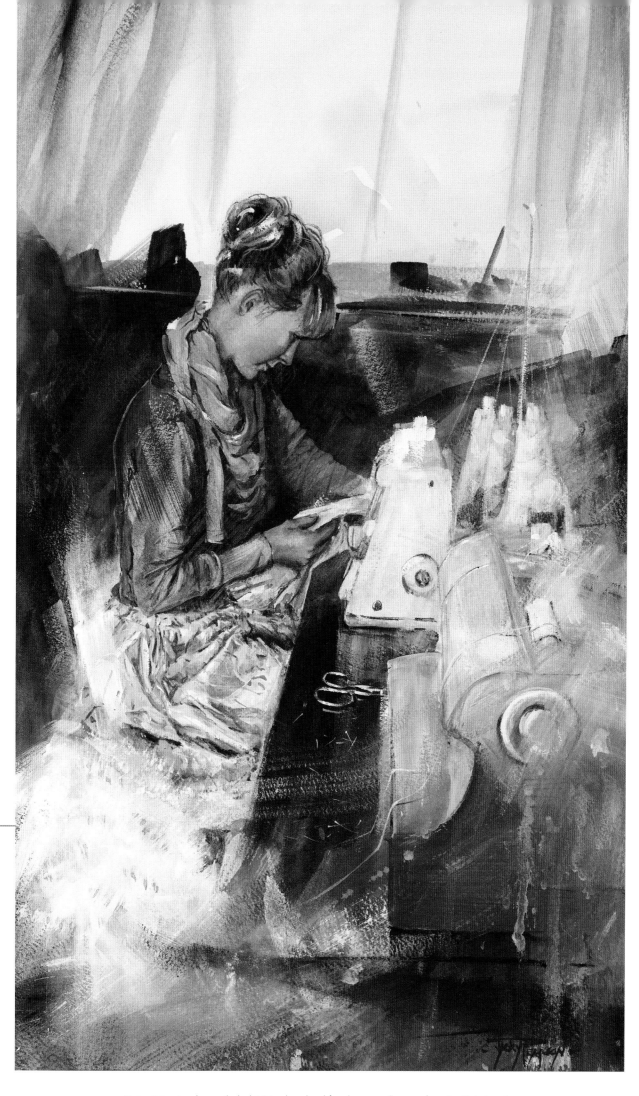

Visit artistsnetwork.com/splash16 to download free bonus wallpapers from the *Splash* series.

121

DAYDREAMER | CHERYL CHALMERS
Transparent watercolor on 140-lb. (300gsm) cold-pressed Arches
21" × 27" (53cm × 69cm)

A fascination for creating the illusion of bright light in watercolor prompted me to pose my daughter reclining in the sun on my favorite vintage linens. A week before she was to leave for college, I took a series of photographs, mindful of the shapes created by the highlights and deep shadows. With intense value and color contrasts, I tried to capture the various textures of the fabrics, skin and hair. The result was not merely a likeness of my daughter but an expression of her soft nature and my emotionally charged feelings.

> "
> Make one thing, like texture, your priority—and it will stand out if there's nothing competing with it.
> "
>
> —Carla Gauthier

JEANNE D'ARC | CARLA GAUTHIER
Transparent watercolor on 140-lb. (300gsm) paper
30" × 22" (76cm × 56cm)

Rouen, France, is the site of Joan of Arc's execution in 1431 and where this statue stands honoring the martyred saint. By day, the statue is easy to miss—white marble against a white church. But at night, the lighting and shadows bring it to life. The sculptor's art beautifully depicts the faith, fear and suffering of this young girl. Painting Joan was simple and direct, using just three primary colors and planning for the lights and highlights. The heavy texture was laid down first, spattering using a toothbrush, covering all but the face area of the statue. I carefully glazed over the texture with dark but transparent washes, and then built up the values to create the contrast and drama this saint deserved.

ALL THAT REMAINS | EVELYN DUNPHY
Watercolor, charcoal and pastel on 300-lb. (640gsm) cold-pressed Arches
22" × 30" (56cm × 76cm)

Exploring an old cottage on an island in Maine, I opened the door to
this unforgettable image. Graffiti on the walls, a rusted iron bedstead
and a moldy poster of the Mona Lisa. Texture is what tells the story
of this painting. I chose cold-pressed paper for its pebbly surface,
and Ultramarine and Cerulean Blue, both of which granulate. I
rubbed Cerulean Blue pastel on the wall, drawing graffiti with vine
charcoal. I scraped out random marks from the dark panel to give
the impression of a presence in the room. The iron bedstead was
painted with Cerulean Blue, Quinacridone Burnt Orange, red and
Ultramarine Blue. I let my brush skip over the places where the
edges were light-struck and charged in more Cerulean Blue on the
damp surface to create the look of old iron.

66

Ask yourself: Is the surface rough,
silky, velvety, lustrous, reflective,
tweedy? Then challenge yourself
to find a way to describe it.

99

—Evelyn Dunphy

SELF-PORTRAIT | PATRICIA GUZMAN
Watercolor and white gouache on 140-lb. (300gsm) hot-pressed Arches
28" × 21" (71cm × 53cm)

Perhaps the noblest purpose in life is trying to become complete
and pure, like children. Inspired by psychology books, shaman-
ism and personal experiences, I wanted to show how we are
fragmented through the appearance of a broken mirror, mirroring
the human condition. I took photos of myself with a dirty, broken
mirror. I applied many transparent watercolor layers and intensi-
fied the effect of dirt with white gouache as I really wanted to
create the illusion of the dirty texture of the mirror in the painting.
The poet Walt Whitman said, "We contain multitudes."

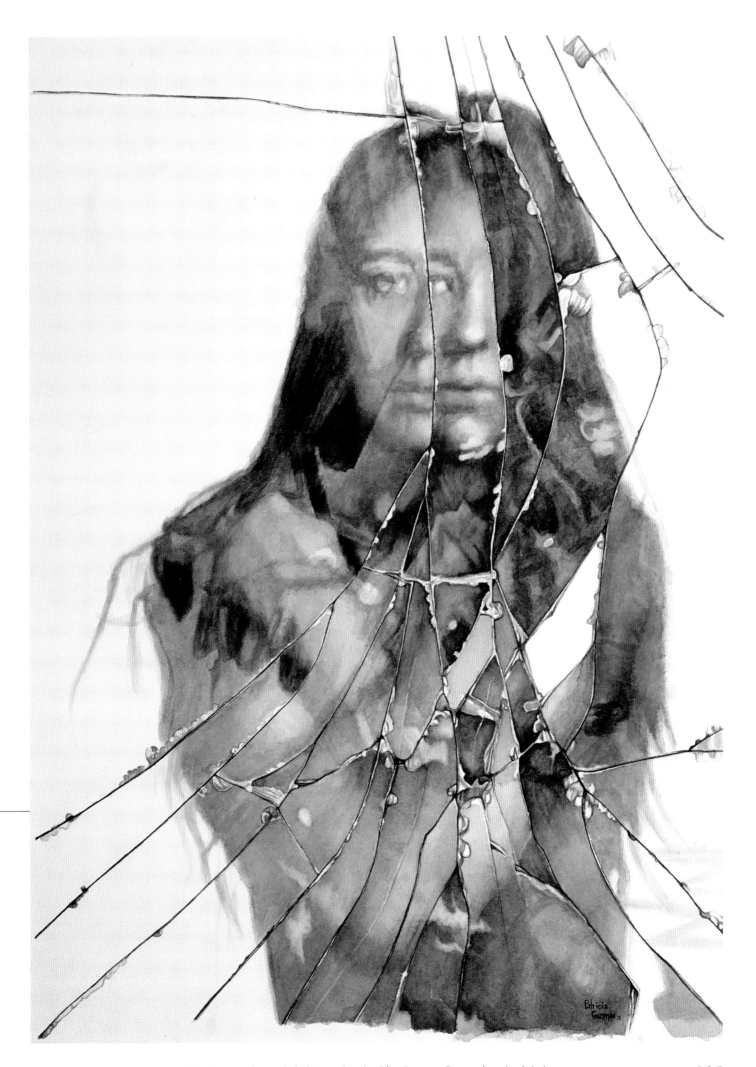

Visit artistsnetwork.com/splash16 to download free bonus wallpapers from the *Splash* series.

125

EMMETT | KRIS PRESLAN
Transparent watercolor on 140-lb. (300gsm) cold-pressed Arches
18" × 24" (46cm × 61cm)

Emmett Kelly was an American circus performer who
created the beloved Depression era hobo character Weary
Willie. The torn and pitiful rags he wore draped his body
like tattered curtains in an abandoned house. I photographed
the memorabilia at the Ringling Bros. Circus Museum and
sketched from my photos and notes. The challenge was to
combine positive and negative shapes with vibrant colors,
while alternately controlling and letting go of control with my
pigment/water mix of transparent watercolors.

SLEEPING CHILD | ARIANNE GUAN TOLENO
Transparent watercolor on 140-lb. (300gsm) cold-pressed Arches
7" × 9½" (18cm × 24cm)

I was eager to sing my two year old to sleep so I could get some
work done. I watched the sunbeams moving on her hair with her
every breath, making a thorough mental sketch of the moment,
then took a photo before she stirred. I masked the highlights of
the hair. After the initial layer of color was dry, I removed the
masking, then scraped the paper with a craft knife to create
more highlights. When painting the pillow, I added a drop of
granulation medium into my sepia. The face alone has at least
seven different layers of light fleshtone glazes.

RAINY DAY | MICHAEL W. BERMEL
Watercolor on 300-lb. (640gsm) cold-pressed Arches
20" × 28" (51cm × 71cm)

Rainy Day was painted in the comfort of the warm, dry office of our home, a stark contrast to that magical day my camera captured our children splashing through puddles on the driveway. These photos and my quick crayon sketches supplied the foundation for my painting. Trying to capture the varied textures of nature and synthetic fabrics, I thrashed water over the paper's surface with an oversized, water-saturated brush. I turned the paper at different angles to blow air at the pooling water, disturbing the semidried Winsor & Newton pigment to infuse the piece with movement.

Visit artistsnetwork.com/splash16 to download free bonus wallpapers from the *Splash* series.

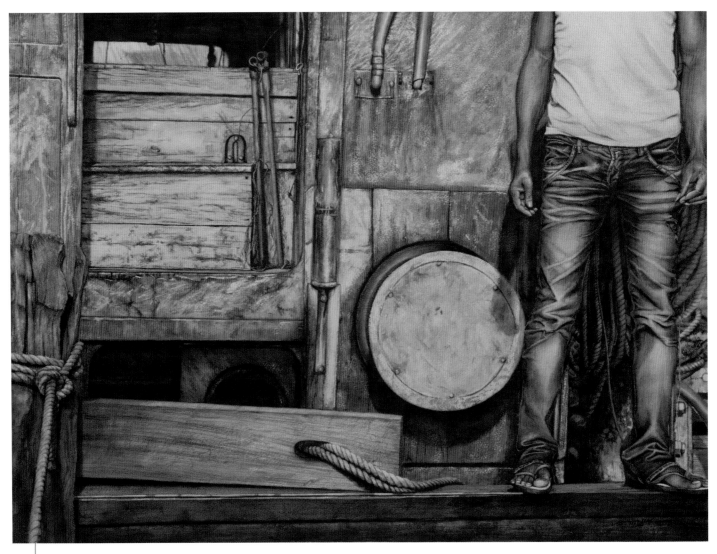

FISHING VILLAGE NO. 46 – OUTLOOK | LIM BEE TAT
Watercolor on 140-lb. (300gsm) cold-pressed Saunders Waterford
22" × 30" (56cm × 76cm)

Detailed work is one of my recent painting passions. The journey of this painting was not just a click of a camera. It was to express the future vision of a low-income expatriate who is currently at a crossroads of his life. I used simple wet-into-wet and dry-brush techniques, with layering, for the entire painting. To depict the texture of the years of wind and rain thrashing the old boat, the background was rubbed with sandpaper. Finally I strengthened the lights by adding darker shadows to produce the sense of future vision.

66

Texture tells the stories. This is evidence of the indelible.

99

—Lim Bee Tat

PREPARING THE NETS, KYPROS | LANCE HUNTER
Transparent watercolor on cold-pressed Arches watercolor board
22" × 16" (56cm × 41cm)

My wife is from the island of Cyprus, and we have traveled there frequently, usually staying in an apartment overlooking a small marina. This Greek fisherman often sat on his boat in the afternoons, preparing his nets to be used the next morning to catch octopus and squid. Vinyl baskets with colorful stripes stored the nets. Now retired I do not think I ever saw that fisherman with a shirt or without a cigarette. I found it interesting the way the color and coarse fabric of the nets were echoed in his tobacco-stained beard. The effects of exposure to salt and sun were very apparent on the marina and the man. I dropped salt into washes of color to create the texture on the side of the boat and the crusted glass of the windows.

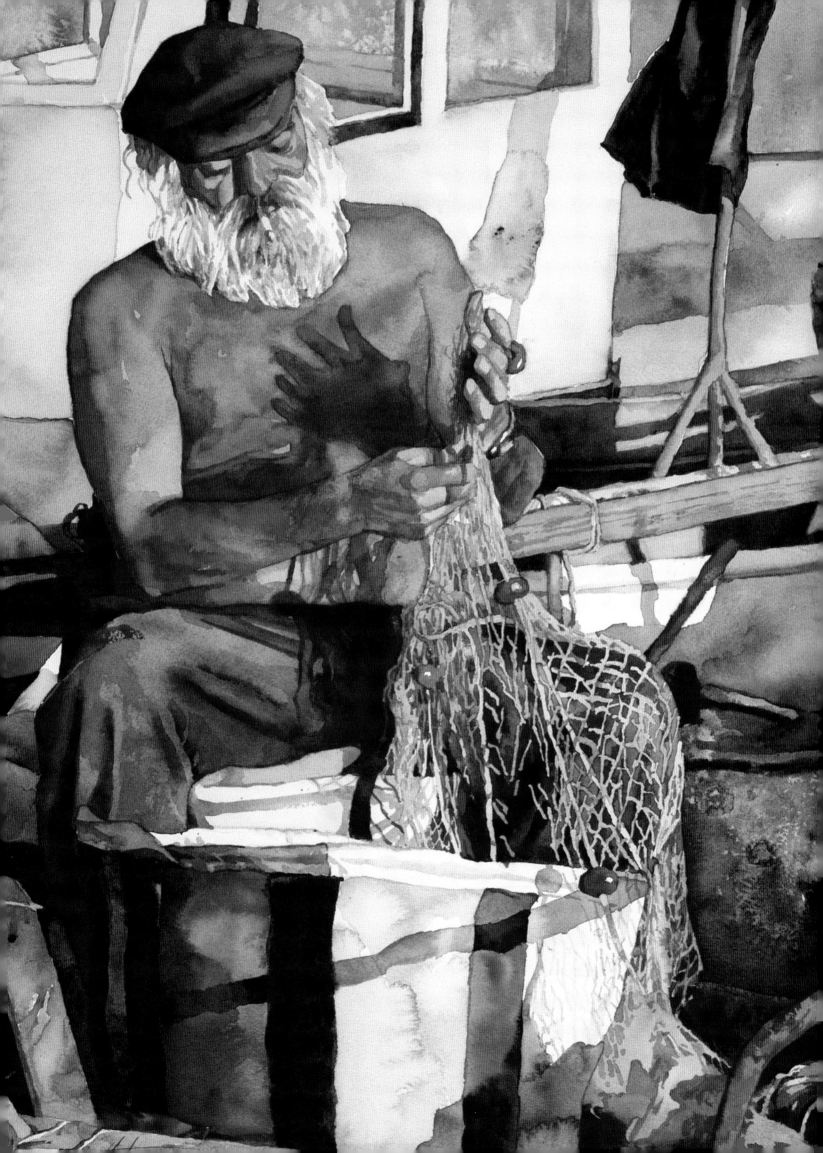

CHA CHA CHA – SILVERLAKE | WILLIAM MCALLISTER
Transparent watercolor on 300-lb. (640gsm) Fabriano Artistico
22" × 30" (56cm × 76cm)

Using a sedimentary pigment to contrast the textures of cotton napkins and the oilcloth table covers was an easy decision. I seek out and celebrate the texture of the people in my paintings. Different people in different locations create environments to conduct their public lives, which are very telling about themselves and the texture of their lives. This East Hollywood fixture is a crazy quilt of varied surfaces, like the patterns in the tablecloths and, like a quilt, is sewn together with a common thread. I center your focus by the use of a bit of detail in the portraiture in that area. A favorite place of mine to sup for the past two decades is now a favorite place to paint.

My palette has mainly nonstaining colors so I can lift off paint and keep my options open.

,,

—Susan Avis Murphy

PEACE AND DUMPLINGS | SUSAN AVIS MURPHY
Transparent watercolor on 140-lb. (300gsm) cold-pressed Arches
28" × 20" (71cm × 51cm)

When we visited Beijing, a young woman was always stationed outside our small hotel selling *bao-tze*, steamed dumplings. She let me take her picture and gave the peace sign. Later I was teaching a class titled "Painting People Working" and decided to use my photo for a demonstration. Years back, I devised an approach to watercolor that I call "the rivulet method." It results in a richness that resembles oil painting. I first coat the paper with a wash of Raw Umber and then spray it with water while holding it vertical. The water washes down over the Umber, and interesting rivulets form in the thick paint. I then work the painting by lifting out lights with stencil brushes and glazing transparent colors over the Raw Umber until the desired results are obtained.

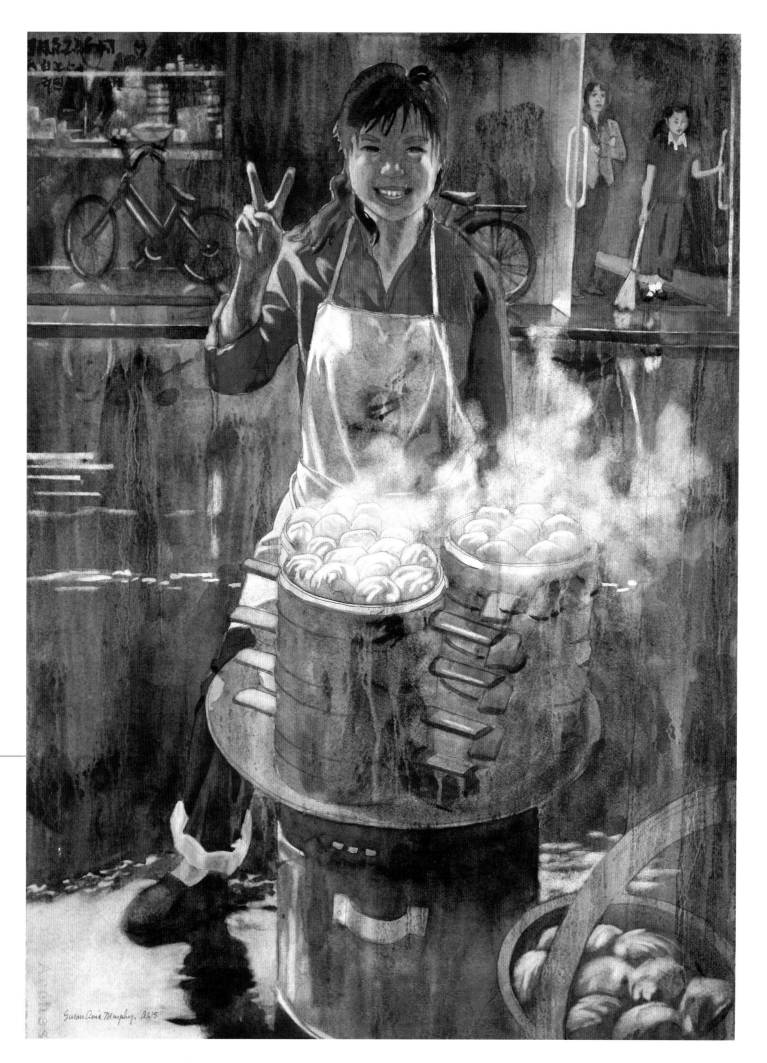

Visit artistsnetwork.com/splash16 to download free bonus wallpapers from the *Splash* series.

131

STUDIO | LEI CHI
Watercolor with gouache accents on 140-lb. (300gsm) cold-pressed
Fabriano Artistico
17" × 23½" (43cm × 60cm)

A photograph was taken as a basis for an oil painting, but it inspired me toward watercolor instead. I was drawn to the intimate feel of the interior with its variety of tactile surfaces. In order to bring out these elements, I took the time to build up the painting with many layers of transparent glazes while modeling its forms. This forced me to be patient and deliberate, squinting my eyes frequently to assess values. Edges were softened as necessary to create depth. I judiciously mixed watercolor and white gouache to accentuate edges, give more volume and render textures. A sound and accurate drawing is the painting's foundation. The subject is my studio in downtown San Francisco while I attended the Academy of Art University.

FUTURE ARTISTS | DUNCAN SIMMONS
Transparent watercolor on 300-lb. (640gsm) cold-pressed Arches
17¾" × 19½" (45cm × 50cm)

These two children, Bella, age 7, and Tyler, age 9, are my great-niece and -nephew. I was impressed by the interest they showed in these two paintings at the Crocker Art Museum in Sacramento, California. I noted the body language of the two children. Bella's legs were hanging very still above the floor, while Tyler's right foot was fidgeting. To me, this represents how little girls and boys act. One challenge was obtaining depth, due to the dominant horizontals and everything being in close proximity. I used the perspective of the top and bottom of the bench to guide the viewer into the painting, as well as by applying more corona to the children, bench and floor shadow in the foreground. I further created depth via the white caption on the wall between the two paintings by drawing the viewer's eye through the dark corona in the foreground.

Visit artistsnetwork.com/splash16 to download free bonus wallpapers from the *Splash* series.

133

GYPSY AT THE GATE | MICHAEL HOLTER
Transparent watercolor on 300-lb. (640gsm) hot-pressed Arches
13¼" × 13¾" (34cm × 35cm)

I photographed this young Gypsy woman at the Kadifekale castle ruins in Izmir, Turkey. In my studio I spent considerable time pondering the image and worked on several compositions. I wanted the painting to be an impressionistic treatment of a magical moment in that colorful place. To get what I was after, I tightly controlled the negative areas and loosely treated the splashes of sun and shade, allowing jewels (spots) of color to accent the softer areas. Painting the trees, fence and bricks in this manner entices the viewer's eye to travel throughout the entire painting, still keeping the young woman as the center of interest.

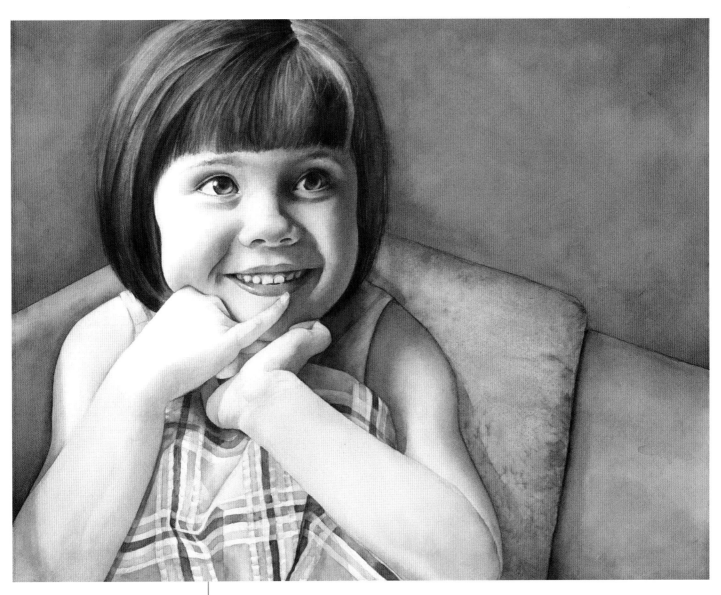

JOY AND A LITTLE MISCHIEF | AMY G. SNOWDEN
Watercolor on 300-lb. (640gsm) cold-pressed Arches
17" × 22½" (43cm × 57cm)

This painting was a commission for a family desiring to capture
the essence of early childhood. Working from my own photog-
raphy, I chose a composition that featured her tiny, rounded
shoulders and pudgy fingers—characteristics that change with
adolescence. Texture came up repeatedly with my client, so it
influenced choices throughout my process. I chose cold-pressed
paper over my usual hot-pressed. This worked especially well
for creating the feel of the seersucker. The texture of her hair was
developed using many layers and careful lifting. As a watercolor
purist, I left my comfort zone to define the shape of the blanket.
Not wanting to insert another color or pattern, I used salt to create
a fuzzy, warm texture and loved the outcome.

Visit artistsnetwork.com/splash16 to download free bonus wallpapers from the *Splash* series.

135

CONTRIBUTORS

KATHLEEN ALEXANDER
WW, NWWS
2645 Alohia Pl., Apt. A
Haiku, HI 96708 (January–July)
160 Stanley Ave.
Pacifica, CA 94044 (August–December)
650.455.0998
kathleenalexanderwatercolors.com
Village Galleries, Maui, HI
pp80–81 Makana Hele

MINA ANGELOS
AWS
40 Sunnyside Rd.
Plattsburgh, NY 12901
518.561.2972
petmin@charter.net
Set for Breakfast—Accepted at
AWS 145th International Exhibition,
2012
p106 Set for Breakfast

GENADY ARKHIPAU
genady@arkhipau.com
arkhipau.com
p141 Harvard Bridge

MARLENE BACHICHA-ROBERTS
Los Ranchos de Albuquerque, NM
abqmbr@aol.com
marlenebachicha-roberts.com
p58 Achemon Sphinx

LINDA DALY BAKER
AWS, NWS, TWSA
295 Seven Farms Dr., C222
Charleston, SC 29492
616.846.3453
lindabakerartist@gmail.com
lindabaker.biz
His Keys—Adirondacks 2013
p87 His Keys

SALLY BAKER
WW, Signature Member
5990 Vine Hill School Rd.
Sebastopol, CA 95472
707.829.0396
knsbaker@yahoo.com
sallybaker.com
Graton Gallery
p89 Still Life with Green Colander

CHRIS BECK
NWS, TWSA, WW
PO Box 1661
Los Altos, CA 94023
650.941.7951
chris@chrisbeckstudio.com
chrisbeckstudio.com
p98 Arabesque

MICHAEL W. BERMEL
Randolph, NJ
mrbermel@yahoo.com
mrbermel.com
p127 Rainy Day

GRAHAM BERRY
38 Tarragon Dr.
Blackpool, Lancashire FY2 0WJ
United Kingdom
+44 01253 592636
grahamberrystudio@gmail.com
grahamberrystudio.com
p1 Doing the Rounds
p120 Coffees in the Sun

JUDI BETTS
AWS; NWS; Watercolor USA,
Honor Society
PO Box 3676
Baton Rouge, LA 70821
225.926.4220
judibettsaws.com
Rendezvous—Mississippi Watercolor Society Grand National, Mississippi Museum of Art
p107 Rendezvous

ROBERTA J. BOLT
NFWS, BSA
4400 Arondale Dr.
Williamsville, NY 14221
716.983.7849
robertabolt@me.com
robertabolt.blogspot.com
Fog Light—Gold Medal at Buffalo
Society of Artists 118th Catalog
Exhibition
p71 Fog Light

CINDY BRABEC-KING
TWSA; NWS; WCWS, Master
Status
3989 Rapid Creek Rd.
Palisade, CO 81526
970.464.4996
cbrabecking@msn.com
p97 Ivory Dice

HELEN BROWN
Sunriver, OR 97707
541.593.7728
hbrownart@aol.com
hbrownart.com
Tumalo Art Company, Bend, OR
p84 Curb Appeal

CHRISTINE MISENCIK BUNN
OWS, PWS, WW
109 Ebersole Ave.
Fredericktown, OH 43019
740.485.2894
chris.m.bunn@gmail.com
facebook.com/watercolorbychristinemisencikbunn
Last Mile … Almost Home—
People's Choice, 45th Watercolor
West International Juried Exhibition
p13 Last Mile … Almost Home

DEBBIE CANNATELLA
LWS
Corpus Christi, TX
225.936.4716
debbie.cannatella@gmail.com
debbiecannatella.com
Studio C Gallery, Corpus Christi, TX
p58 Emerging

DIANE F. CANNON
PWCS, PWS, BWS
23 Tullamore Dr.
West Chester, PA 19382
diane7337@aol.com
dianecannonart.com
Howard Pyle Studio, Wilmington, DE
Fall Frolic—First Prize, Delaware
Valley Art League
p11 Fall Frolic

JILL M. CARDELL
AWS; American Society of Botanical
Artists, DipSBA
356 Timberton Cir.
Bellefonte, PA 16823
814.441.3073
jillcard2@gmail.com
jillcardellart.com
p29 Mandevilla

DEBORAH L. CHABRIAN
AWS, NWS
28 Spooner Hill Rd.
South Kent, CT 06785
860.927.4945
deborahchabrian@earthlink.net
deborahchabrian.com
Susan Powell Gallery, Madison, CT
Rosedale Fish Market—Finalist,
Plein Air Salon 2013; Finalist, ARC
10th Annual Competition
p85 Rosedale Fish Market

CHERYL CHALMERS
2115 Taughannock Park Rd.
Trumansburg, NY 14886
607.387.4133
cherchalmers@yahoo.com
cherylchalmers.com
facebook.com/cherylchalmersart
p122 Daydreamer

CHERYLE CHAPLINE
8301 Whippoorwill
Woodway, TX 76712
254.717.1149
cachapline@yahoo.com
cherylechapline.com
Emma—Award Winner, Central
Texas Watercolor Society
p59 Emma

NADINE CHARLSEN
NAWA
344 W. 49th St., 2D
New York, NY 10019
917.656.1313
nadine@nadinepaints.com
nadinepaints.com
p75 Around the Garden

LEI CHI
2231 Calle De Primavera
Santa Clara, CA 95054
626.856.9526
michelle.chi@live.com
michellechi.com
p63 Nike
p132 Studio

PERRY CHOW
info@perrychow.net
perrychow.com
p32 The Weed

KAREN S. COLEMAN
American Society of Botanical
Artists, Botanical Art Society of the
National Capital Region, Colored
Pencil Society of America
19499 Yellow Schoolhouse Rd.
Round Hill, VA 20141
kcoleman@rstarmail.com
*p29 Common Milkweed Pods,
 Asclepias Syriace*

RON CRAIG
Valley Springs, CA
925.457.3419
roncraig@me.com
roncraigart.com
p77 Cinque Terre

SANDY DELEHANTY
CWA
PO Box 130

Penryn, CA 95663
916.652.4624
sandydelehanty@yahoo.com
sandydelehanty.com
Art Obsessions Gallery, Truckee, CA
*Tongue Tied—Second Place Paint-
ing, Animal House Open Juried Exhi-
bition, Sacramento Fine Art Center
p53 Tongue Tied

OSCAR R. DIZON
AWS, TWSA, Salmagundi Club
7 Windermere Dr.
Holbrook, NY 11741
631.472.3719
oscarrdizon@yahoo.com
oscarrdizon.com
Gallery North, Setauket, NY
*Ole' Reliable—Frank C. Wright
Medal of Honor, American Artists
Professional League's 82nd Grand
National Exhibition, 2010; Exhib-
ited at the ArtistSpace Gallery, Ayala
Museum, Philippines, March 2011
p69 Ole' Reliable

VIE DUNN-HARR "VISAGE"
San Antonio, TX
210.532.8036
vie@dunn-harrstudios.com
viedunn-harr.com
p109 Villa d'Estrees

EVELYN DUNPHY
NEWS, Signature Member; Interna-
tional Guild of Realism; American
Society of Marine Artists
596 Foster Point Rd.
West Bath, ME 04530
207.443.5045
artist@evelyndunphy.com
evelyndunphy.com
North Light Gallery, Millinocket, ME
*All That Remains—First Prize,
National Watercolor Society All-
Members Show
p124 All That Remains

GARY C. ECKHART
Niagara Frontier Watercolor Society,
NEWS, Vermont Watercolor Society
200 Orion Rd.
Warren, VT 05674
802.583.2224
fineart@moosewalkstudios.com
moosewalkstudios.com
Vermont Fine Art, Stowe, Vermont
p86 Buckets 5

KELLY EDDINGTON
Illinois Watercolor Society
401 W. Grand Ave.
Saint Joseph, IL 61873

217.377.1210
kellyeddington@gmail.com
kellyeddington.com
*Allure—Accepted for Watercolor
Missouri International 2014
p96 Allure

L. S. ELDRIDGE
AWS
3507 Mockingbird Ln.
Rogers, AR 72756
lse1232@gmail.com
lseldridge.com
p110 Revolutions of Five

LINDA ERFLE
NWS, AWS, WW
2723 Ivy Knoll Dr.
Placerville, CA 95667
530.622.2210
erfle@directcon.net
lindaerfle.net
The Artery, Davis, CA
p40 Cow Licks #2
p91 Persimmons at Sunrise

MICHAEL FERRIS
21 Kamerunga Rd.
Stratford Cairns, QLD 4870
Australia
617 412 855 515
ferris15@bigpond.com
p56 Heron at the Marina Basin

BEVERLY FIELDS
Sacramento Fine Arts Center,
Watercolor Artists of Sacramento
Horizons, California Watercolor
Society
7301 Green Valley Rd.
Placerville, CA 95667
530.622.4440; 530.748.9530
fieldsofart@inreach.com
reflectionsinwatercolor.com
Highlight Gallery, Mendocino, CA
*Capital Dreams—Best of
Watercolor, Watercolor Artists of
Sacramento Horizons
p74 Capital Dreams

JAN FINN-DUFFY
PO Box 103
Woodford, VA 22580
540.903.5302
jkfinnduffy@gmail.com
janfinnduffy.com
Sophia Street Studios, Frederisck-
burg, VA
p44 Steppin' Out

RYAN FOX
1928 Jupiter Hills Ct.
Raleigh, NC 27604

919.645.8345
ryan@rfoxphoto.com
rfoxphoto.com
p72 Walk Down the Street

JANE FREEMAN
TWSA
PO Box 1451
Bemidji, MN 56619
218.243.3333
jane@janefreeman.com
janefreeman.com
p90 Musical Pears

CARLA GAUTHIER
NWS, CSPWC, WAS-H
2007 Walnut Green Dr.
Houston, TX 77062
281.384.2473
carla.gauthier@yahoo.com
carlagauthier.com
Upper Bay Frame and Gallery
p123 Jeanne d'Arc

JEAN K. GILL
AWS, NWS
Oak Hill, VA
jkgillwatercolor@aol.com
jeankgill.com
p31 Potholders

XI GUO
912.346.2396
luben928422@yahoo.com
xiguopainting.blogspot.com
Gallery 209, Savannah, GA
p17 Green-Meldrim House in
 Savannah

PATRICIA GUZMAN
IGOR, SMA
patriciafineart@gmail.com
patriciaguzman.blogspot.com
facebook.com/patriciaguzman
p125 Self-Portrait

YUKI HALL
4136 Fox Fern Ct.
Beavercreek, OH 45432
937.426.7229
yukihall@woh.rr.com
yukihall.artspan.com
pp64–65 Commuters in Detroit

VALERIE HARPER
Society of Canadian Artists
valerie.harper@me.com
valerieharperart.com
p8 Majestic Falls

LIANA HARVATH
932 Paulsboro Dr.
Rockville, MD 20850

301.509.4568
lianaharvath@verizon.net
p28 Fuzzy Dandelions

TED HEAD
FWS, JWS
5425 N. Autumnbrook Tr.
Jacksonville, FL 32258
904.504.7711
ted@tedheadfineart.com
tedheadfineart.com
p102 Better Days—Winter

CATHERINE HEARDING
WHS, MOWS
9901 Tapestry Grove
Lake Elmo, MN 55042
651.777.8158
cathy@chearding.com
chearding.com
p114 All Tied Up

TOM HEDDERICH
North East Watercolor Society, Sig-
nature Member; Audubon Artists,
Signature Member; Salmagundi
Club New York
529 Lower Rd.
Westtown, NY 10998
845.726.3406
tomart@optonline.net
tomhedderich.com
*Abby—First Prize, President's Best
of the Best Watercolor Exhibition,
2011, Salmagundi Club; Mary Lou
Fitzgerald Award, Allied Artists of
America Annual Exhibition, 2011
p5 Abby

HAILEY E. HERRERA
NWS, Texas Watercolor Society,
Watercolor Art Society-Houston
3504 Farah Dr.
College Station, TX 77845
979.209.0075
hailey.art@gmail.com
hailey-e-herrera.artistwebsites.com
The Gallery at Round Top, Round
Top, TX
p42 Serenity Koi

ROBERT HIGHSMITH
AWS, NMWS, WFWS
2920 Suncrest Arc
Las Cruces, NM 88011
575.650.1556
ra_highsmith@hotmail.com
rhighsmith.com
Marigold Arts, Santa Fe, NM
p111 Narrow Gauge

ANNE HIGHTOWER-PATTERSON
SCWS, WSA
112 Crystal Cove Rd.
Leesville, SC 29070
803.606.6505
patter816@aol.com
annehightowerpatterson.com
Charlotte Fine Art Gallery, NC
p93 Antiques

CATHY HILLEGAS
Kentucky Watercolor Society;
AWS, Associate Member
3285 Jones Ln.
Floyds Knobs, IN 47119
812.923.3805
cahillegas@aol.com
cathyhillegas.com
Copper Moon, New Albany, IN
Summer Rain—Outstanding
Watercolor, Bold Brush Painting
Competition, July 2013
p33 Summer Rain

PATRICIA HITCHENS
WPW
367 Prospect St.
Seattle, WA 98109
206.282.3033
pjhitchens@mac.com
pathitchens.com
Women Painters of Washington
Gallery
p44 Breakfast

MICHAEL HOLTER
NWS, Signature Member; SWS,
Signature Member; SWA, Signature Member
2816 Crow Valley Tr.
Plano, TX 75023
972.965.2078
michael@michaelholter.com
michaelholter.com
Thunder Horse Gallery, Ruidoso, NM
Gypsy at the Gate—Merit Award,
29th Texas & Neighbors Competition
p134 Gypsy at the Gate

CARY HUNKEL
Society of Animal Artists, Signature
Member
3317 Tallyho Ln.
Madison, WI 53705
hunkel@tds.net
p45 First in Line

LANCE HUNTER
AWS,NWS,WHS
lance@lancehunter.com
lancehunter.com
Brad Smith Gallery, Santa Fe

p49 Cricket
p129 Preparing the Nets, Kypros

PETER V. JABLOKOW
TWSA
847.651.7161
peter@3rdtowerillustration.com
3rdtowerillustration.com
p105 Engine 8380-Crosshead

MARY M. JANSEN
MPSGS
300 Addison Rd.
Riverside, IL 60546
708.443.3373
marymjansen@msn.com
marymjansen.com
p57 Koi Ahoy

LORI PITTEN JENKINS
AWS, SW, FWS
3211 Wind Song Ct.
Melbourne, FL 32934
321.259.1759
jenks1156@aol.com
loripittenjenkins.com
Fifth Avenue Art Gallery, Melbourne, FL
Say Ahhhhh!—Jeanette Thayer
Schmidt Memorial Award, National
Watercolor Society, 2013; Potomac
Valley Watercolorist Award, Southern Watercolor Society, 2013
p34 Say Ahhhhh!

RUSSELL JEWELL
NWS, TWSA
116 Deer Creek Ct.
Easley, SC 29642
864.430.0559
jewellart@charter.net
russelljewell.com
Charlotte Fine Art
p116 Taxi!

KIM JOHNSON
AWS, NWS, TWSA
3744 E. Joan De Arc Ave.
Phoenix, AZ 85032
kim@kj-art.com
kj-art.com
I'm Here For You—Pulsifer
Award, 2013 Annual Adirondacks
National Exhibition of America
Watercolors
p47 I'm Here for You

SUE JOHNSTON
AWS, Associate Member; NWS,
Associate Member; CWA, Signature
Member
22 Ascot Ln.
Oakland, CA 94611

suj22ascot@yahoo.com
Sunrise Bistro, Walnut Creek, CA
p52 Vegetarian Vacation

BEV JOZWIAK
AWS, NWS, TWSA
315 W. 23rd St.
Vancouver, WA 98660
paintingjoz@gmail.com
bevjozwiak.com
Cole Gallery
p51 The Sentinel

KRISTINA JURICK
Hoehenstrasse 12
91227 Leinburg, Germany
jurick-art@web.de
jurick-art.de
p16 Moro Bay, CA
p21 Morning in Girona

CHIZURU MORII KAPLAN
WHS, NEWS, AWS
chizurukaplan@gmail.com
chizuruart.com
p70 Melodious Paris
p71 FDR Drive, NYC

ONA KINGDON
CSPWC, CWA, PWS
10 Candlelight Dr.
Richmond Hill, Ontario L4E 5E4
Canada
647.478.6276
ona@onak.ca
onak.ca
Incriminate-Ted—The Framing
Depot Gold Award for Best in
Show, BWS Luminosity 2013
p41 Incriminate-Ted

MARIE LAMOTHE
Interlochen, MI
mariejoseelamothe@yahoo.com
marielamothe.com
Bier Art Gallery, Charlevoix, MI
p27 First Light—Wood Lily

ELIZABETH NICKERSON LAROWE
AWS, Associate Member;
Jacksonville Watercolor Society;
Wyoming Watercolor Society,
Founding President
PO Box 1845
Red Lodge, MT 59068
406.426.0269
laroweelizabeth@gmail.com
Carbon County Arts Guild and
Depot Gallery
p12 Rock Creek

JC LINDELOF
Watercolor Artists of Sacramento
Horizons, Folsom Art Association
jclindelof@gmail.com
jclindelof.weebly.com
Guard Dogs—Award Winner in
Art of Excellence Show 2014
p103 Guard Dogs

BRITTNEY LINTICK
brittneylintick@gmail.com
brittneylintick.com
p30 Pattern and Illusion 14

CHERYLE LOWE
TWSA, WSI, NWS
5035 E. 76th St. Ct.
Indianapolis, IN 46250
317.370.5195
lowecheryle@yahoo.com
Dash To The Past—Merit Award,
Indianapolis Museum of Art
p113 Dash to the Past

YAEL MAIMON
Ashkelon, Israel
yael_mai@walla.co.il
yaelmaimon.com
Due Any Day Now—Honorable
Mention, 6th Annual Watermedia
Showcase, *Watercolor Artist*
magazine
pp38–39 Due Any Day Now

WILLIAM MCALLISTER
215 Holland Ave.
Braddock, PA 15104
412.251.1749
bath392000@yahoo.co.uk
mcallisterpaintings.com
p130 Cha Cha Cha—Silverlake

GEOFFREY MCCORMACK
NWS, AWS
146 Mackin Ave.
Eugene, OR 97404
mcsurf@mac.com
mcsurf.com
*Amazon Package Sent by
Robert*—Best of Show, Watercolor
Society of Oregon, 2013
*p104 Amazon Package Sent By
Robert*

LAURIN MCCRACKEN
AWS, NWS, TWSA
1005 Picasso Dr.
Fort Worth, TX 76107
817.773.2163
laurinmc@aol.com
lauringallery.com
Greenberg Fine Art, Santa Fe, NM

*Onions in the Market—Barcelona—Third Place, 5th Annual Watermedia Showcase, *Watercolor Artist* magazine, 2013
p9 Barn with Tractor
p94 Onions in the Market—Barcelona

LINDA L. METCALF
90 East Ave.
Attica, NY 14011
585.591.2406
oneolivebranch@hotmail.com
pp118–119 Hussies

DIANE MORGAN
AWS; NWS; CWWS, Past President
Indian Wells, CA
760.902.8855
diane@dianemorganpaints.com
dianemorganpaints.com
p35 Rainy Day Rose

STEVE J. MORRIS
MOWS, STLWS
2679 Joyceridge
Chesterfield, MO 63017
636.530.6807
sjmorrisart@gmail.com
sjmorrisart.com
OA Gallery, Kirkwood, MO
Proud Father—M. Graham Award, Missouri Watercolor Society National Members Invitational, 2013; Patron Purchase Award, Kansas Watercolor National Exhibition, 2013
p43 Proud Father

KYLE MORT
p50 Distant Relatives

SUSAN AVIS MURPHY
AWS, BWS
17520 Doctor Bird Rd.
Sandy Spring, MD, 20860
susan@susanavismurphy.com
arthouseart.com
Les Yeus du Monde, Charlottesville, VA
Peace and Dumplings—Award of Merit, Pennsylvania Watercolor Society International Exhibition, 2014
p131 Peace and Dumplings

DANIEL NAPP
Hafenstrasse 64 (Haus 1)
48153 Muenster, Germany
email@daniel-napp.de
facebook.com/napp.watercolour
p78 Watergate on Dortmund-Ems Canal, Muenster
p79 Residenzplatz Salzburg

ANTERPREET NEKI
Central Ohio Watercolor Society
7501 Pharoah Ct.
Dublin, OH 43016
614.735.3092
anterpreetneki@gmail.com
anterpreetneki.blogspot.com
pp100–101 Retired

R. MIKE NICHOLS
SDWS, WW, NWS
4648 Ladera Ln.
Riverside, CA 92501
951.686.4099
mnico13@yahoo.com
mnico.weebly.com
Time for My Walk—Second Place in Watercolor, Art Show at the Dog Show, 2014
p48 Time for My Walk

JANET NUNN
CWS
21531 Main Ave.
Golden, CO 80401
303.704.2052
janetnunn@comcast.net
janetnunnwatercolors.com
p25 Red Hibiscus

JUDY NUNNO
FWS, GCWS
3180 Paddock Rd.
Weston, FL 33331
954.349.1105
jnunno@aol.com
judynunno.com
Fowl Play—First Place, Plantation Art Guild Exhibit, 2013
p95 Fowl Play

BARBARA OLSEN
AWA, CWS
1411 Red Oak Ct.
Fort Collins, CO 80525
barbaraolsenart@gmail.com
barbaraolsenart.com
p108 The Brush Off

KAAREN ORECK
NWS, TWSA, NWWS
6215 S. Highlands Ave.
Madison, WI 53705
608.231.6702
kboartist@aol.com
kaarenoreck.com
p92 The Orient Came to Me

KRIS PARINS
NWS, FWS, SW
kris.parins@gmail.com
krisparins.com

Nine Bicycles—First Place, Florida Suncoast Watercolor Society, 2014
p10 Salute to the Sun
p73 Nine Bicycles

MONIKA PATE
NWS, TWSA, TWS-PS
2221 Rockingham Loop
College Station, TX 77845
979.690.7426
map352@gmail.com
monikapate.com
p115 Abandoned

JACKY PEARSON
Watercolour New Zealand, New Zealand Academy of Fine Arts, Hutt Art Society
230 Muritai Rd.
East Bourne, Lower Hutt 5013
New Zealand
+64 04 562 8664
info@jackypearson.com
jackypearson.com
p121 Seamstress

SANDRINE PELISSIER
Associate Federation of Canadian Artists; San Diego Watercolor Society, Signature Member; North West Watercolor Society, Signature Member
604.781.4606
sandrine@watercolorpainting.ca
watercolorpainting.ca
Princess Park—Finalist in Landscape Competition, *International Artist* magazine, August–September 2013
p18 Princess Park

ANITA K. PLUCKER
IWS
PO Box 116
Terril, IA 51364
aplucker@terril.net
Artworks by Anita
p14 From My Kayak—Trumball Lake

JILL E. POYERD
NWS
42031 Raspberry Dr.
Leesburg, VA 20176
703.254.6724
jillpoyerd@gmail.com
jpwatercolors.com
p20 Still Waters

KRIS PRESLAN
NWS, Signature Member; TWSA, Signature Member; WW, Signature Member
17841 Lake Haven Dr.
Lake Oswego, OR 97035

971.285.0918
krispreslan@me.com
preslanart.com
Portland Art Museum
Emmett—Northwest Watercolor Society
p126 Emmett

DAVID RANKIN
Society of Animal Artists, Signature Member; Ohio Watercolor Society, Signature Member; Artists for Conservation, Flag Expedition Member
2320 Allison Rd.
University Heights, OH 44118
216.932.2125
davidrankinwatercolors@gmail.com
davidrankinwatercolors.com
facebook.com/davidrankinwatercolors
p19 Beach Grass Abstractions
p54 Working the Tall Grass
p55 Meerkat Radar

VERONICA P. RITCHEY
SWA
204 NE Shady Oaks Dr.
Burleson, TX 76028
817.295.6619
rritchey@sbcglobal.net
p50 Mye Tye

CHRIS ROGERS
PO Box 1734
Hilltop Lakes, TX 77871
936.855.9033
crnovelist@earthlink.net
carogersart.com
Xanadu, Scottsdale, AZ
p12 My Turn

ANTHONY ROGONE
NWS, Signature Member
5303 Ridge Gate Ct.
Rocklin, CA 95765
916.630.5433
arogone@starstream.net
rogonewatercolors.com
Palm Lines—Exhibited in the National Watercolor Society 93rd International Exhibition, 2013/14
p26 Palm Lines

IRENA ROMAN
AWS, TWSA, New England Watercolor Society
PO Box 81
Scituate, MA 02066
617.759.4510
irena@irenaroman.com
irenaroman.com
p90 Citrus

SHERRY ROPER
SDWS
15792 Via Santa Pradera
San Diego, CA 92131
sroper15@cox.net
sherryroper.com
pp22–23 Under Foot

NICOLE RENEE RYAN
Mercer, PA 16137
artbynicolerenee@gmail.com
artbynicolerenee.com
p16 Til It Be 'Morrow

PATRICIA RYAN
LAAG, LWS
6270 North Shore Dr.
Baton Rouge, LA 70817
p_ryan@bellsouth.net
patriciasartstudio.com
*＊Vegan Fare—Accepted into 44th
National River Road Show, 2013*
p83 Vegan Fare

CAROL ANN SHERMAN
5476 Grande Palm Cir.
Delray Beach, FL 33484
561.637.5059
batchmoon1@aol.com
carolannsherman.com
p46 Daisy and the Dude

DUNCAN SIMMONS
NWS, TWSA, WAS-H
16306 DeLozier St.
Houston, TX 77040
713.466.6841
duncansimmonsartist@yahoo.com
2collaboratingartists.com
Harris Gallery, Houston, TX
p133 Future Artists

JERRY SMITH
AWS, ASMA, WSI
119 S. Green St.
Crawfordsville, IN 47933
765.366.3406
jsmith@jsmithstudio.com
jsmithstudio.com
Brown County Art Guild, Nashville,
IN
p15 Heartland Connection

AMY G. SNOWDEN
VWS
Williamsburg, VA
757.812.8894
amysnowden@cox.net
amygsnowden.com
p135 Joy and a Little Mischief

FRANK SPINO
NWS, FWS, SW
6777 Ward Pkwy
Melbourne Village, FL 32904
321.722.0424
fspino@att.net
frankspino.com
p36 Squeeze Me First!
p37 Color Wheels

KAY STERN
PWS, WSA, WAS-H
210 Terrace Dr.
Houston, TX 77007
713.864.7322
lhstern@earthlink.net
p99 Gin Up the Blues

IAIN STEWART
NWS
404.622.4631
mail@stewartwatercolors.com
stewartwatercolors.com
p67 To the Heiligeweg—Amsterdam
*p68 To the Queensboro Bridge—
NYC*

DAVID L. STICKEL
AWS, NWS, Watercolor Society
of North Carolina
111 Morgan Oaks Dr.
Chapel Hill, NC 27516
919.942.3900
dlstickel@juno.com
davidstickel.com
waverlyartistsgroup.com
*＊Window Watching—North
Carolina State Fair Award*
p66 Window Watching

SEAN D. STICKEL
Watercolor Society of North
Carolina
111 Morgan Oaks Dr.
Chapel Hill, NC 27516
919.942.3900
seanstickel93@gmail.com
*＊Reflections of the Hood—Fine Arts
League of Cary Award*
p117 Reflections of the Hood

LIM BEE TAT
8, Jalan Puteri 11/5, Bandar Puteri
47100 Puchong, Selangor
Malaysia
+6012-3389808
limbeetat@gmail.com
Meida Studio
*p128 Fishing Village No. 46—
Outlook*

ARIANNE GUAN TOLENO
2730 Acadia Rd., Apt. 218
Vancouver, British Columbia
V6T1R9
Canada
604.209.2694
arianne.toleno@gmail.com
ariannetoleno.com
p127 Sleeping Child

JAMES TOOGOOD
AWS, NWS, AAA
920 Park Dr.
Cherry Hill, NJ 08002
jtoogood@verizon.net
jamestoogood.com
*＊The Grand Canal—Best in Show,
Philadelphia Sketch Club, 2012*
p76 The Grand Canal

CARRIE WALLER
PSC 87 Box 4167
APO AE 96326-0012
843.813.7752
carriewallerart@gmail.com
carriewallerfineart.com
Boswell Mourot Fine Art, Little Rock,
AZ, and Miami, FL
*＊Nostalgia—Merit Award,
Louisiana Watercolor Society 42nd
International Exhibit*
p24 Nostalgia

WEN-CONG WANG
1F., No. 43, Ln. 120, Zhong 3rd St.
Xizhi District, New Taipei City,
22153
Taiwan (ROC)
886.2.8646.2688
wencong.w@gmail.com
wangwencong.com
p61 Caring
p60 The Story on the Prairie

SOON Y. WARREN
AWS, NWS, TWSA
4062 Hildring Dr. W.
Fort Worth, TX 76109
817.926.0327
soonywarren@gmail.com
soonwarren.com
*＊Your Private Collection Art Gallery
Transparency—Merit Award, SWA
Membership Show*
p62 Green Parrot
p88 Transparency

MONIQUE WOLFE
214 Broughton Drive
Greenville, SC 29609
864.242.3551
p112 Hog Heaven

KEIKO YASUOKA
AWS, NWS, TWSA
23 Litchfield Ln.
Houston, TX 77024
713.973.2739
keiko_yasuoka@hotmail.com
2collaboratingartists.com
Harris Gallery, Houston, TX
*＊Prelude to a Beautiful Day—Merit
Award, Watercolor Art Society of
Houston 36th Annual International
Exhibition*
pp6–7 Prelude to a Beautiful Day

PEGGY FLORA ZALUCHA
NWS, Signature Member; AWS,
Signature Member; TWSA, Signature
Member
109 Sunset Ln.
Mount Horeb, WI 53572
zalucha@zaluchastudio.com
zaluchastudio.com
p82 Copper Pots Reflected #9

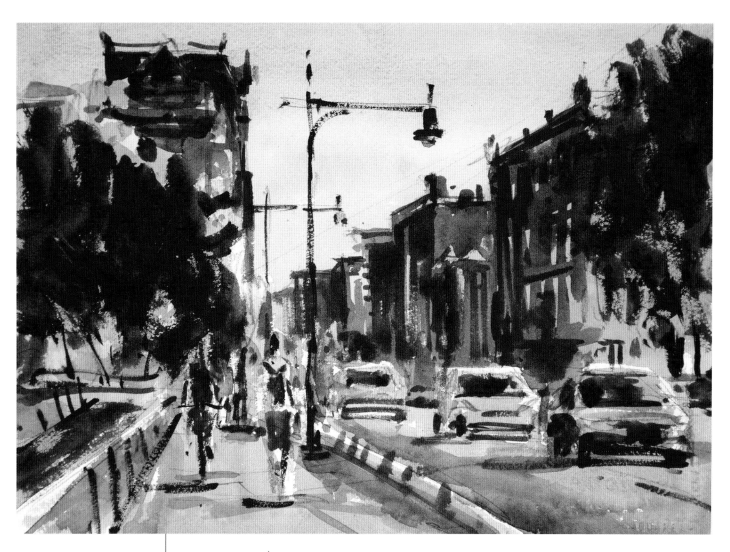

HARVARD BRIDGE | GENADY ARKHIPAU
Watercolor on 140-lb. (300gsm) cold-pressed Arches
11" × 14" (28cm × 36cm)

Watercolor, when handled in a transparent manner, does not produce a physical texture, which makes it a great medium to create the illusion of textures. I like to make use of the paper texture with dry or semidry brushwork or through altering its surface by scratching or scraping. For that reason I prefer to paint on the wire side of the paper. I like how it handles graphite pencil, and I consider drawing to be the most important step in the process. I don't pick up a brush until I'm happy with my drawing. Wire side offers a finer canvas-like texture, which makes it perfect for smaller pieces, with texture noticeable but not too distracting, and produces less ragged brushstrokes.

INDEX

a content + ecommerce company

Other fine North Light Books are available from your favorite bookstore, art supply store or online supplier. Visit our website at fwcommunity.com.

19 18 17 16 15 5 4 3 2 1

DISTRIBUTED IN CANADA BY FRASER DIRECT
100 Armstrong Avenue
Georgetown, ON, Canada L7G 5S4
Tel: (905) 877-4411

DISTRIBUTED IN THE U.K. AND EUROPE
BY F&W MEDIA INTERNATIONAL LTD
Brunel House, Forde Close, Newton Abbot, TQ12 4PU, UK
Tel: (+44) 1626 323200, Fax: (+44) 1626 323319
Email: enquiries@fwmedia.com

DISTRIBUTED IN AUSTRALIA BY CAPRICORN LINK
P.O. Box 704, S. Windsor NSW, 2756 Australia
Tel: (02) 4560 1600; Fax: (02) 4577 5288
Email: books@capricornlink.com.au

ISBN 13: 978-1-4403-3469-6

Edited by Sarah Laichas
Designed by Elyse Schwanke
Production coordinated by Mark Griffin

METRIC CONVERSION CHART

To convert	to	multiply by
Inches	Centimeters	2.54
Centimeters	Inches	0.4
Feet	Centimeters	30.5
Centimeters	Feet	0.03
Yards	Meters	0.9
Meters	Yards	1.1

ABOUT THE EDITOR

Rachel Rubin Wolf is a freelance editor and artist. She has edited and written many fine art books for North Light Books including *Watercolor Secrets*; the *Splash: The Best of Watercolor* series; the *Strokes of Genius: Best of Drawing* series; *The Best of Wildlife Art* (editions 1 and 2); *The Best of Portrait Painting*; *Best of Flower Painting 2*; *The Acrylic Painter's Book of Styles and Techniques*; *Painting Ships, Shores and the Sea*; and *Painting the Many Moods of Light*. She also has acquired numerous fine art book projects for North Light Books and has contributed to magazines such as *Fine Art Connoisseur* and *Wildlife Art*.

AKNOWLEDGMENTS

We could not produce *Splash* without the editors, designers and staff at North Light Books who take care of the many thankless details needed to make this into a beautiful finished book including publisher Jamie Markle, designer Elyse Schwanke and production coordinator Mark Griffin. Special thanks as always to my esteemed *Splash* partner, production editor Sarah Laichas, who, I suspect, is visited at night by elves that help her finish all of the work she is responsible for.

My gratitude also goes to all of the artists in this book, who fill my life with beautiful and varied textures! You are a lovely bunch of wonderful, creative people! Thank you for sharing your techniques and your thoughts with us. I am appreciative of the time (and money) spent in getting the properly format- ted digital photos to us. We certainly couldn't do it without you!

Front cover image: **I'M HERE FOR YOU** | KIM JOHNSON, p47

Back cover image: **BETTER DAYS—WINTER** | TED HEAD, p102

Page 1 image:
DOING THE ROUNDS | GRAHAM BERRY
Transparent watercolor on 300-lb. (640gsm) rough Saunders Waterford 28" × 11" (71cm × 28cm)

Working in the studio from photos taken on a trip to Algarve, Portugal, I was attracted by the very dramatic viewpoint and fantastic shadows. I began with a very pale wash of Aureolin Yel- low, Cerulean Blue and Alizarin Crimson and allowed the colors to merge, taking advantage of the rough paper texture. Each little group of figures was painted in one continuous wash, adding more pigment and less water as I continued to add detail. Though I mainly wanted to convey the heat of the midday sun, each figure had to be drawn correctly. Each gesture is part of the story.

IDEAS. INSTRUCTION. INSPIRATION.

Find the latest issues of *Watercolor Artist* on newsstands, or visit artistsnetwork.com.

@artistsnetwork

Get your art in print!